IMAGES
of America

CALHOUN
COUNTY

IMAGES
of America

CALHOUN
COUNTY

Kimberly O'Dell

ARCADIA
PUBLISHING

Published by Arcadia Publishing
Charleston, South Carolina

Library of Congress Catalog Card Number: 98-85885

For all general information contact Arcadia Publishing at:
Telephone 843-853-2070
Fax 843-853-0044
E-mail sales@arcadiapublishing.com
For customer service and orders:
Toll-Free 1-888-313-2665

Visit us on the Internet at www.arcadiapublishing.com

Contents

Introduction

The state of Alabama entered the Union in 1819, but inhabitants had been in Calhoun County for centuries. The first immigrants to the state were the Muskogee (Creek) Indians, who settled in Northeast Alabama in the 1500s. The Creeks settled in small villages and towns, with Rabbit Town as the largest settlement. Many of the names these inhabitants gave to local sites were retained by the Anglo settlers in the later centuries. In July 1540, Hernando de Soto visited the Creeks in Calhoun County when his expedition passed through via the Coosa River.

In the northern half of the state of Alabama lies the Highlands area. Calhoun County is part of this region which is rich in red iron ore, needed for the iron and steel industry, as well as the rugged peaks of the hill country. In the early 1800s immigrants from nearby Georgia and South Carolina settled in these hills. They set up farms in the valleys and the towns of Oxford (Lick-Skillet) and Jacksonville (Drayton), and were neighbors to the Creeks. In 1832, the Creeks signed the Treaty of Cusseta, in which they surrendered their sovereignty of the lands. The land was divided out among the Creeks under the condition that the land was not to be sold for five years without the consent of the President of the United States. After that time, if they wished the Creeks could remain as ordinary American citizens or they could sell out and go to the Oklahoma Territory.

Also in 1832, Benton County was chartered by the State of Alabama. It was named for Colonel Thomas Hart Benton, a veteran of the Creek Indian War. Jacksonville (Drayton) was selected as the county seat. Benton County was located approximately 30 miles from the Georgia state line. It sat in the

northern shadow of the Talladega National Forest. The fertile soil made this area ripe for farming. The major money crops of the county were cotton and corn. The county remained predominantly a farming county until after the American Civil War.

Life in 1833 Benton County was hard. Settlers were sparse and their cabins were constructed with dirt floors. There was a trading house at Boiling Springs and a few farming families had settled on various creeks in the county. White Plains had a small trading cabin and Alexandria had Houston's store. Chief Ladiga occupied most of present-day Jacksonville. In 1836, the Cane Creek Blast Furnace was erected near Polkville to furnish settlers with iron ore for wagon wheels, plow shares, pots, skillets, and other necessary tools.

Tensions between the North and South escalated in the 1840s and 1850s. The South became a strong supporter of States' Rights and its champion, South Carolinian John C. Calhoun, who was Andrew Jackson's vice-president (1825–1833). In 1858, the name of Benton County was changed to honor Calhoun. In 1866, due to the organization of Cleburne County to the east and Etowah County to the west, Calhoun County was reduced to its present dimensions.

The county supplied many young men to fight for the Confederacy during the Civil War. The years after the Civil War were prosperous, and saw the primarily agricultural community turn into an industrial area. The city of Anniston was founded and opened for settlement and a teacher's college was added.

The growth of Calhoun County continued into the 20th century. By World War I, the federal government needed training areas for soldiers, so the county became the home of Camp McClellan. In 1929, the camp was designated as a fort and became a permanent base, training soldiers who fought in World War II, Korea, Vietnam, and Desert Storm.

Calhoun County is one of the larger counties in northeast Alabama. It contains four towns: Oxford, Anniston, Jacksonville, and Piedmont. It is also home to the Anniston Ordinance Depot and Jacksonville State University. Each of these areas has a distinct history of its own that illustrates its roll in the county.

Legend

- ◉ County seat
- ○ Current place name
- ● 34 Historic place name
- ● Current place with variant name

— Primary highway

— Secondary highway

— Other roads

Ottery

Prices 24

H. Neely Henry Lake

H. NEELY HENRY DAM

Laney
2
4
5
6
1
Colwell
3
41 Reads Mi
43 Laney
42
Duke
Sulph
Spri
44
45
46
431
47
Well
50
49
35
36
151
37
54
55
48
51
52
53
38
Ottery
Grayton
56
57
58
Ohatchee
62
59
60
A
39
Middleton
West Alexandria
Francis Ferry
40
62
Lowrimores Crossroads
152
61
101
102
FORT McCLELLAN
Boiling Springs
Morrisville
104
90
Cane
91
Francis Mill
103
Leatherwo
89
92
97
93
105
MILITARY RESERVATION
94
77
95
96
146
98
99
Sulphur Springs
100
ANNISTON ORDNANCE DEPOT MILITARY RESERVATION
107
106
109
108
Eulaton
Tar
Burns Crossroads
Vinnette
Bynum
128
129
130
127
Eastaboga
131
78
Coldwater
134
Coosa River
Ohatchee
Tallasseehatchee
Creek
Creek

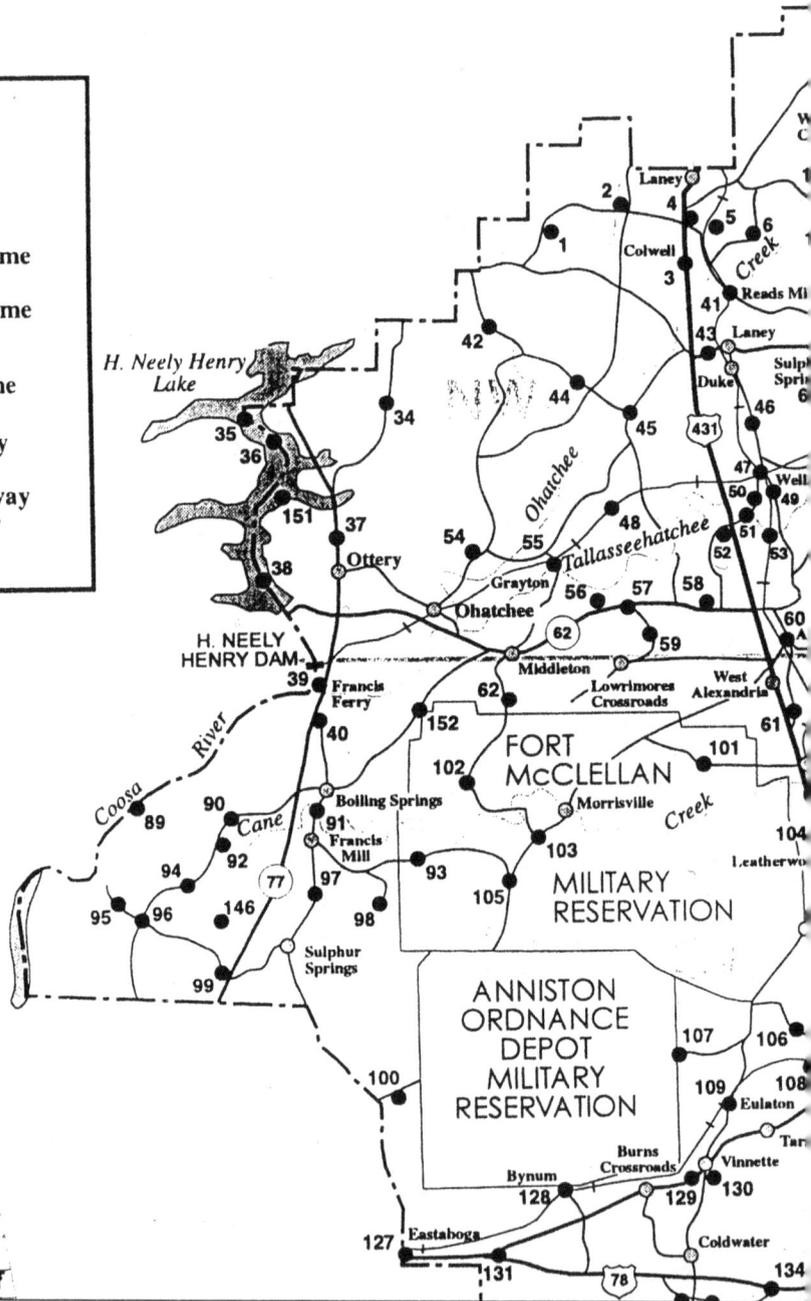

Calhoun County is shown here in the 1990s. Historical places, some no longer in existence, are

Knightens Crossroads
16
278
26
27
145
29
28
Ladiga
18
Allsop
17
30
7
8
48
19
33
32
Vigo
11
Piedmont
Springs
31
Piedmont
13
Williams
21
20
24
Asberry
23
22
Prices
143
9
65
25
64
15
21
Maxwellborn
TALLADEGA
NATIONAL
FOREST
67
Merrellton
83
Nances
Creek
88
Burns
Tredegar
71
Angel
73
Jacksonville
84
Cedar
Springs
74
75
Broadwells
Mill
Holley
Crossroads
85
Jenkins
77
Leydens Mill
79
Bonny
Brook
Rabbittown
87
80
Whites
Gap
149
Weaver
White
Plains
86
82
Whitesides
Mill
117
112
110
FORT McCLELLAN
White
111
118
Saks
113
MILITARY
RESERVATION
121
Joseph
Springs
119
120
9
Iron
City
122
Choccolocco
Old Davisville
126
14
147
125
Anniston
anni
16
123
Ardrey
124
Hobson
City
Golden
Springs
78
d
135
DeArmanville
115
Creek
20
6
138
Choccolocco
139
140
141

Produced by the Dept. of Geography
College of Arts and Sciences
The Universtiy of Alabama

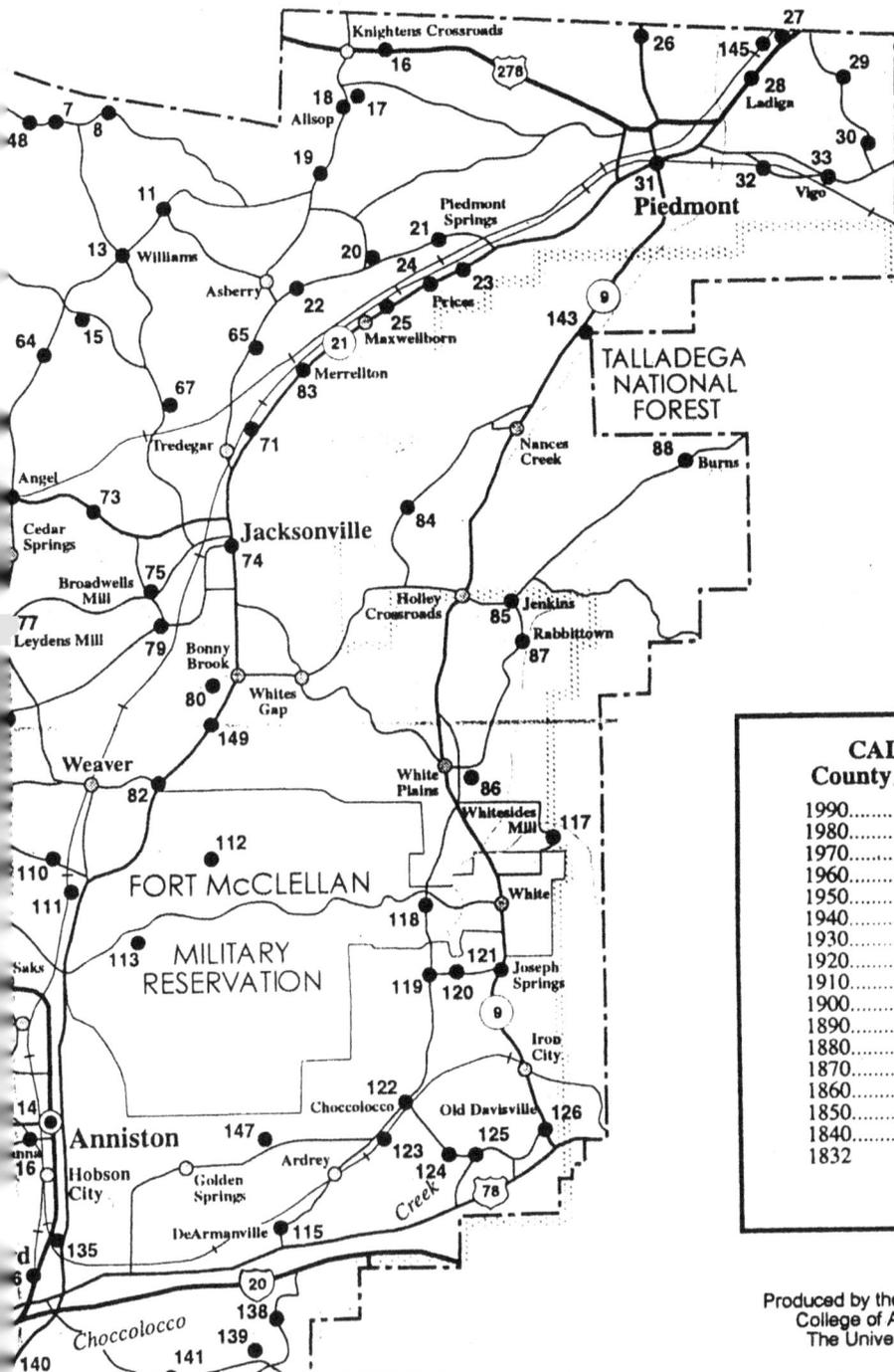

CALHOUN County Population	
1990	116,034
1980	119,761
1970	103,092
1960	95,878
1950	79,539
1940	63,319
1930	55,611
1920	47,822
1910	39,115
1900	34,874
1890	33,835
1880	19,591
1870	13,980
1860	21,539
1850	17,163
1840	14,260
1832	established

also labeled on the map. (Courtesy of *Historical Atlas of Alabama, Vol. 1.*)

One

Oxford

Oxford is located in the southern portion of Calhoun County and borders Talladega and Cleburne Counties. In 1833, the Snow and Simmons families were the first white settlers in the southern part of Benton County. They established homesteads on either side of present-day Choccolocco Street. "Lick-skillet" was a trading center for the area before the Civil War. The name "Lick-skillet" is said to have reflected the inhabitants' economics since food and clothing were scarce.

About 1850, the name of the hamlet was changed to Oxford, probably in honor of Oxford, England. On February 7, 1852, and again on February 21, 1860, the town of Oxford was incorporated with an intendant and councilmen as the governing body and Dr. S.C. Williams as the mayor. During the American Civil War, the iron ore in the area became important to the war effort. In November 1862, the Oxford Iron Company was founded to mine the iron ore in the area and convert the raw material into pig iron. In 1863, a charcoal furnace was built with a capacity of approximately 20 tons a day. In 1865, the furnace was burned by federal troops. Not only did Oxford provide iron ore and pig iron, but it also organized a company of soldiers named "the Dudley Snow Rangers."

After the War between the States ended, the town of Oxford began to grow and prosper. Education, as well as business, was important to the people of Oxford. In 1868, the town had the Oxford Male and Female Colleges to instruct in all arts and sciences. Three years later saw the founding of Oxford College. From 1878 to 1884, the town witnessed rapid and successful growth in business. By 1884, Oxford had about 25 businesses, and Oxford Lake Park became a popular vacation spot for many travelers.

Around the turn of the 20th century, Oxford had paved sidewalks, an electric streetcar system, a weekly newspaper, and Calhoun County High School. Industries had also blossomed and included a cotton seed-oil mill, a cotton cord and twine mill, a linter ginnery, a fertilizer plant, a cotton ginnery, and a fire-brick plant—not to mention iron ore and coal mines. Oxford continued to grow during the 20th century. With the interstate highway system of the 1950s, Oxford's growth was aided by Interstate 20 passing through the town. The town continues to grow in the 1990s due to industries and several interchanges on the interstate system.

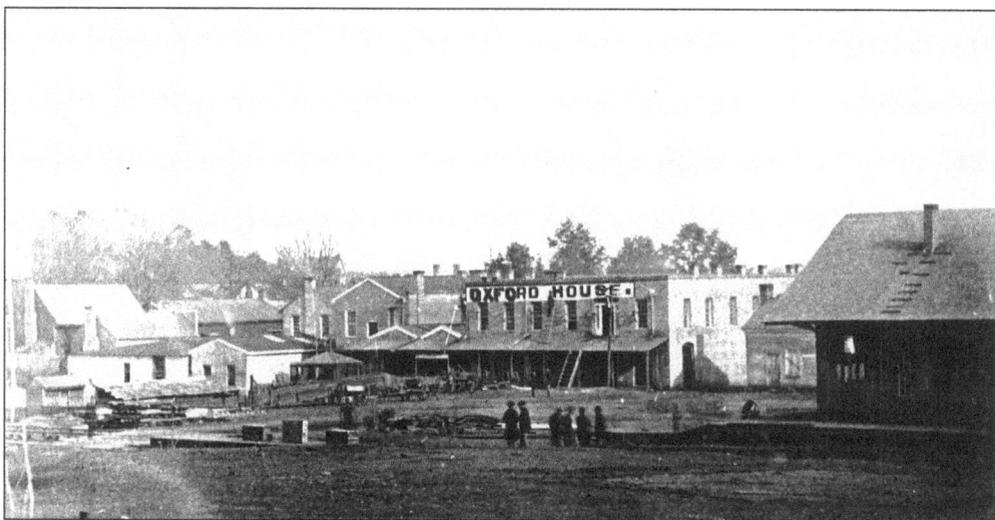

When settlers first arrived at Oxford in the 1830s, a ditch ran through the village. The north side of the ditch was referred to as "Lick-skillet," and the south side was known as "Skace Grease." The main building in town was Dudley Snow's hotel, located across the street from the Southern Depot. This building later became a stable. Some believe the town of Oxford received its name from the fact that oxen forded the creek near the center of town, hence "Ox-Ford." The town was first incorporated in 1852, when the population was around 200. At that time it was home to an architect, a builder, and two blacksmiths. The town was incorporated again in 1860, with the limits of the town set as 1/2 mile in every direction from the railroad culvert in the town. (Courtesy of Oxford Public Library.)

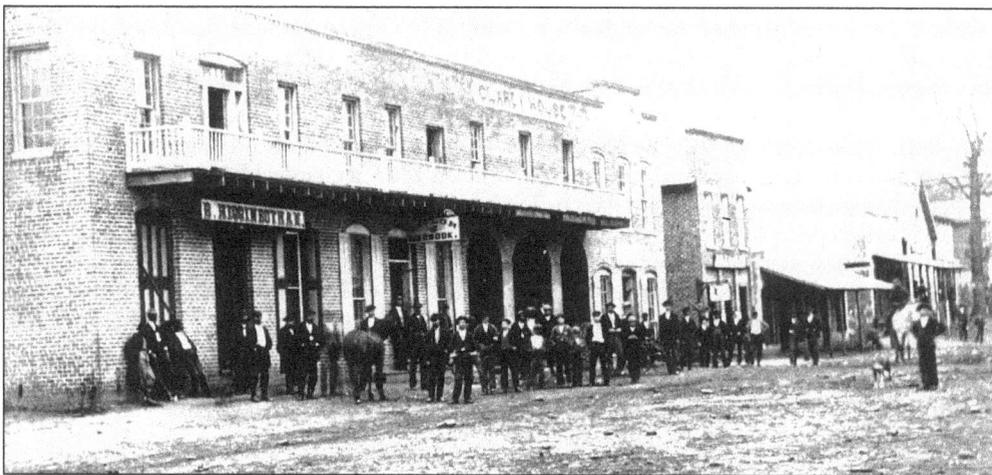

In 1865, Union soldiers burned all the buildings of value in downtown Oxford. Soon after the war, the downtown area was rebuilt. The following year, Daniel Draper and his sons established a bank. They named the bank D.D. Draper and Sons, Bankers, Retailers, Wholesale Dealers, and Cotton Merchants. Eventually one of the sons left, and the bank became simply D.D. Draper and Sons. The bank had branches that extended into neighboring counties and was responsible for supplying the ports of Mobile and New Orleans with cotton to ship. The bank building burned in 1883, but was soon rebuilt. The new building became the First National Bank of Oxford, which closed during the Great Depression in 1932. (Courtesy of Oxford Public Library.)

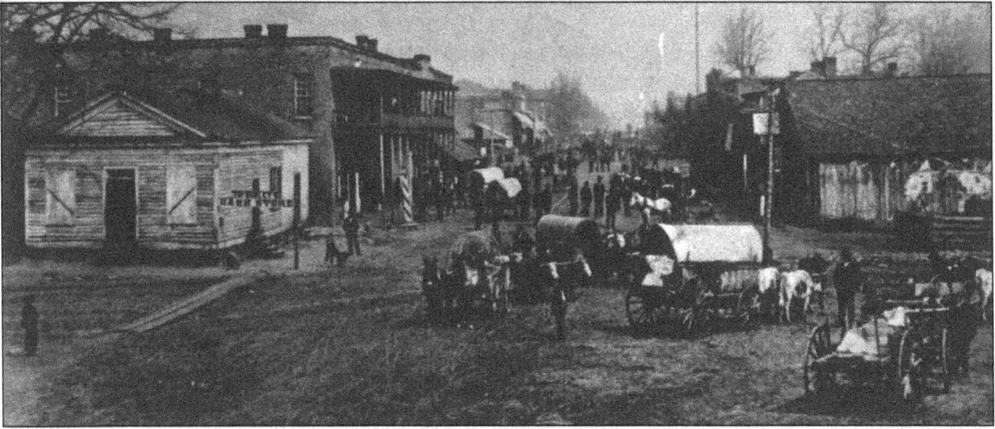

Oxford was still small in the 1880s. The population was approximately 780. The town's first "streetcar" was introduced in 1875 and was a cart drawn by a horse. A round trip from Oxanna to Oxford was 5¢. Oxford was home to two railroads: the E.T. Virginia & Georgia & the Georgia Pennsylvania and the E.A. & Cincinnati. The railroads made Oxford a terminal and gave it the same freight as larger cities. The city also had a cotton market, 2 heavy groceries, and about 25 businesses along Main Street. (Courtesy of Oxford Public Library.)

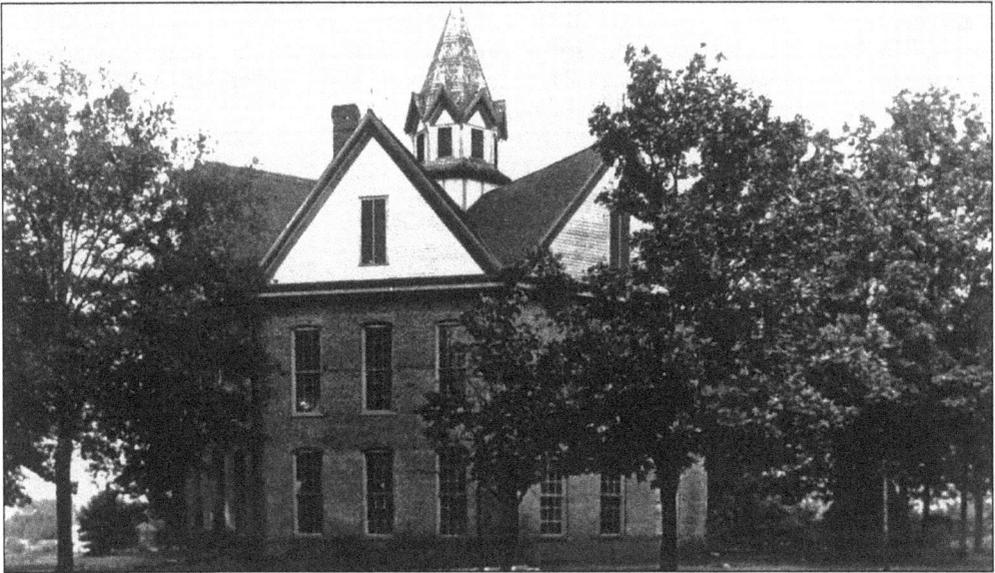

In 1867, the City of Oxford met to discuss plans for an institution of higher learning. On May 24, 1871, Oxford College received a charter from the State of Alabama. Mr. John Dodson of Summerville, GA, was selected to head the college, which was financed by selling shares of stocks that many prominent citizens purchased. Dodson Hall, pictured here, was the main building and was used for classes. Also located on the school property were a frame building used for the music department and the "Sheltering Arms," the Dodson home that was added onto for a dormitory for boarding students. The school instructed classes in all the arts and sciences, made rules for the conduct of students, and granted diplomas and degrees. Oxford College grew rapidly between 1878 and 1884. After 1884, there was a steady decline attributed to numerous factors, including the chartering of private schools and colleges in the area and the declining health of President Dodson. In 1899, Dr. Dodson resigned as head of the school and the college closed its doors. (Courtesy of Oxford Public Library.)

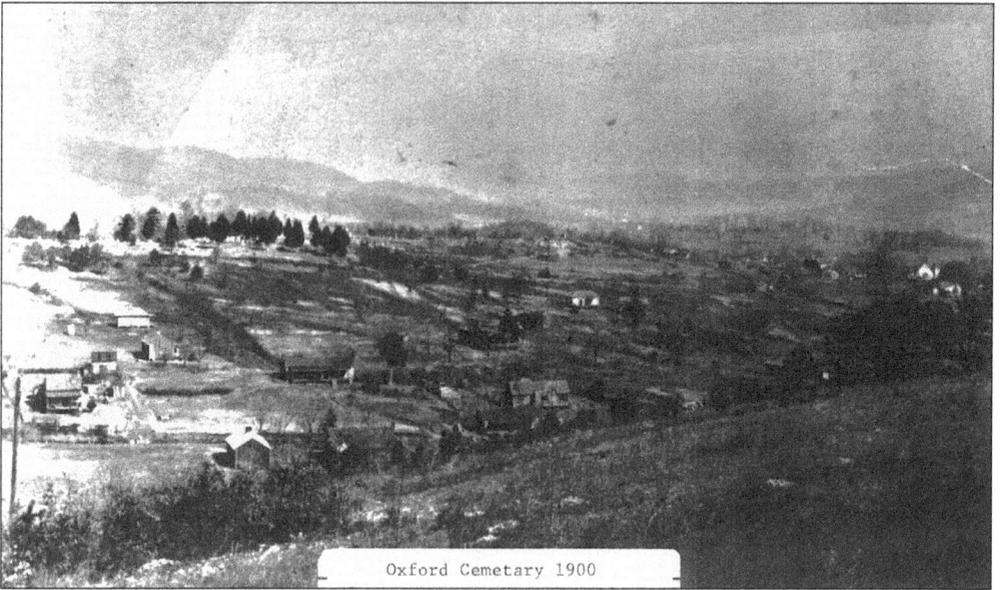

Oxford Cemetary 1900

The Oxford Cemetery, located on a cedar-covered hill west of town, contains the remains of many early settlers dating back to the 1850s. The cemetery is located at the end of McKibbon Street. The land on both sides of this street was once owned by E.S. Simmons, who possibly gave the land away to develop the area. The homes of some of the earliest settlers were located in this area. (Courtesy of Oxford Public Library.)

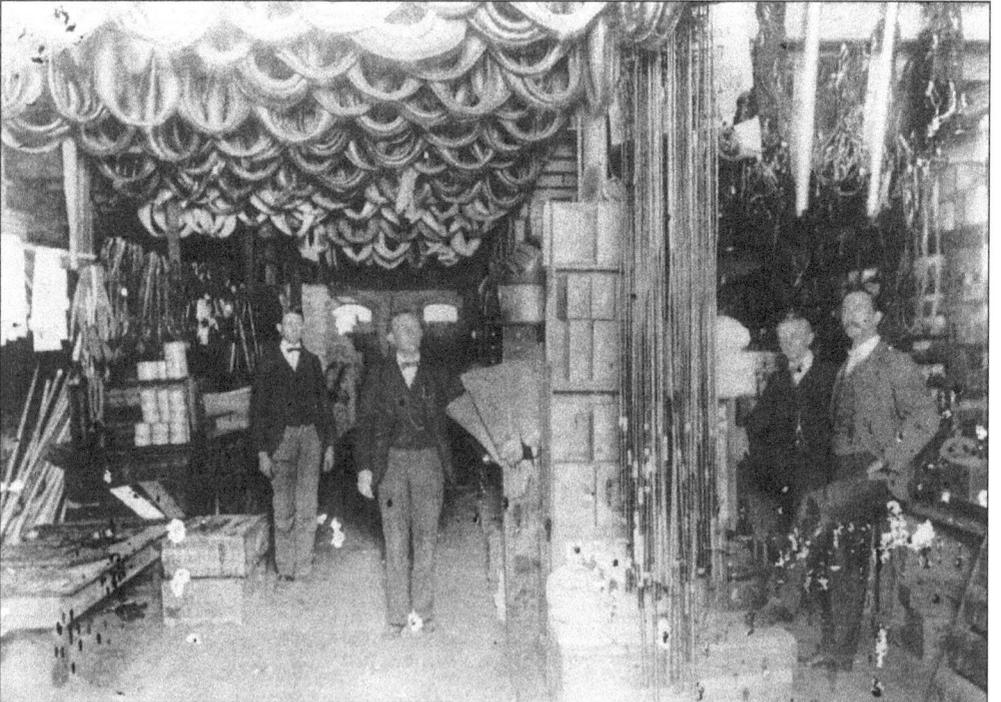

The local hardware store was not just for supplies. One went to the hardware store to pick up a horse harness, nails, paint, and often times dishes. Until the late 20th century, brides registered for their china and silver in the local hardware store. (Courtesy of Oxford Public Library.)

14

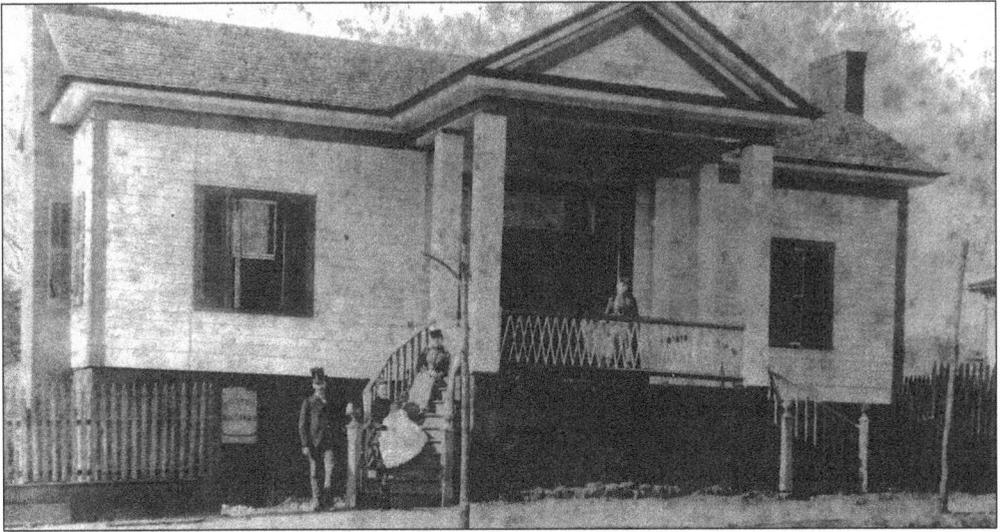

Dr. B. Dudley Williams, shown at his office and residence, was a leading expert in the South on hookworms. He served as the health officer for Oxford in the late 1800s, as well as the president of the Calhoun County Medical Society. Williams not only served Calhoun County, but also the nation. Indian Commission to Utah and Minnesota and a delegate to the Democratic convention were just a few of the ways Williams served the United States. Dr. Williams died in March 1911. He is shown with his wife and baby daughter, Jean, and housekeepers, Fannie and Simmie Montgomery. (Courtesy of Oxford Public Library.)

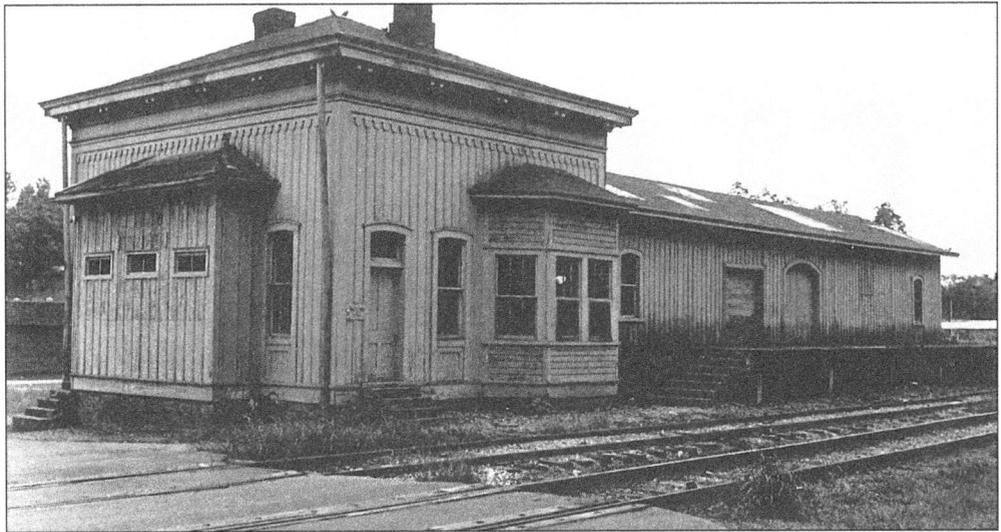

The Southern Railway Depot was located west of Main Street on Spring Street. The Alabama and Tennessee Rivers Railroad came to Oxford about 1860. The railroad played an important roll in the town's post–Civil War growth. The original structure was destroyed in 1865. This modified Italianate-style depot was built about 1884. The station was built at a time when segregation was law in the South. The sign next to the door identifies it as the "colored waiting room." The depot closed in the 1960s, and only four of the Southern Railway depots remain today, two of which are located in Calhoun County. The Oxford and Piedmont depots, along with the depots in Cave Springs, Georgia, and Selma, Alabama, remain the only examples of this style depot. (Courtesy of Oxford Public Library.)

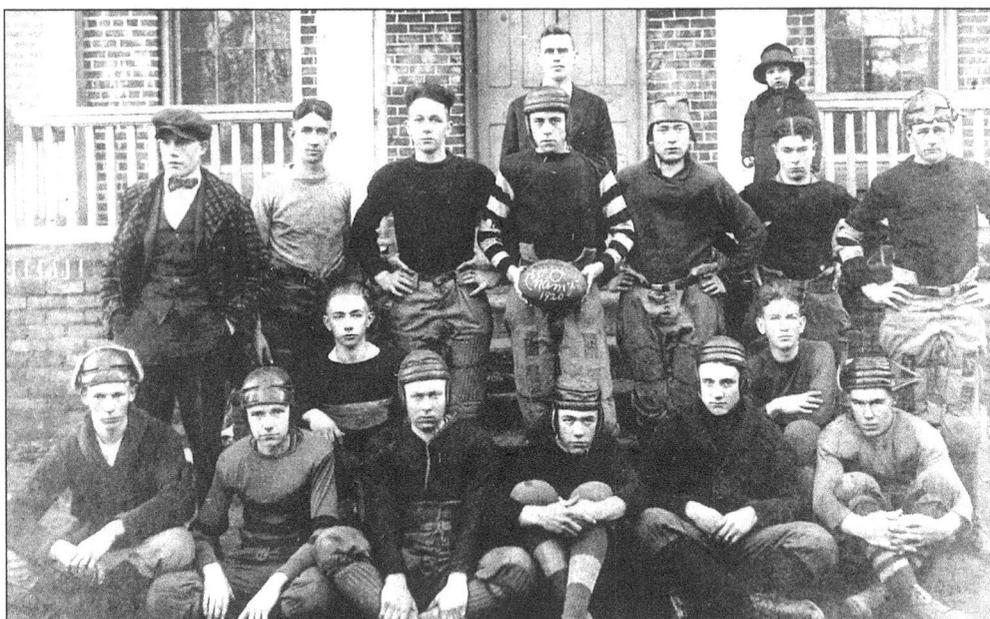

The sport of football was created in 1869 and the rules were similar to soccer. By the 1880s the game resembled modern football. This 1920 local football team posed on the steps of the old Oxford College to display their championship. Football at this time was dangerous for its participants. The uniforms had little padding, and leather "helmets" offered virtually no protection from head injuries. (Courtesy of Oxford Public Library.)

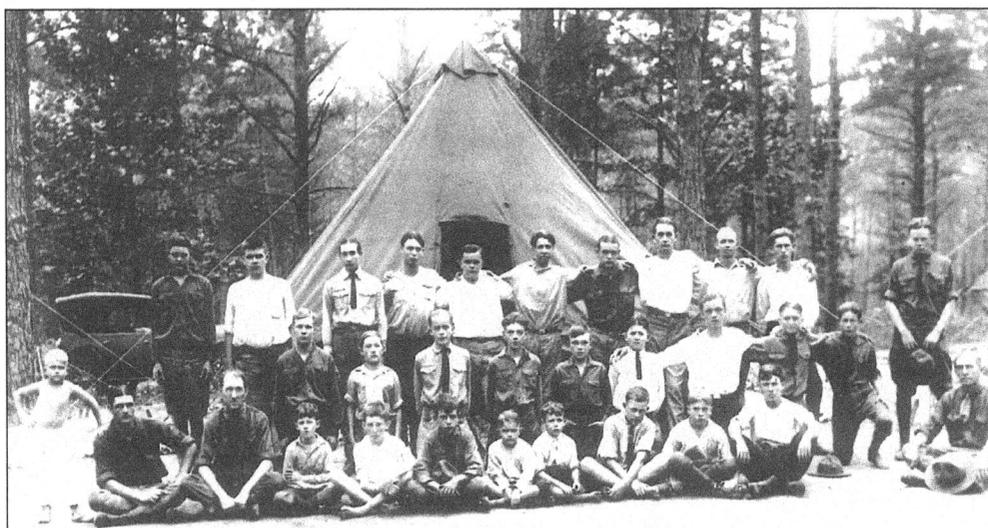

The Boy Scouts of America was founded on February 8, 1910, in the District of Columbia. This program of training to develop character, citizenship, and physical fitness of boys ages 8 to 18 became popular. Local units were sponsored by churches, service clubs, schools, or other community organizations. The Scouting program was divided into three groups: Cub Scouts (ages 8–10) centered activities around the home; Boy Scouts (ages 11–13) was geared toward outdoor activities; and Explorers (ages 14 and up) emphasized outdoors, social service, and vocations. Camping and hiking played a major part of Scouting. This photo shows Oxford Troop #10 on a camping trip in 1922. (Courtesy of Oxford Public Library.)

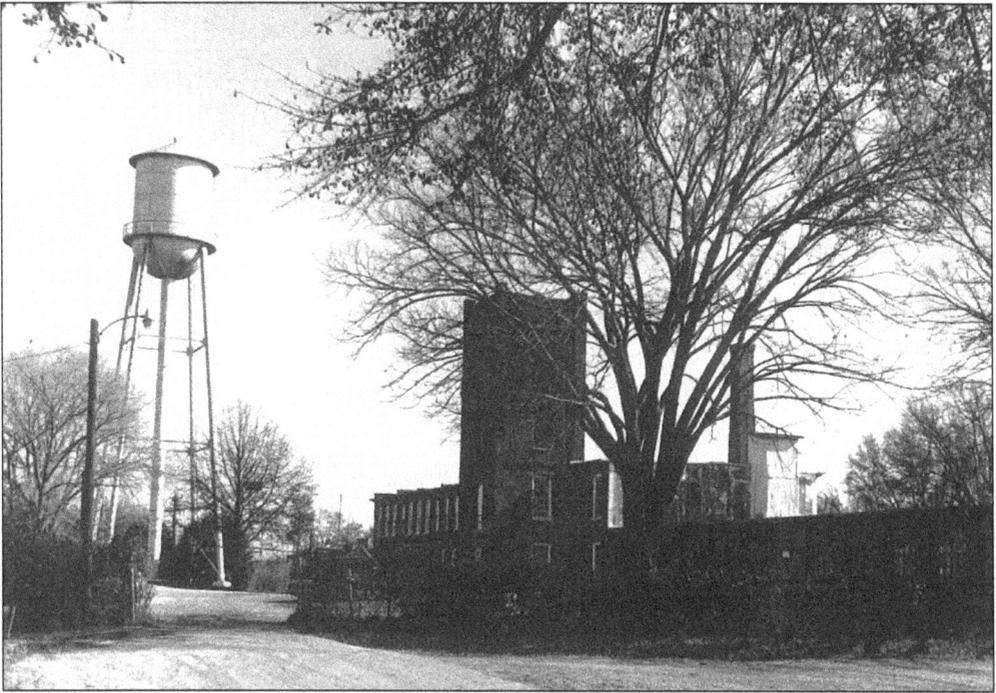

The Blue Springs Mill Complex was located on Mill Street, near present-day Interstate 20. Built in 1885 as a response to Oxford's importance as a shipping point for cotton, the mill was the town's oldest industrial installation. In addition to the mill, homes for its workers were built at the same time. The mill is located approximately 150 feet from a natural spring which provided water for the steam production. (Courtesy of Oxford Public Library.)

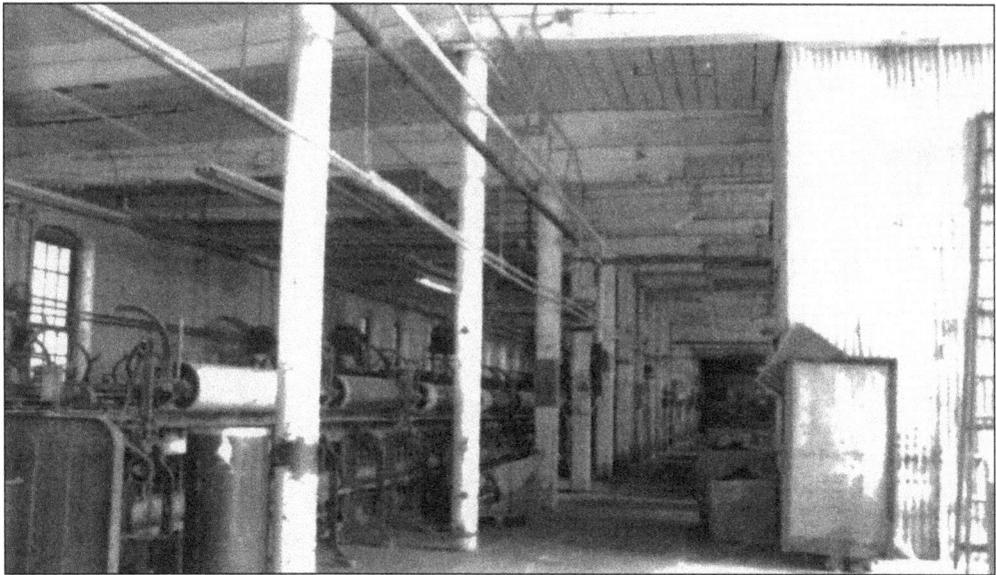

The Blue Springs Mill was a cotton mill which produced rope, twine, maps, and specialty products. The card room was the cotton's stop after it left the picking room. The cotton left the picking room in rolls and then went through the carding machine and came out into a can. (Courtesy of Oxford Public Library.)

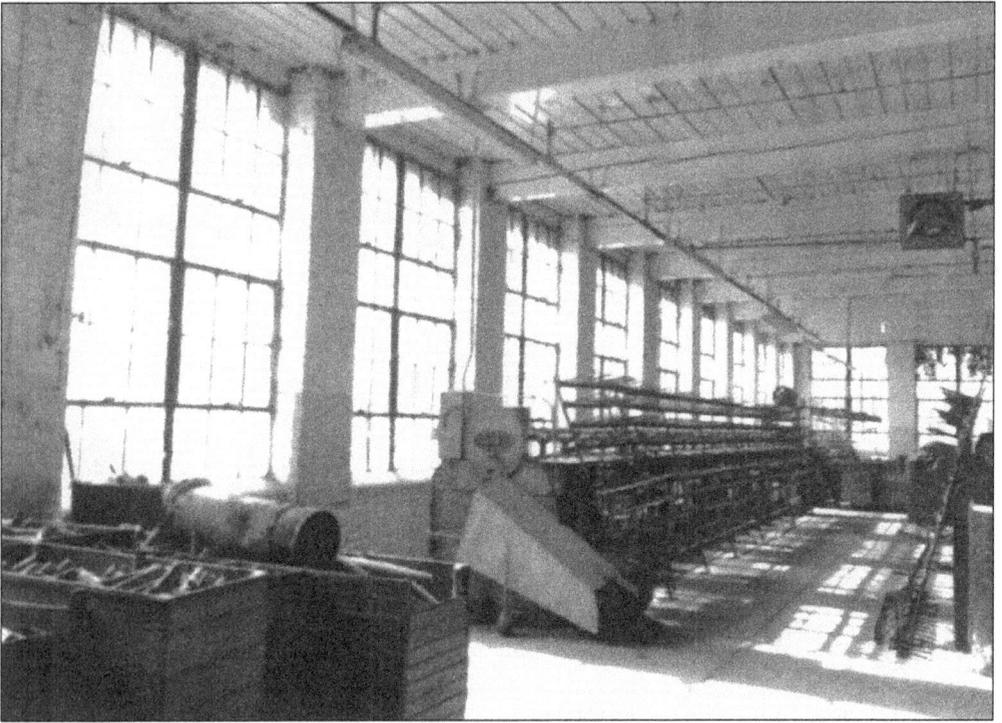

The weaving room took cotton from the spindles and used large looms to weave the cotton into cloth. (Courtesy of Oxford Public Library.)

The mill closed in the 1970s. The machinery was removed and the space was used for an antique mall. In 1998, the mill was torn down to develop commercial real estate. The mill's location, so close to I-20, made it an ideal location for modern development. (Courtesy of Oxford Public Library.)

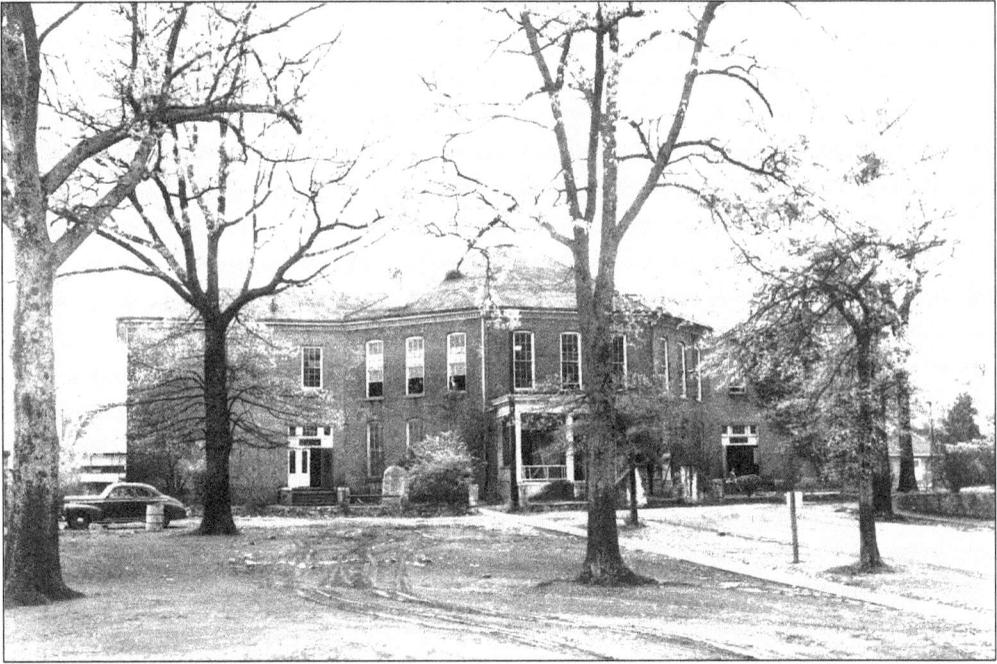

In 1899, Oxford College closed and the building was leased to the City of Oxford. Eventually the town purchased the building to serve as Calhoun County High School. The building served as the county high school for the first half of the 20th century. In 1953, after the completion of the new Oxford High School building, the old college was demolished. (Courtesy of Oxford Public Library.)

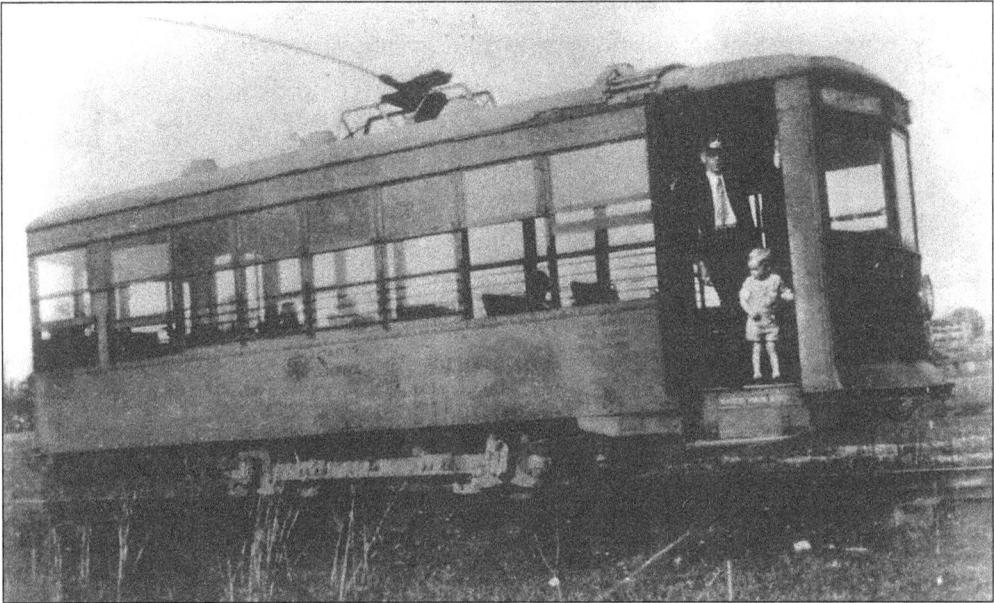

The electric trolley car came into use thanks to steel rails and wooden ties laid as tracks. It employed a driver and ticket catcher. The fare was 10¢. In the summer of 1932, the streetcar made its last run down Main Street. When buses, and ultimately cars, replaced the streetcar, the park at Oxford Lake saw a decline in business. (Courtesy of Oxford Public Library.)

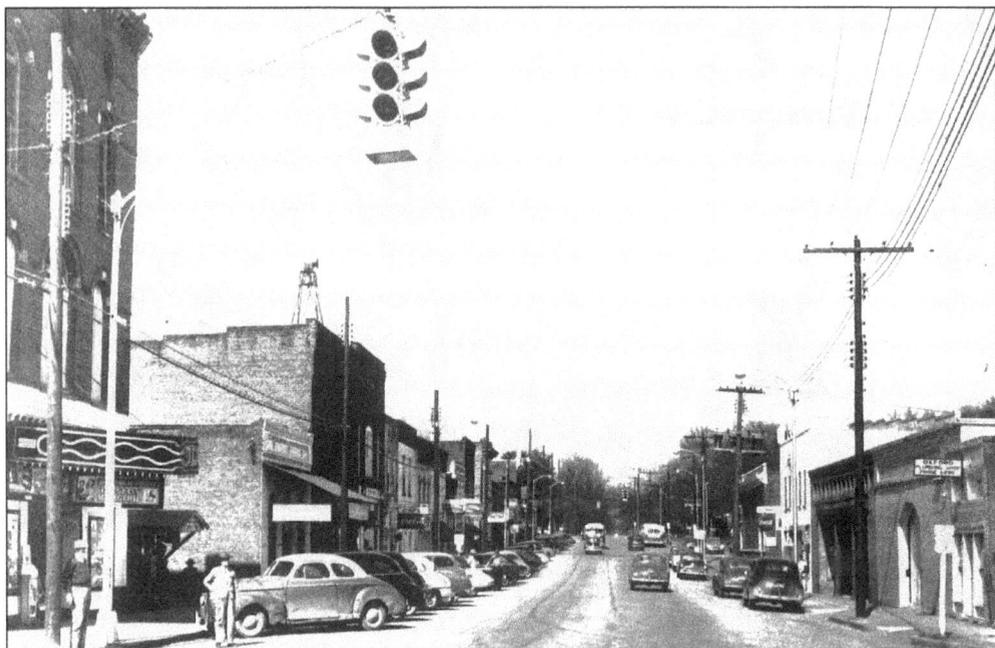

In 1952, Oxford was growing. The population was 1,639. New construction was evident in the General Electric plant, a grain elevator, a new city hall, a new high school, a Girl Scout hall, and library. The town government consisted of a mayor, city council, city clerk, and four policemen. Downtown had numerous shops and the Oxford Theater. (Courtesy of Oxford Public Library.)

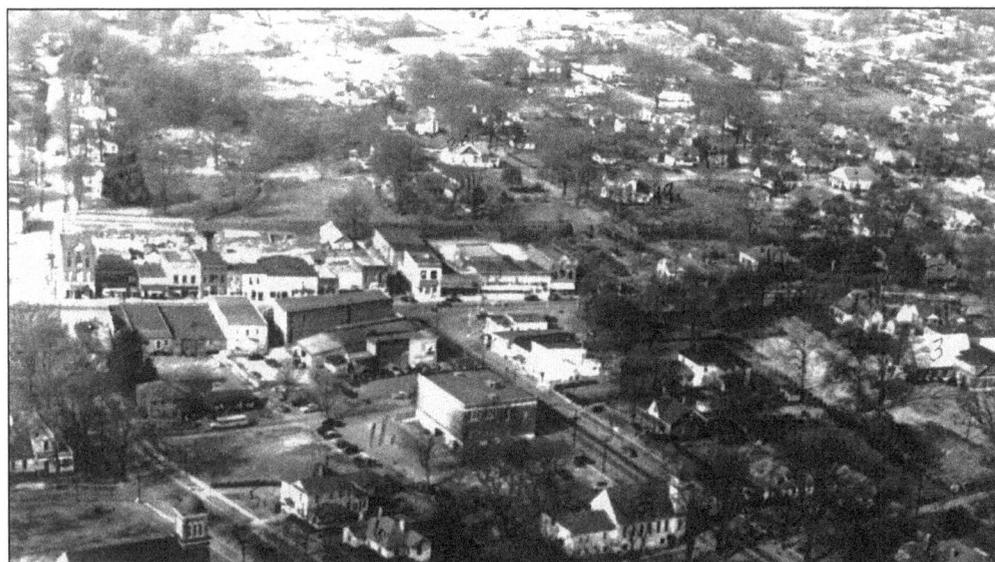

This aerial view of Oxford in 1955 shows the downtown area (upper left) and surrounding residential areas. At 415 Main Street, on the northeast side of Main, is the city park. The park was originally used as a wagon yard for farmers bringing their cotton to market. The farmers camped overnight and sold their cotton at auction early the next morning. In 1860, Sylvanus Simmons deeded the property to the City of Oxford for public use. The town well, for public use, was located in the city park. (Courtesy of Oxford Public Library.)

In 1836, Snow's Creek residents met to organize a Baptist church. In 1860, Sylvanus Simmons donated the land, at 101 East Oak Street, to build the Friendship Baptist Church, later the First Baptist Church of Oxford. In 1910, the building (pictured here) was torn down and a new structure built on the site. (Courtesy of Oxford Public Library.)

In 1857, Reverend H.A. Houston organized the Oxford Presbyterian Church with 11 members. The church, constructed in 1891, was located at 825 S. Main Street. The church's architecture is High Victorian, reflecting the open interior plan and open truss work roof. In 1919, the congregation honored the late president of Oxford College, John Dodson, by renaming the church the Dodson Memorial Church. (Courtesy of Oxford Public Library.)

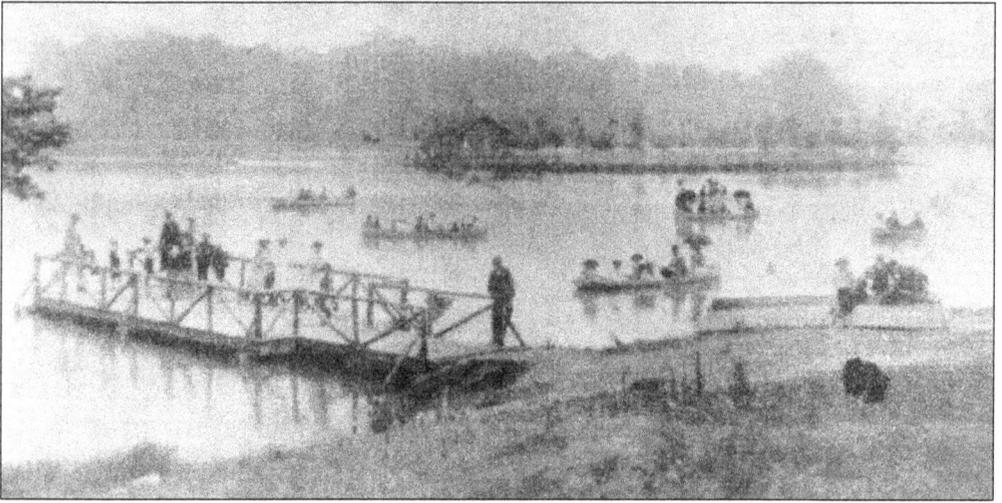

In the 1830s, Barnett McCulley of Alexandria purchased the Springs near Oxford for his home. In 1888, the Minnie Lula Lake Company purchased the land. Shortly thereafter, the land was transferred to the Anniston, Oxford, Oxanna Street Railway Company. The year 1889 saw the creation of Oxford Lake as a vacation and recreation site for the surrounding area. Many Victorian ladies and gentleman turned out for afternoon canoe rides on the lake. After the boat ride, they would return to shore for a picnic or dancing in a nearby pavilion. Fishing for brim off the pier was also a popular activity for young boys. (Courtesy of Oxford Public Library.)

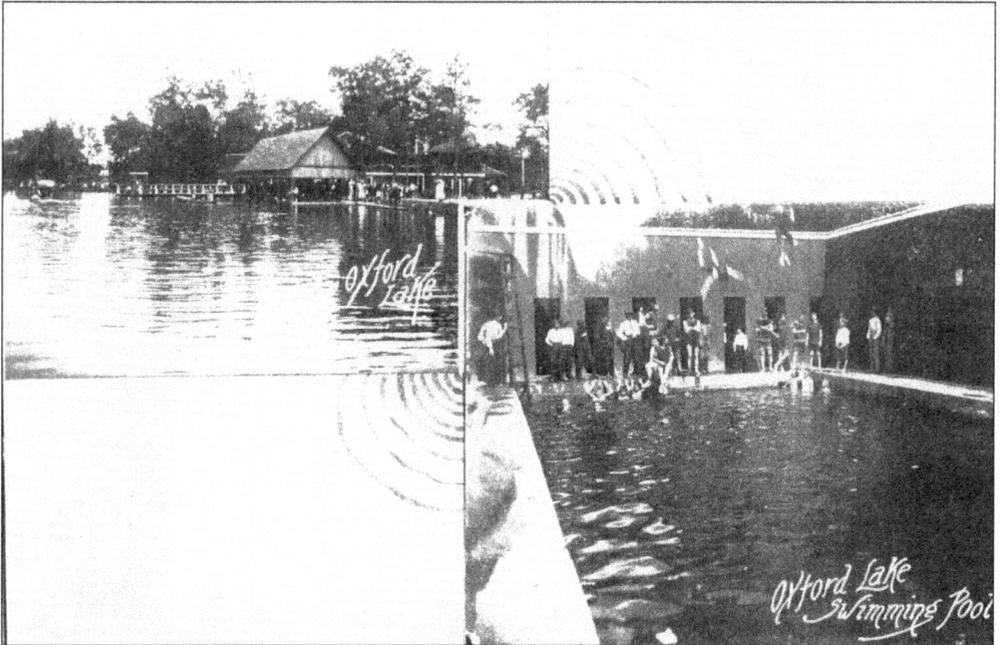

A foreclosure on the mortgage transferred the lake property to the Anniston Electric Company. In the Victorian era, amusement parks were built at the end of streetcar lines to encourage people to ride the streetcars. The streetcars arrived at the lake at the hour and half hour up until about 11:00 at night for a 5¢ fare. By the turn of the 20th century, Oxford Lake had a horse-racing track, canoe rides, swimming, and various vaudeville shows. It was also the location of the county's only swimming pool and bathhouses. (Courtesy of *Select Views of Anniston*.)

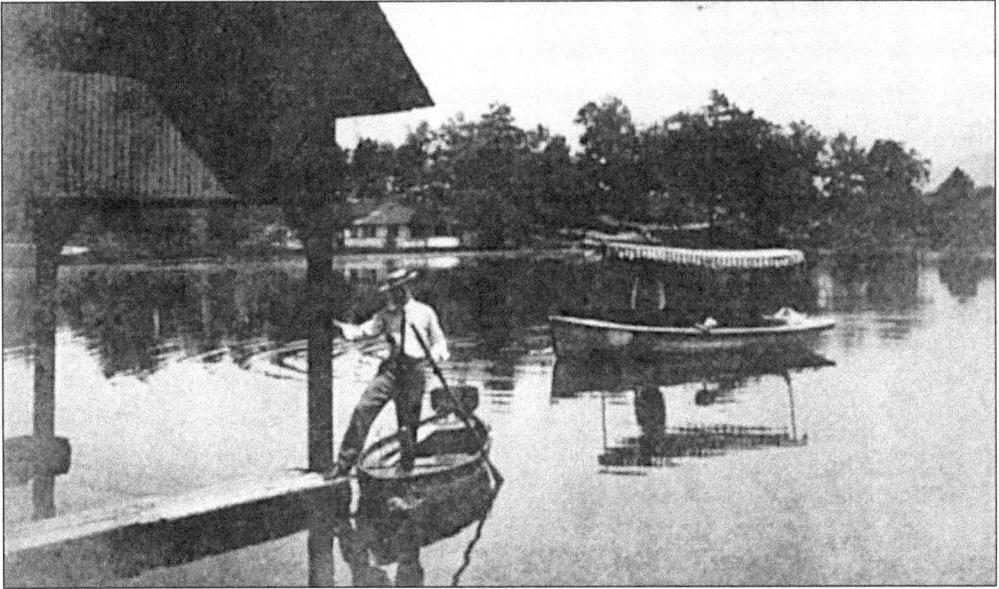

The Oxford Lake boathouse once held a large quantity of boats which could be rented for 25¢ an hour. The boats were numbered, and a gong summoned the boats back to the boathouse when rental time was up. The boathouse, later an enclosed picnic area which was rented out, was torn down in 1978. The bowling alley had six lanes and was destroyed in an electrical storm in 1968. Two years earlier, fire claimed the dance hall. (Courtesy of Mrs. T.E. Kilby Jr.)

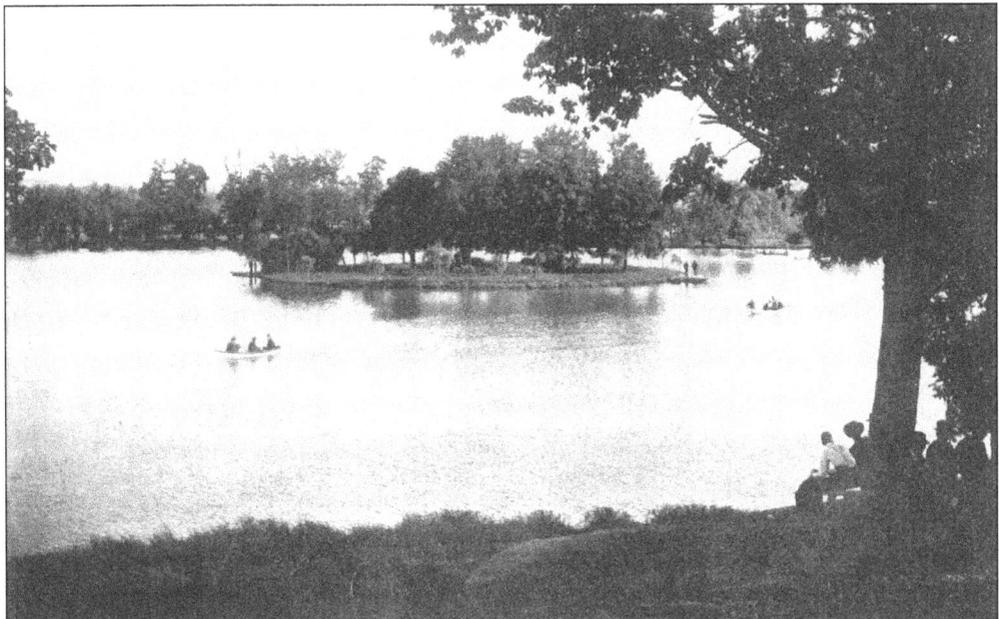

In the center of the lake was a 2-acre island. In the 1890s, canoe rides to and picnics on the island were a popular diversion, and even a few marriage ceremonies were held on the island. In the 1920s, the Second Ku Klux Klan held initiations for its new members on the island, while spectators watched the secret activities from the shore. The oak trees on the island were destroyed by beavers in the 1960s. Eventually the beavers were eliminated as a result of an intense cleaning of the lake area. (Courtesy of *Alabama Military Institute Catalogue*.)

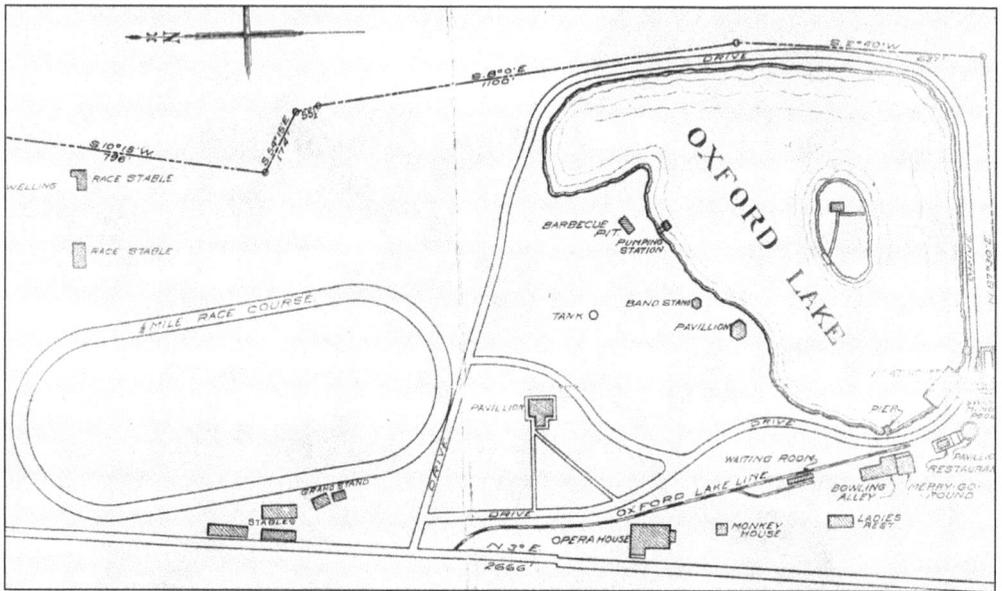

The blueprints for Oxford Lake in 1915 show a 1/2-mile horse track complete with grandstands and stables located approximately where Highway 78 currently passes through. The Oxford Lake Line streetcar waiting room was located in the heart of the entertainment complex. The opera house was home to different stock companies in the summer. The troupes performed mostly musicals and dramas. According to some, the opera house was the closest thing to a legitimate theater in the county. (Courtesy of the Alabama Room of Calhoun County Public Library.)

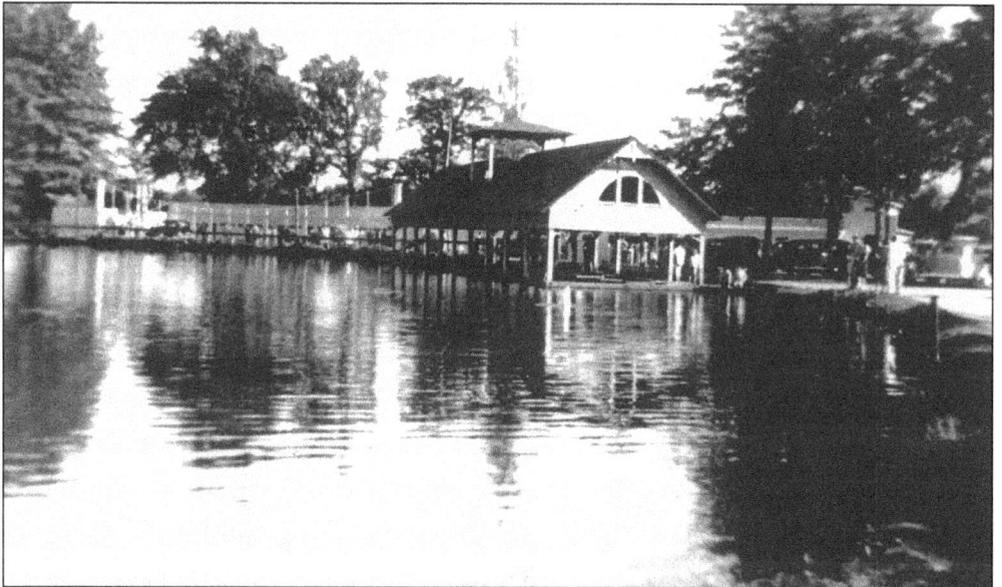

In the 1830s, McCulley Springs was home to two Native American tribes and a burial ground. From the 1890s to the 1940s, Oxford Lake went through many changes. An updated swimming pool was added to the right of the boathouse. The vaudeville shows and the monkey shows gave way to the midway. A hundred years later the Springs were a thriving entertainment complex for a growing Calhoun County. (Courtesy of Oxford Public Library.)

24

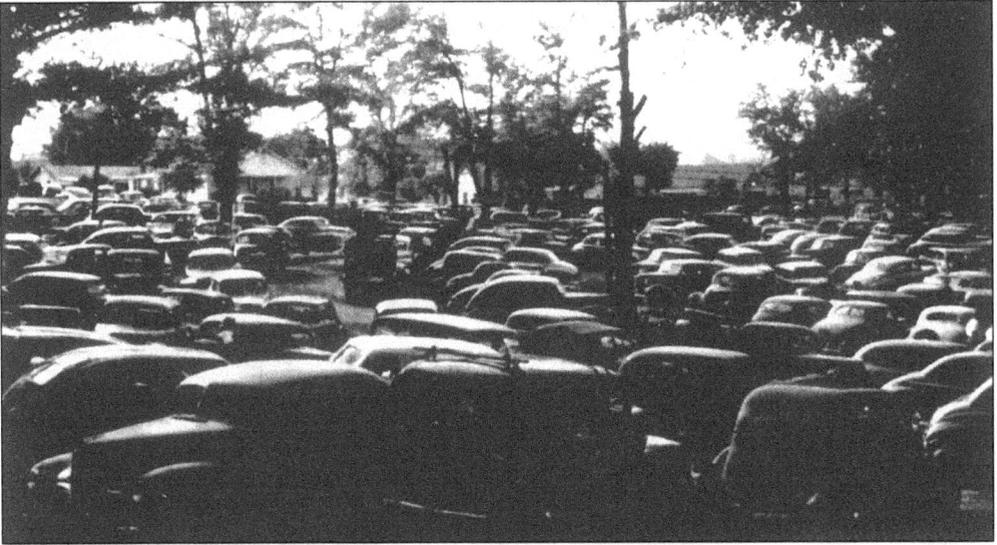

In the 1930s, the Great Depression took its toll on attendance at Oxford Lake. In addition to the Great Depression, many of the cities had built pools, so fewer people came to the lake. There were no rides at the lake except an old merry-go-round. By 1940, World War II helped the nation back to economic prosperity, and as a result people once again came to enjoy Oxford Lake. (Courtesy of Oxford Public Library.)

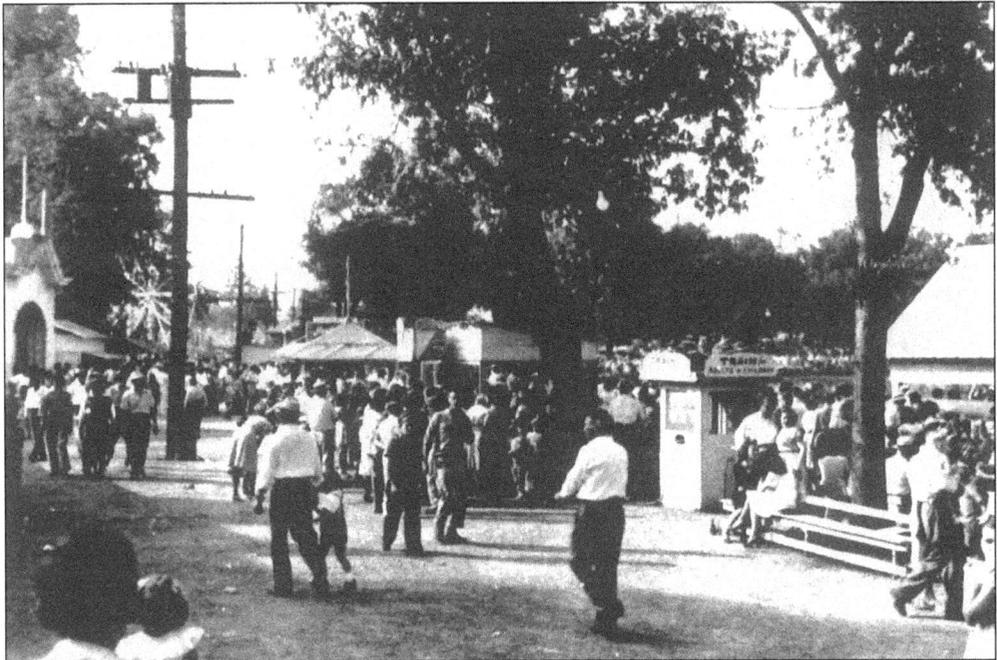

In 1942, Billy and Ann Morgan, natives of Piedmont, settled at the lake because of wartime gasoline rationing. They leased the park and lake to set-up a permanent home for their traveling amusements. The park reached its boom time in the mid-1940s. It served as a recreation area for not only residents of the county, but also soldiers stationed at Fort McClellan. Now there was an animal park, rides for young and old, bowling, boating, and swimming. (Courtesy of Oxford Public Library.)

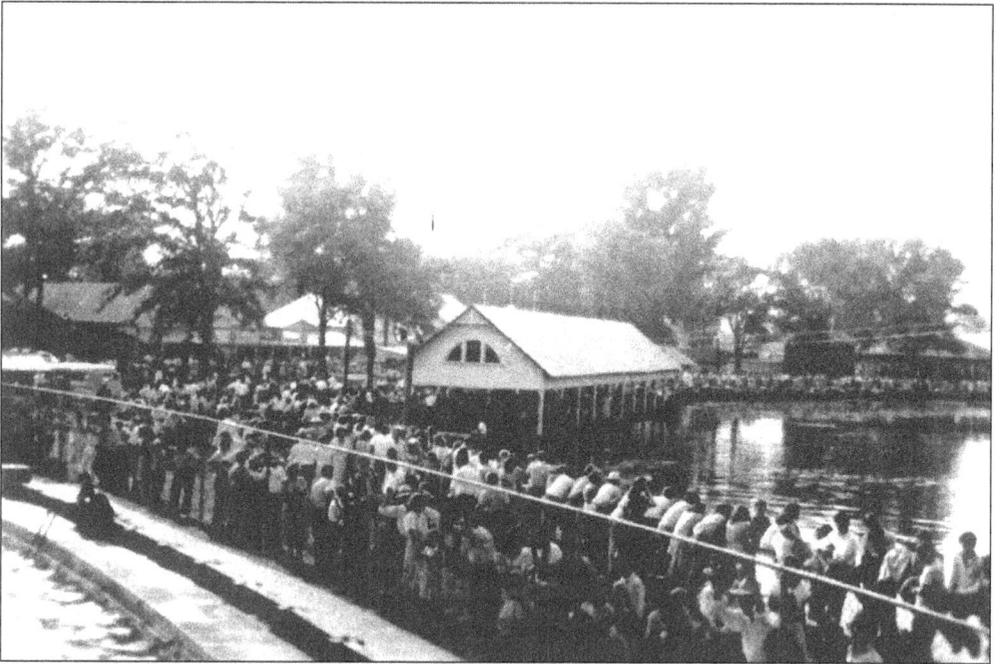

The Morgans brought in special attractions to entertain visitors. Boat races were a popular activity and drew large crowds to view. (Courtesy of Oxford Public Library.)

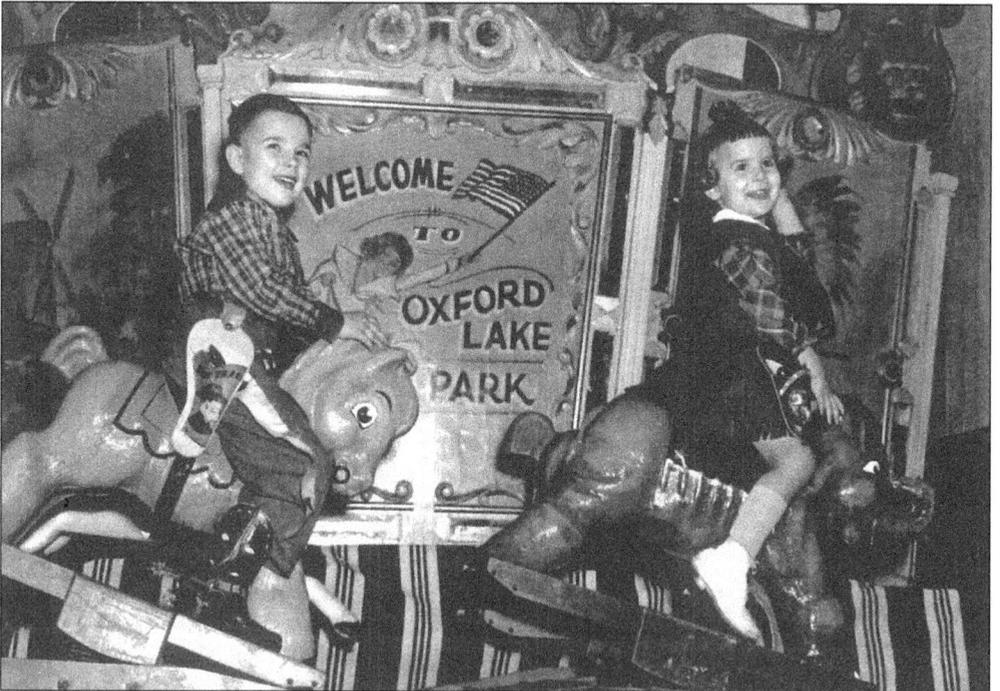

Westerns were a popular genre in the 1940s and 1950s. The westerns played out the theme of good versus evil that was synonymous with the Cold War attitudes of Americans. Children could enjoy a smaller carousel and often came outfitted complete with Lone Ranger and Dick Tracy sidearms. (Courtesy of Oxford Public Library.)

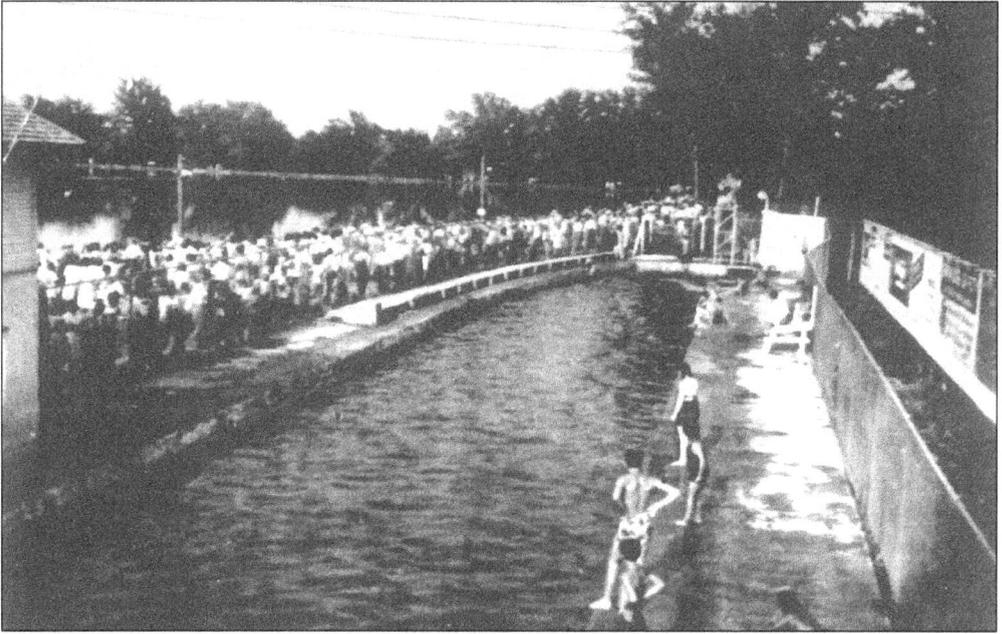

The pool was ideal for swimming laps or just cooling off in the hot summer. Bathhouses were provided for the swimmers to change clothes. When special events such as professional speedboat races or air circuses came even swimmers paused to watch the activities on the lake. Some of the events were so popular that the highway patrol came to the lake to direct traffic. (Courtesy of Oxford Public Library.)

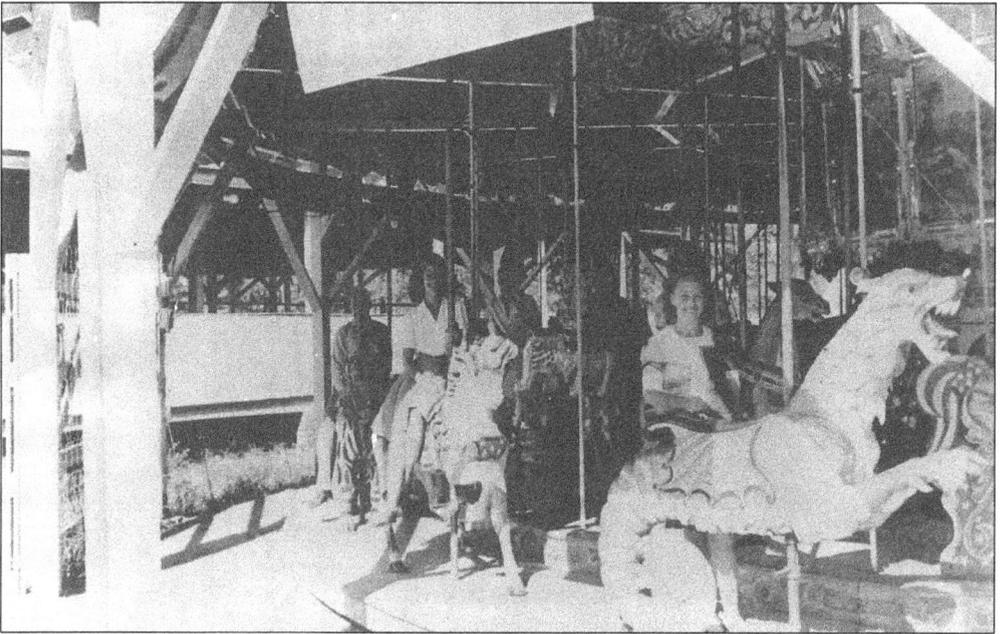

The wooden musical carousel was built around the turn of the century. It had 50 animals, among them horses, dragons, roosters, and storks, traveling on their poles. Adults could enjoy amusements such as the merry-go-round or stroll around the lake while the children enjoyed the other rides. (Courtesy of Oxford Public Library.)

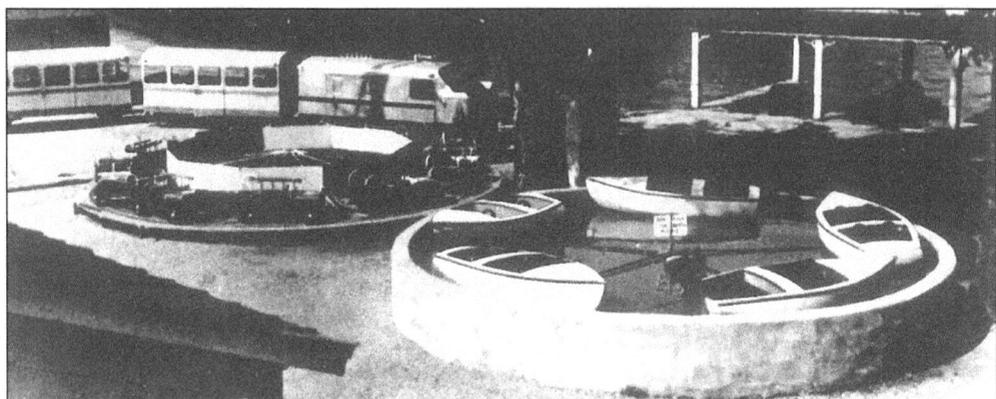

"The small fry" could enjoy sailing a boat, driving a car, or flying a plane while mom and dad watched. In addition to the children's rides, there was a Ferris wheel and a Tilt-A-Whirl. The rides and refreshment stands were economically successful. Unfortunately, a recession in the 1950s caused a lasting decline in the park. In 1955, the Morgans pulled out of the park, and the amusement rides were sold across the country. (Courtesy of Oxford Public Library.)

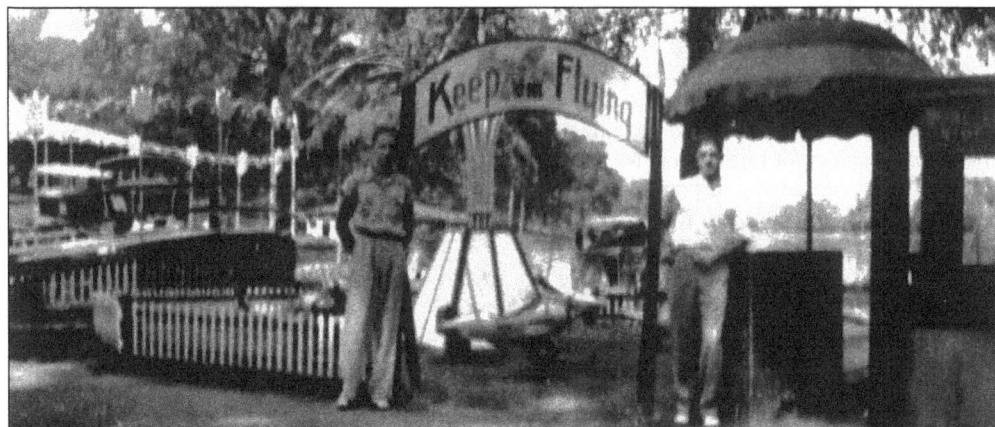

The Morgans widened the bare walkway that encircled the lake. A train for adults and children circled the mile-long circumference of the lake. In 1960, the City of Oxford purchased the property. The park in the 1990s barely resembles its predecessor. There is a civic center, swimming pool, golf course, softball complex, and picnic area at the lake complex. (Courtesy of Oxford Public Library.)

Two

Anniston

Anniston, a Reconstruction city, was located in the center of the county on the site of the former Oxford Furnace. Residents called the area "Pine Ankle" because of the dense pine forests near the iron furnace. The Confederates built the furnace in 1862. It was ready for operation in April 1863, but was destroyed by Union General John Croxton's Raid in April 1865. After the Civil War, many Southern cities had to rebuild and some businesses relocated to other cities. It was this relocating and rebuilding that precipitated the birth of Anniston.

Noble Brothers Iron Works of Rome, GA, needed to rebuild and expand after the war. The Nobles had purchased land around the old Oxford Furnace and wanted to build an iron works. In 1872, Samuel Noble visited the office of Alfred Tyler of the South Carolina Railroad to sell his family's wares. During the visit he met General Daniel Tyler, Alfred's father. Some time later General Tyler and Noble visited the Oxford Furnace site, and on May 4, 1872, the two men formed the Woodstock Iron Company. This was the beginning of Anniston.

In 1873, Woodstock Iron Works built a 50-ton charcoal furnace. Despite the Panic of 1873 and a depression, Woodstock Iron flourished because of the superior product it produced and the salesmanship of Noble. By 1879, a second 50-ton furnace was added. Samuel Noble, like many industrialists in post–Civil War America, was of the mind to reform many social ills of the day. He decided Anniston, named after Alfred Tyler's wife, would be a utopian-like experiment. He hoped to create a "model city" to avoid the slums and overcrowded conditions of many Northern industrial cities. He built cottages for the workers with yards and gardens, tree-lined streets, a company store, a farm to produce food, churches, and schools. Most importantly, Anniston remained a closed city where the company had complete control; for example, prohibition was strictly enforced.

In 1881, Anniston added a second major industry—cotton textiles. The Anniston Manufacturing Company was created to employ the wives and children of the laborers of the Woodstock Iron Company. On July 3, 1883, Anniston became officially open to settle, and it soon experienced rapid growth and a building boom. By August the town had its first newspaper, the *Hot Blast*. The town saw the founding of social groups such as the YMCA, Masonic Lodge, and the Odd Fellows, along with numerous schools and churches.

By 1900, Anniston had grown so much that it became the county seat of Calhoun County. Anniston's growth continued during the early years of the 20th century. Noble Street was the main street going through Anniston and to its west was the industrial factories of town. By the 1950s, families had access to automobiles and moved away from the mill village to the suburban areas. With this growth the town shifted to the east of Noble, and Quintard Avenue became the main street. In the 1990s, Anniston is still the largest of the towns in Calhoun County and includes numerous industries, churches, schools, and two hospitals.

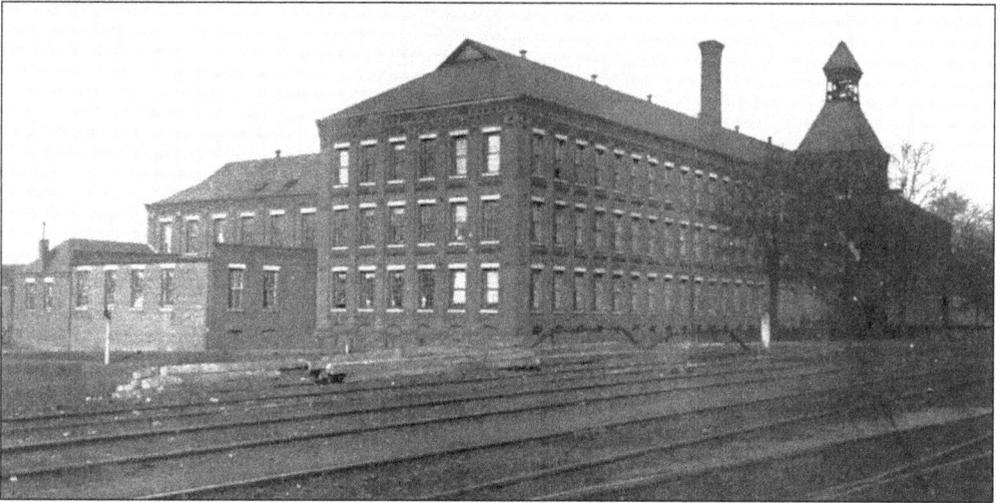

The Anniston Cotton Manufacturing Company was a textile mill completed in May 1880 with Alfred Tyler as president. At the time of its completion, "The Old Mill" was the largest building in the state and consumed 15,000 pounds of raw cotton a week. The first yard of cloth was produced in February 1881. The product created was a coarser grade of staple cotton that was exported to China, as well as other areas. The mill, located on Eleventh Street, was used primarily as an occupation for the wives and children of iron workers. In 1993 the building's owner, the Chalk Line Manufacturing Company, declared bankruptcy. The mill was salvaged for parts and the historic building faces an uncertain future. (Courtesy of *Select Views of Anniston*.)

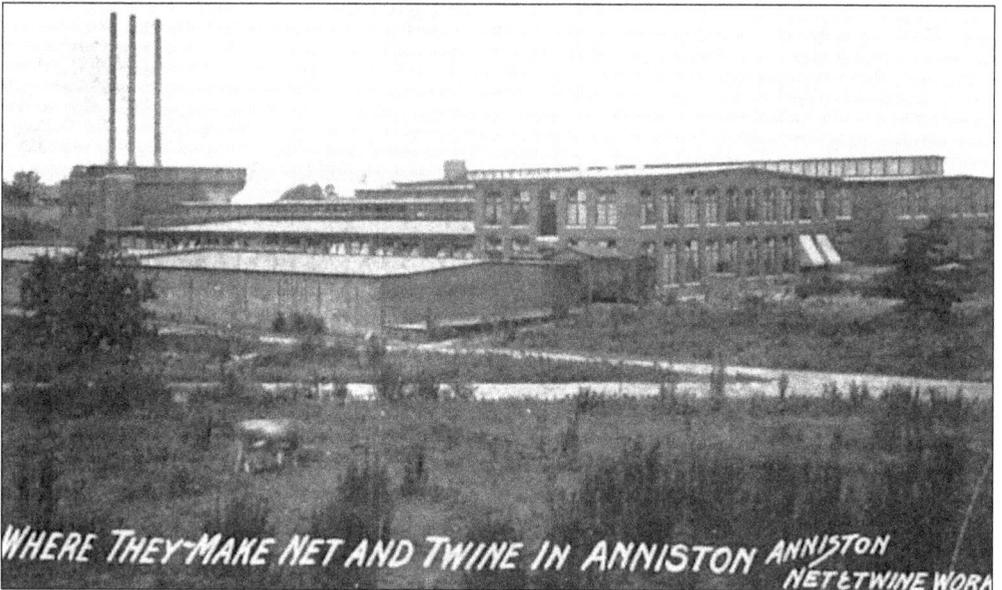

In 1896, the Massachusetts-based American Net and Twine Corporation built a branch of their factory in Calhoun County. The Anniston Net and Twine Works, located in West Anniston, consisted of a mill building, a warehouse, and 15 cottages. Charles M. Noble was the manager of the plant. Operations at the plant began in 1897 and doubled in size a year later. The factory produced twine and netting primarily for the fishing industry. (Courtesy of *Select Views of Anniston*.)

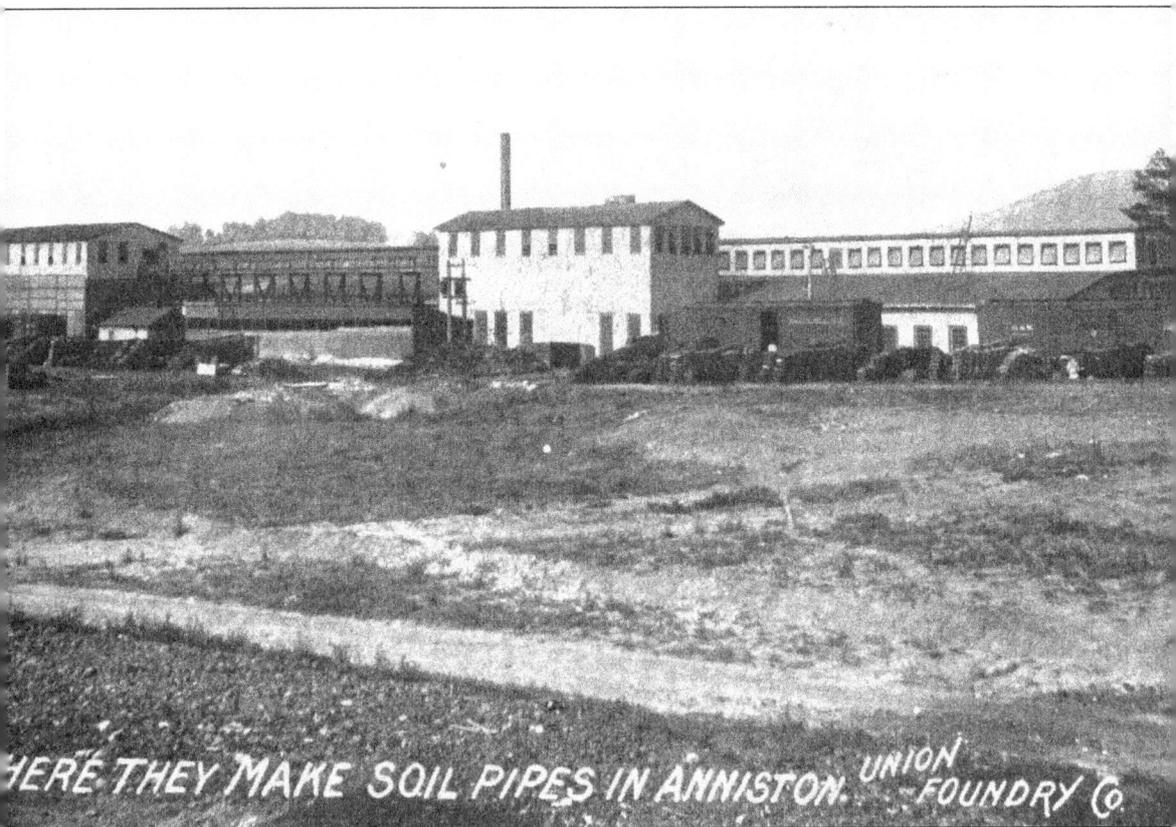

HERE THEY MAKE SOIL PIPES IN ANNISTON. UNION FOUNDRY CO.

The Anniston Pipe and Foundry Company was the forerunner of U.S. Pipe. The company organized around 1887 to manufacture soil pipe. The pipe works were located in West Anniston. The soil pipes, which were used for plumbing and drainage purposes, were built in horizontal flasks. The company merged with other iron-related industries around 1900, thus forming Samuel Noble's dream, the U.S. Pipe Company. (Courtesy of *Select Views of Anniston*.)

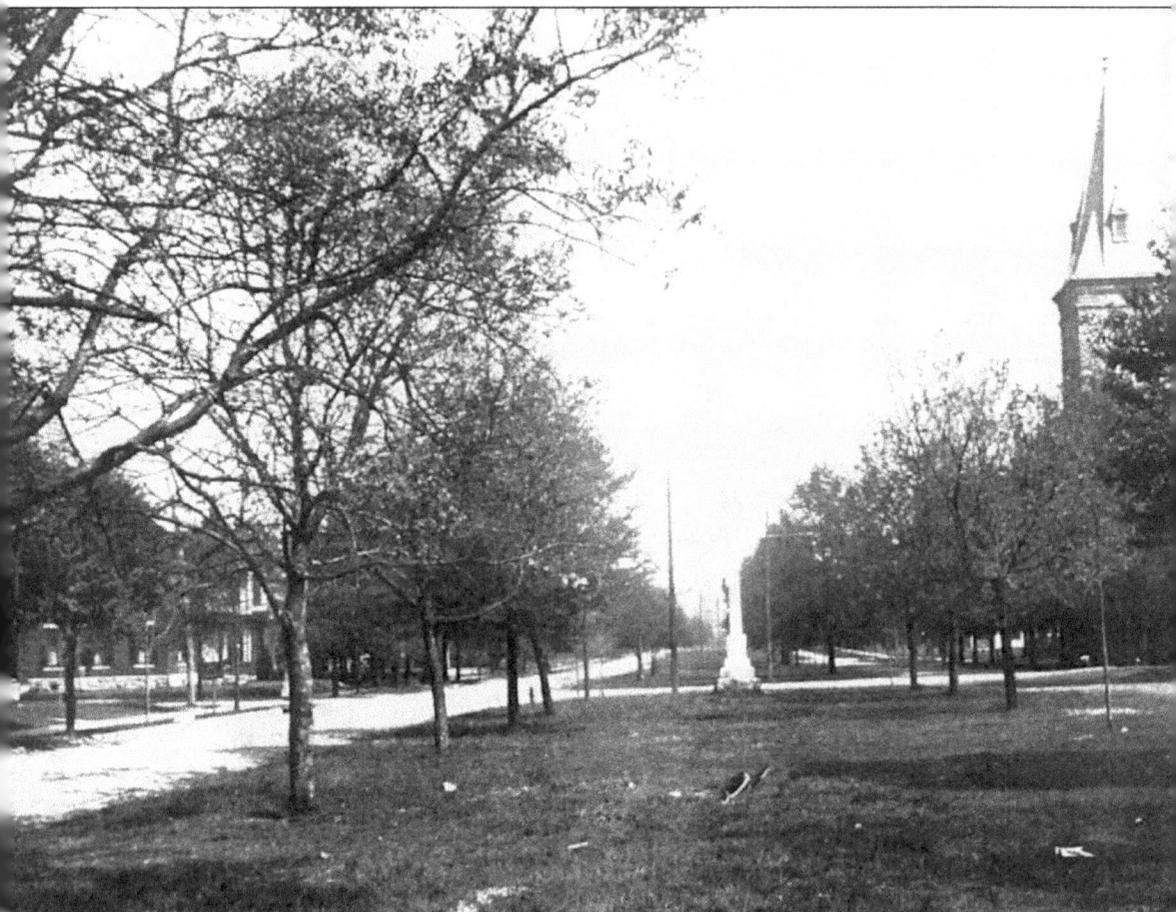

Quintard Avenue was a choice residential street in 1883 and was considered an affluent neighborhood. The avenue had two lanes and a park in the center—much the same as today. The avenue was named for physician and Episcopal bishop of Tennessee, Charles Todd Quintard. The avenue at the turn of the century was largely residential, but the corner of Twelfth and Quintard was occupied by Parker Memorial Baptist Church, on the left. In the 1990s, Quintard Avenue is the main thoroughfare through town, as it is part of Highway 21 connecting the northern and southern sections of the county. (Courtesy of *Alabama Military Institute Catalogue*.)

Sacred Heart Catholic Parish was organized in 1884 with 60 members. The congregation was first served by the Jesuit fathers from Selma. They built a small church in Glen Addie. In 1898, the church was released from the Anniston Mission and given permission to build a sanctuary. (Courtesy of Sacred Heart Catholic Church.)

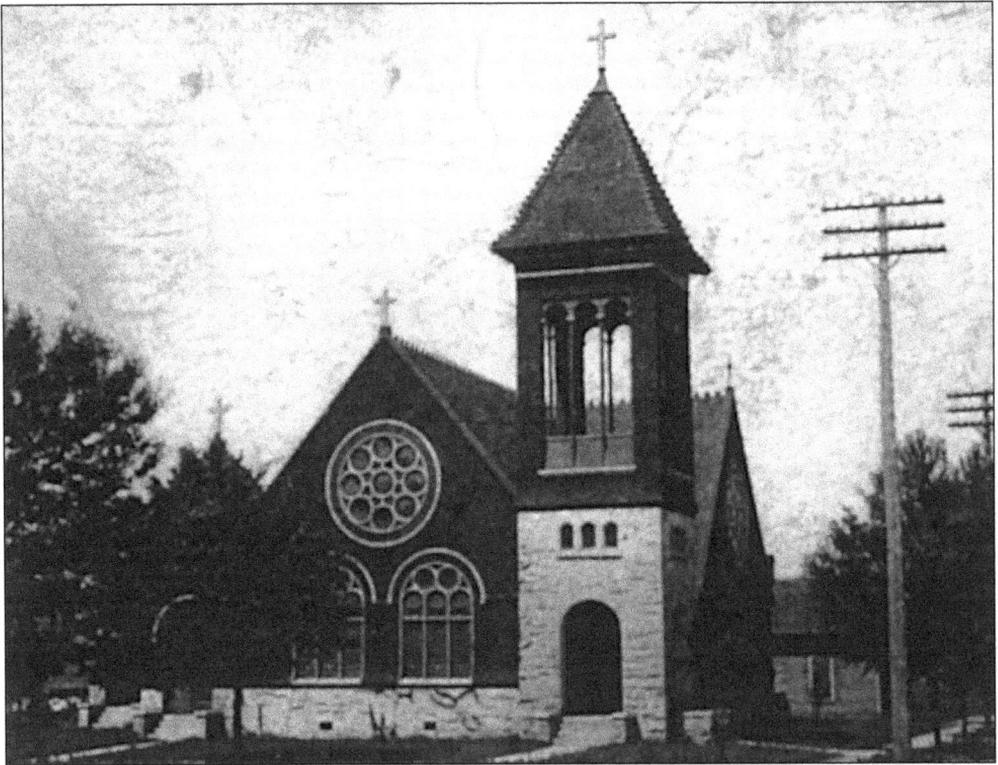

Construction on the Catholic sanctuary at the corner of Eleventh Street and Quintard Avenue was started once the congregation received permission to build. The church was completed in June 1899. During the 1920s Catholics were subjected to persecution by the Ku Klux Klan because of their beliefs. In 1922, the Klan burned the church. The congregation rebuilt at the same location. In 1997 the church sold the property to start construction on a new sanctuary located in Golden Springs. (Courtesy of Mrs. T.E. Kilby Jr.)

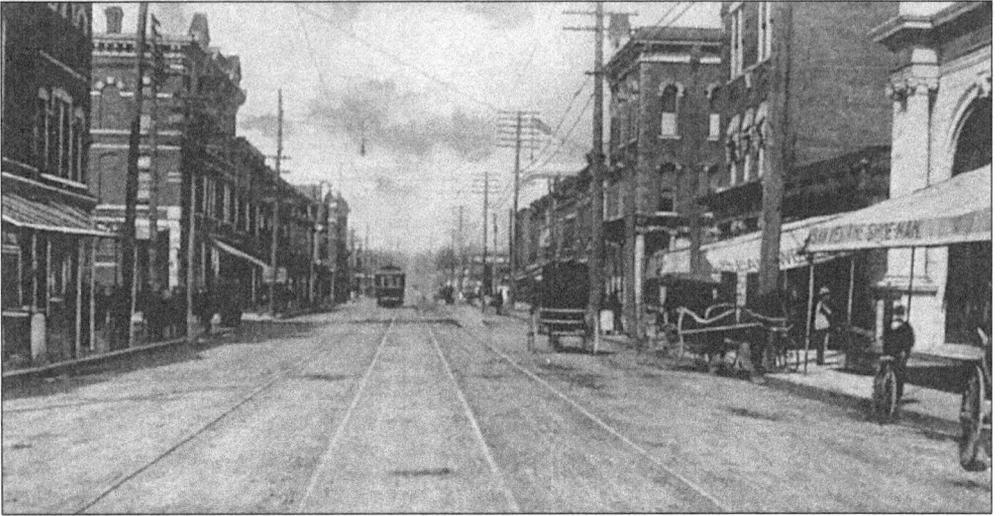

The intersection of Noble Street and Eleventh Street, c. 1906, was part of the business district. Streetcars were the major means of travel. Until the 1890s, "streetcars" were carts pulled by draft animals. In 1886, the streetcars were planned by the Anniston Street Railway Company, a Woodstock company. By 1888 the lines still were not built so the company became the Anniston Electric Railway Company. The central station was built on Moore Avenue and Eleventh Street. In April 1932, the streetcars were replaced by buses. (Courtesy of Mrs. T.E. Kilby Jr.)

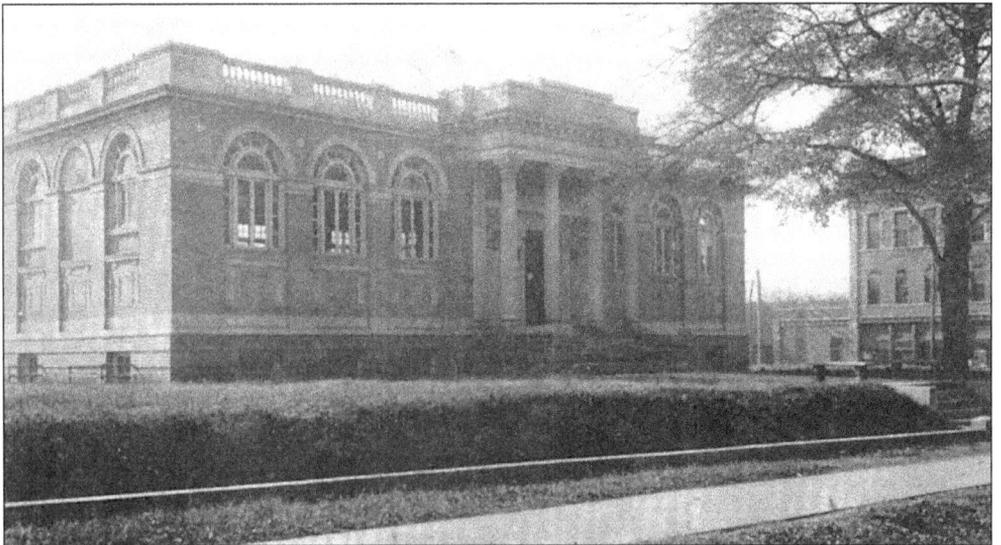

Anniston had tried as early as 1885 to establish a public library. In 1890, the YMCA added a private library for its members that contained about 400 volumes. In 1895, a public library was established and kept at a local drugstore. By 1898, the 600 volumes that made up the library moved to a vacant building on Ninth and Noble Streets. The Carnegie Library was built and opened to the public on May 23, 1918. In 1929, H. Severn Regar offered his collection of mounted birds, two mummies, and assorted historical objects to the city. A two-story addition to the library was completed in August 1930. The Regar Museum was the foundation of the Anniston Museum of Natural History. The current Calhoun County Public Library sits on the site of the Carnegie Library. (Courtesy of *Alabama Military Institute Catalogue*.)

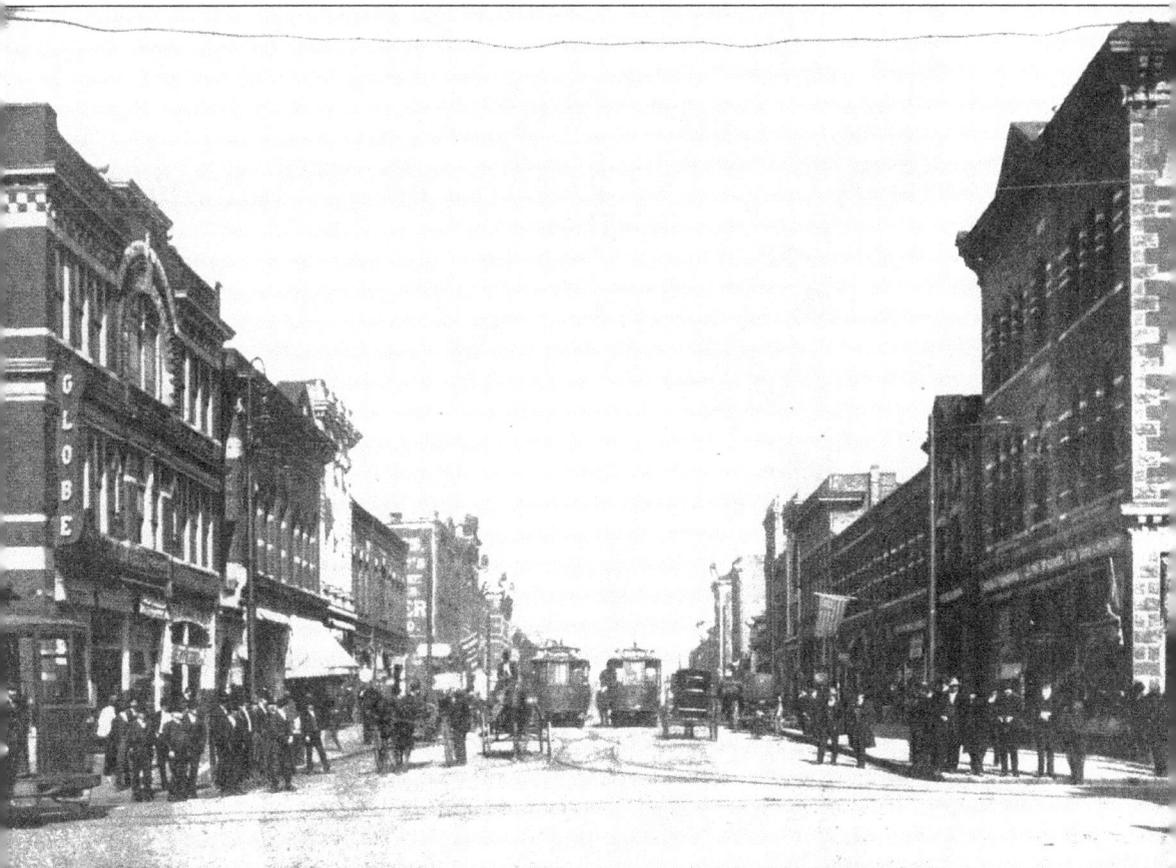

The intersection of Tenth and Noble Streets was the main artery of the business district, shown c. 1910. The Constantine Building (the first building on the left) in 1887 was home to "The Famous," a clothing store started by Joseph Saks. Saks, a native of Germany, gave money in the 1920s for a school for the families on his 800-acre farm. The Saks community was north of Anniston. Wikles Drug (the third building on the left) was the first drugstore in Anniston. Dr. Jesse Wikle of Cartersville, Georgia, established the drugstore while Anniston was still a company town. The building was constructed in 1883 and remains standing. In the early 1900s, Anniston had numerous clothing stores, hotels, bakeries, and many other specialty shops. The downtown area went through changes in the 1960s and 1970s. In the 1990s several of the remaining original buildings were in the process of renovations. The downtown has lost its allure of the early 20th century, when downtown Anniston led to the heart of industry. (Courtesy of *Select Views of Anniston.*)

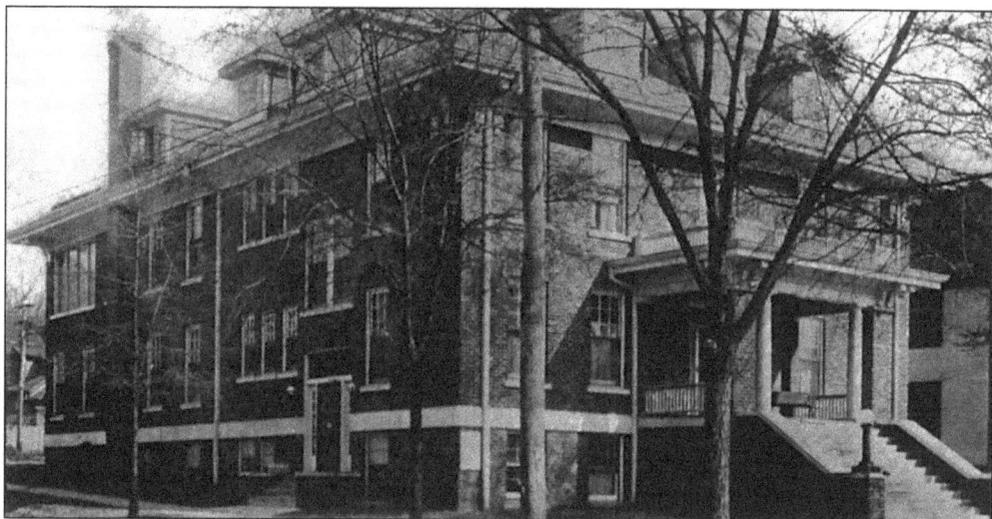

Two nurses, Olma Dickert and Olga Landt, started the Anniston Hospital in 1909 at 101 Marvin Hill. The hospital eventually moved to the corner of Twelfth Street and Quintard. In 1911, several Anniston doctors bought the hospital and renamed it St. Luke's Hospital. The hospital remained open for several years. Today it is a parking lot across from the Parker Memorial Baptist Church. (Courtesy of *Alabama Military Institute Catalogue*.)

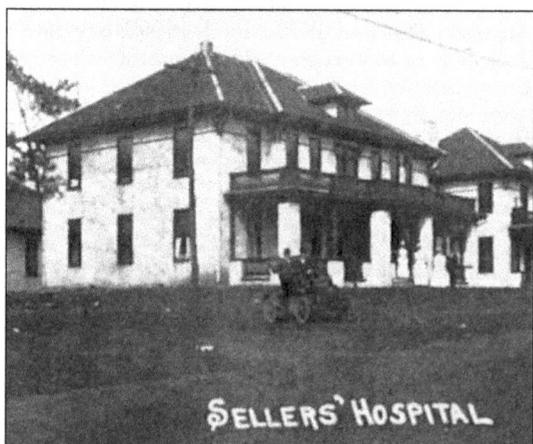

Upper Left: In 1893, Dr. Charles E. Thomas came to Anniston as the first African American practicing medicine in Alabama. He opened what was, at the time, the largest drug store owned and operated by an African American, located at 124 West Tenth Street. He was a physician and surgeon who graduated from Long Island College Hospital in Brooklyn, NY. The drugstore was billed as the Drug and Medicine Emporium, so in addition to medicines, there was a soda fountain, where African-American patrons could sit down to eat and have a soda. (Courtesy of Russell Brothers Collection.)

Lower Left: Sellers' Hospital was a 25-bed hospital organized by Drs. E.M. and W.D. Sellers in 1907. The hospital, located at 500 Leighton Avenue, burned in 1921 but was rebuilt in 1923 with 50 beds. The hospital was sold to the City and renamed Garner Hospital in 1930. When Anniston Hospital opened in 1944, Garner closed its doors. The building is now the Beckwood Manor Nursing home. (Courtesy of *Select Views of Anniston*.)

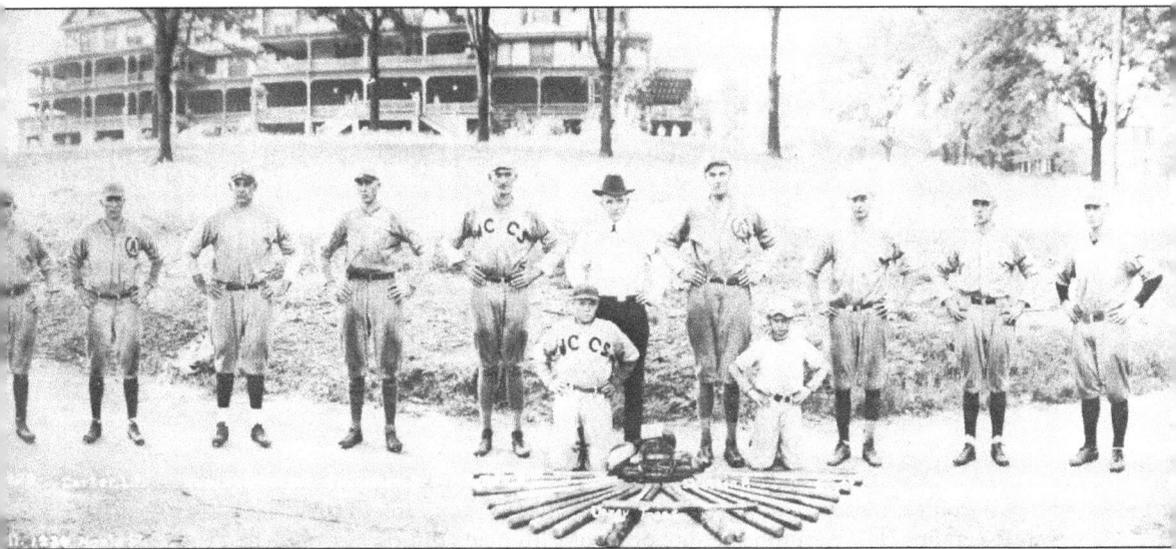

The Anniston Inn, shown in 1919, opened in April 1885 as a summer resort. The Queen Anne-style inn was built in 1884 for $260,000. To arrive at the inn, travelers passed through a 20-acre lawn and up gravel walks to a broad, stone stairway at the main entrance. The first three floors have wide verandas, allowing visitors to enjoy the cool breezes while relaxing in easy chairs. The inn was not financially successful and was taken over in 1895 as the Anniston College for Young Ladies. The college closed in 1906, and the building remained vacant until 1918, when it was again listed as the Anniston Inn. In 1922, the inn burned and left only the separate brick kitchen, which is now the Women's Civic Club. (Courtesy of Ralph Callahan.)

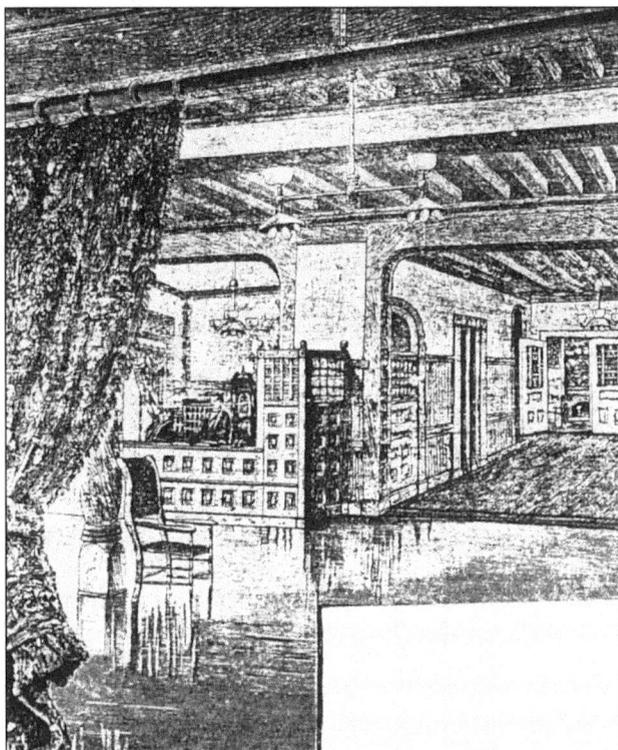

The Anniston Inn office, shown in an 1885 sketch, had finished hardwood beams in the ceiling and supported by columns. Visitors were awestruck by not only the wainscoting, but also the oak, Southern pine, California redwood, and walnut wood used to fashion this marvel of Victorian architecture. The polished hardwood floor, stained-glass window, and grand, carved, oak staircase greeted travelers in the lobby. The five-story luxury hotel had incandescent lights and gas and could accommodate 500 guests. (Courtesy of *The Manufacturer's Record*.)

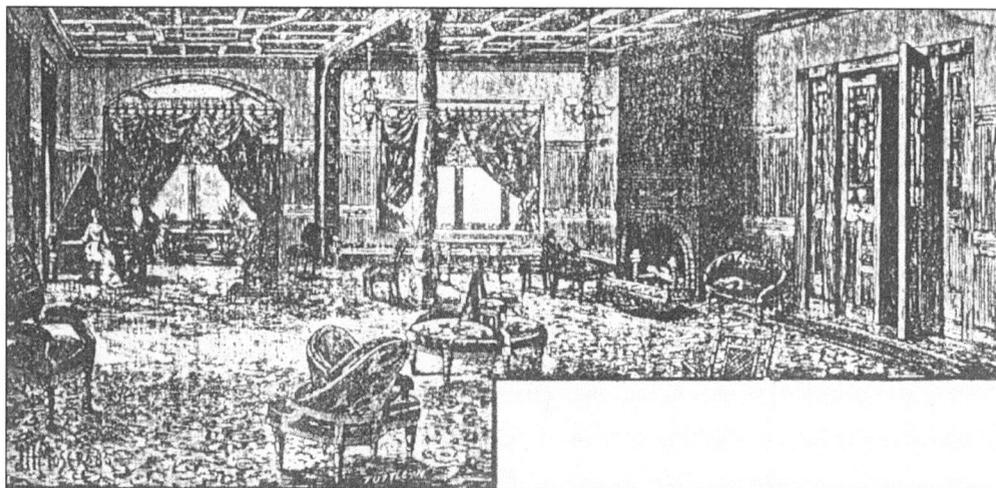

From the office, guests entered the parlor, which had Wilton carpeting and Turcoman gold-and-velvet curtains. The furniture was upholstered with blue crimson silk plush and the tables had inlaid ebony. The chandeliers were yellow brass and a center piece of beaten copper adorned with silver. There was a fireplace to insure warmth and coziness in the winter months. The hotel was equipped with hydraulic elevators, water closets, and steam heat through registers in each room. The chambers were large with double-width windows covered with Madras curtains. The chamber furnishings were of cherry and ash woods with a spring and hair mattress. The linens were of the finest quality and not marked like a "common hotel linen." (Courtesy of *The Manufacturer's Record.*)

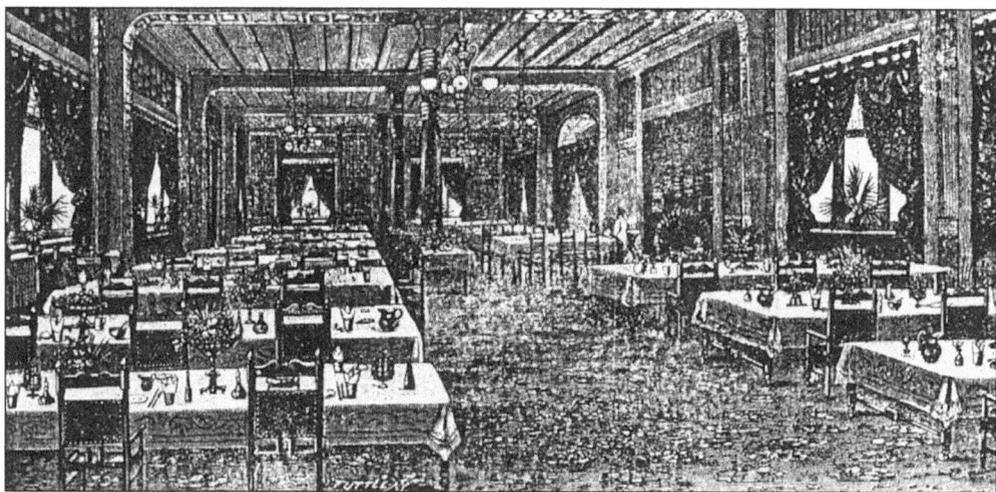

The dining room was lighted by broad square and bay windows on all sides. The lower windows were hinged doors which opened outward to let in the breeze. Covering the windows were rich Turcoman curtains, and the floor was carpeted with Hartford Brussels carpets. The main dining room could comfortably seat 200 guests. The walls were of oak and decorated with carved ornaments. The arches throughout the dining room matched the in-laid work around the windows. The tables were set with linen cloths, plain silver, china, and glass. In addition to the main dining room, the hotel had a children's and servants' dining rooms. The kitchen had two large refrigerators on the ground floor for meat and fruits, a large refrigerator for general storage, and a smaller one on the kitchen floor for daily use. The cost of constructing the dining room alone was $27,000. (Courtesy of *The Manufacturer's Record.*)

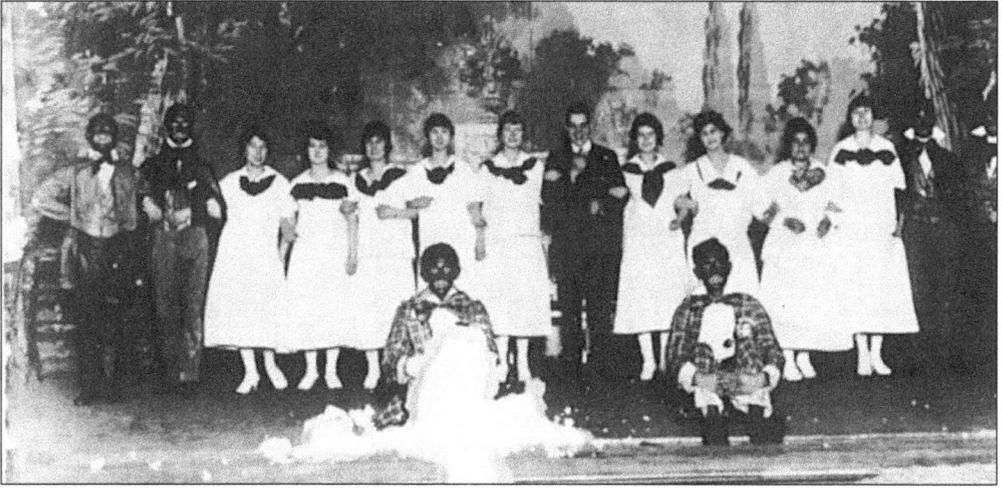

Minstrel shows originated in the 1830s and 1840s as a form of entertainment. The shows featured white actors performing in blackface and acted out broad racial stereotypes with the intent to ridicule. In the 1880s, Jim Crow Laws, which took the name from a song in the 1830s minstrel show, segregated the black South and white South. The minstrel show seen here was performed by the 1917 junior class of Anniston High School at the Noble Theater. (Courtesy of Alabama Room at Calhoun County Public Library.)

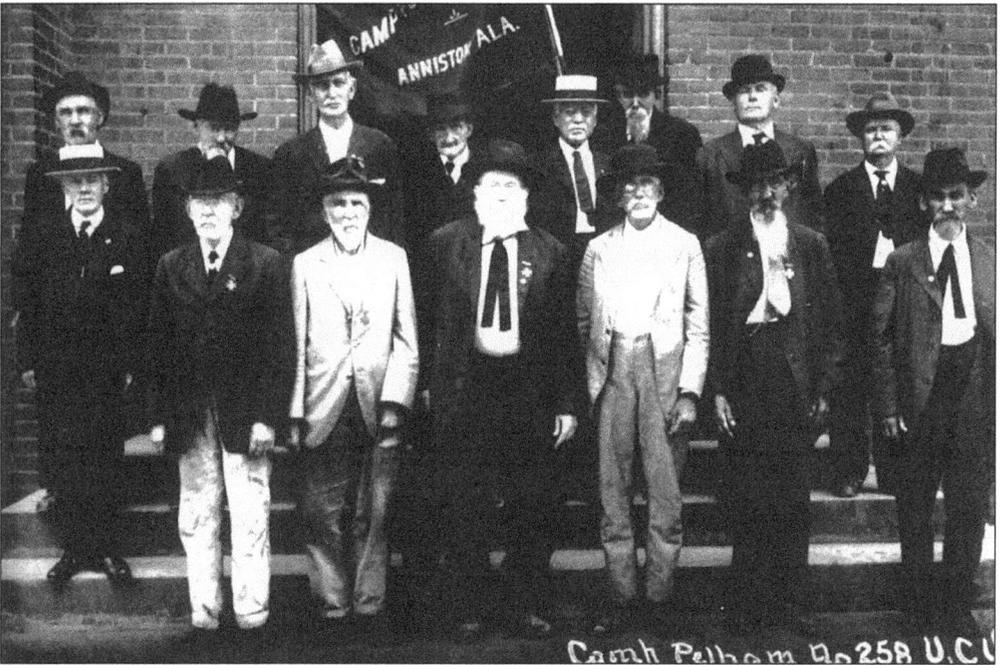

Calhoun County supplied many young men to fight for the Confederacy during the "War of Northern Aggression." These veterans were proud of their service and formed the United Confederate Veterans (UCV). Camp Pelham No. 258 of the United Confederate Veterans is shown here in 1918. In 1905, the UCV met the third Saturday of each month at city hall with J.T. DeArman as commander. By 1918, the group met the last Saturday of each month at the Odd Fellows Hall on 1101 1/2 Noble Street. The commander was C.J. Houser. (Courtesy of Ralph Callahan.)

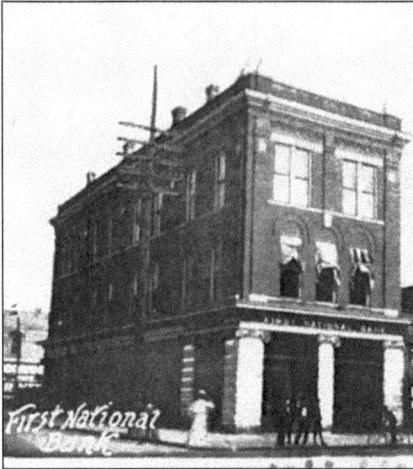

First National Bank

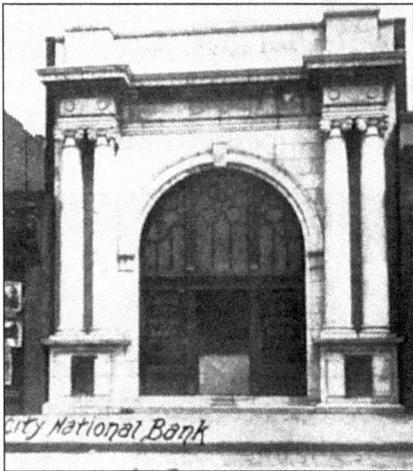

Anniston NATIONAL BANK

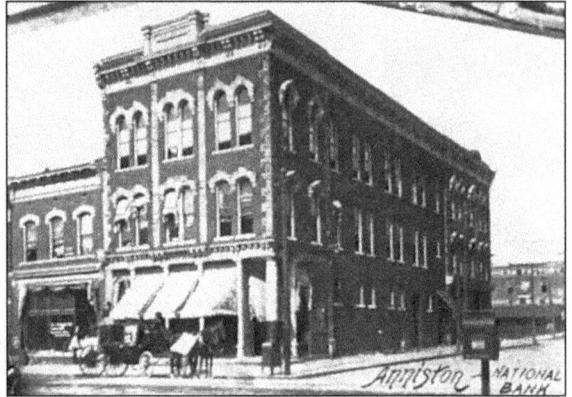

City National Bank

In 1883, the First National Bank was established at 909 Noble Street. The president was Duncan T. Parker, for whom Parker Memorial Baptist Church is named; the vice-president was Samuel Noble, the founder of Anniston. The McKleroy building, the location of Anniston National Bank, was built in the 1880s on the northeast corner of Eleventh and Noble Streets. The Anniston National Bank was organized in February 1890. City National Bank was located at 1023 Noble Street and was organized in November 1901. In 1911, City National merged with Anniston National and formed the Anniston City National Bank. In 1954 a new building was constructed at Twelfth and Noble Streets. In 1958, the present location was built at 1031 Quintard Avenue. In 1982, the Anniston National merged with First Alabama Bankshares. (Courtesy of *Select Views Of Anniston*.)

In November 1884, two telephone systems competed for Anniston customers—Noble Pan-Electric Telephone System and the Bell Company. After a legal battle, both companies installed phones, and most businesses subscribed to both. Phone numbers were printed in the local newspaper for reference. Articles such as "how to place a telephone call," which explained to customers how to use the appliance, were also placed in the newspapers. In 1888, Noble's company was enjoined from operating in Alabama, so the Bell company won the war. Once a person placed a call, switchboard operators, *c.* 1912, connected the call for the customer. (Courtesy of Alabama Room at Calhoun County Public Library.)

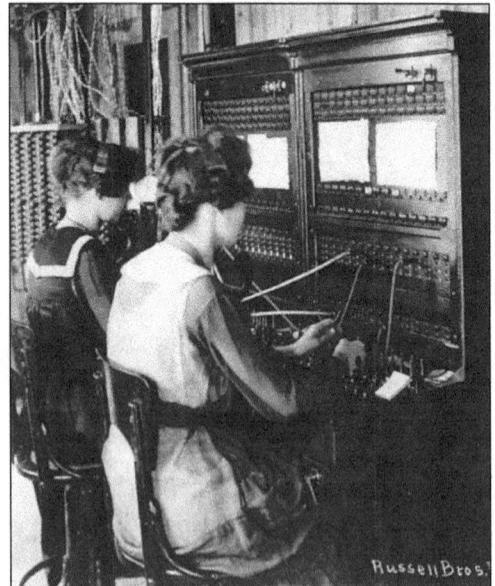

Russell Bros.

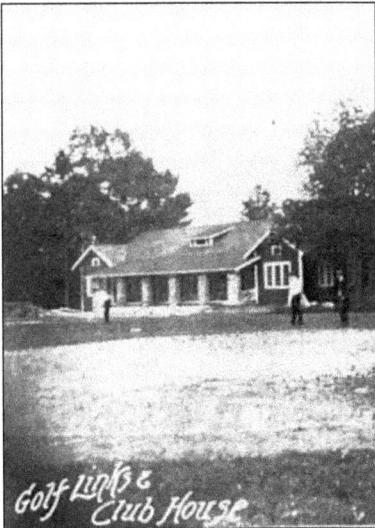

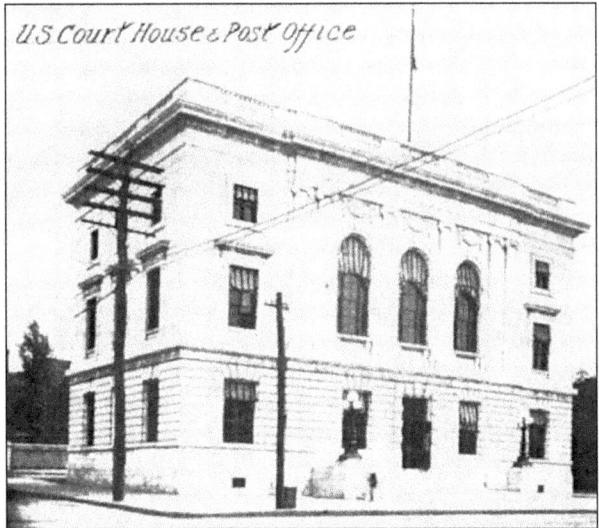

The U.S. Courthouse and Post Office, located at 1129 Noble Street, was built in 1904. Eventually the federal post office moved to the corner of Eleventh Street and Quintard Avenue. The building currently houses the U.S. District Court, Bankruptcy Court, Congressional offices, Department of Labor-Wage and Hour, and Probation officers. The Anniston County Club opened its doors with a gala on June 8, 1910. The Highlands Club, as the house was known, was considered one of the finest golf links in the South. The Country Club is located 601 Highland Avenue and still boasts an excellent golf course, in addition to a tennis court and pool area. (Courtesy of *Select Views of Anniston*.)

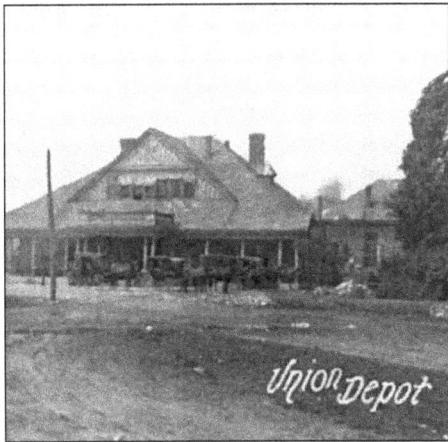

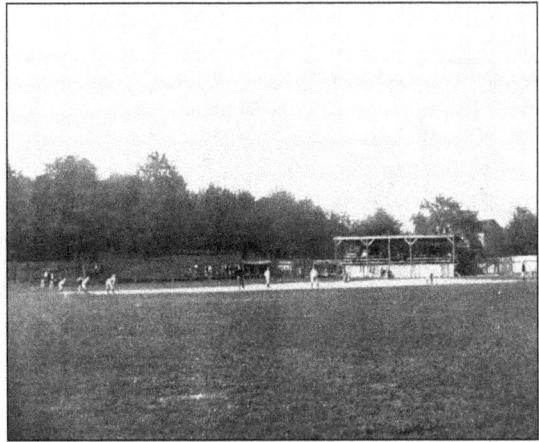

Left: Union Station, also known as the Louisville & Nashville (L&N) Depot, was located at 1300 Walnut Avenue. The L&N came to Anniston in 1889 and gained the handling of the majority of iron in Alabama. As a result, the L&N tracks led right into the Anniston Pipe and Foundry. When the passenger depot closed, it was home to Kelly Supply. In the 1990s, Julian Jenkins remodeled the depot and converted it into his architecture firm. (Courtesy of *Select Views of Anniston*.)

Right: Zinn Park, located at the corner of Fourteenth Street and Gurnee Avenue, was across the street from the Anniston Inn. A baseball field was built in the late 1880s. The Presbyterian College baseball team is shown here *c*. 1906 playing at Zinn Park. The park was named for W.H. Zinn, a successful mercantile store owner. Through the generous donations of his will, the Anniston Park system was started. (Courtesy of *Select Views of Anniston*.)

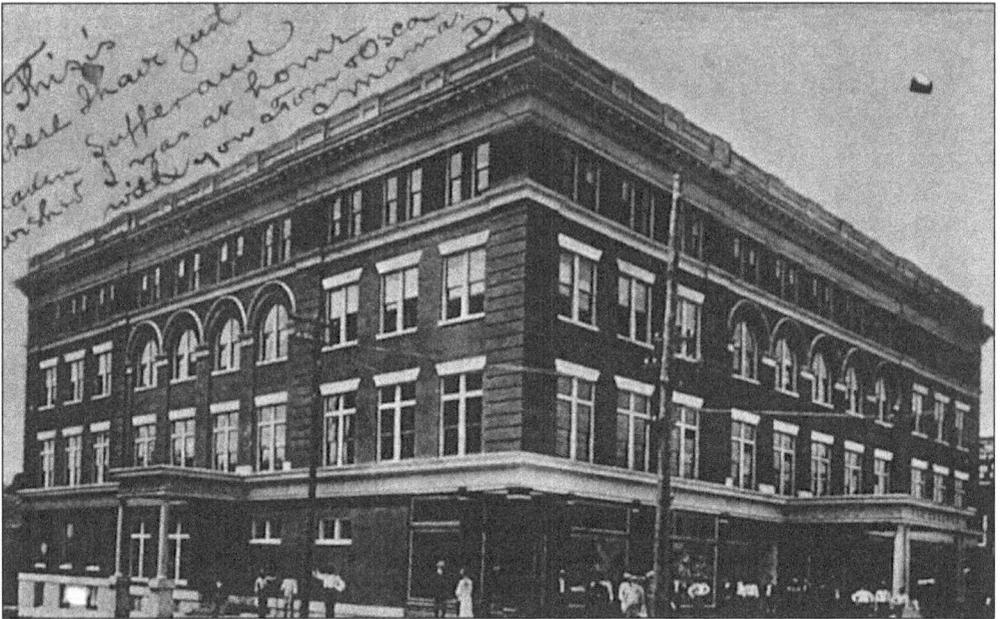

The lavish Alabama Hotel was designed by C.W. Carlton and Company and was under construction in 1902. The hotel, originally to be called "the Anniston," had a 130-feet frontage. The cost of building the hotel was $100,000. The main entrance faced Noble Street, and the ladies entrance was located on the Twelfth Street side. The hotel was four stories and had 94 rooms, in addition to hydraulic elevators. In 1902, the builders promised a telephone in every room with long distance connections. Located at 1200 Noble, the proprietors were F.B. Stubbs and George L. Keen. (Courtesy of Mrs. T.E. Kilby Jr.)

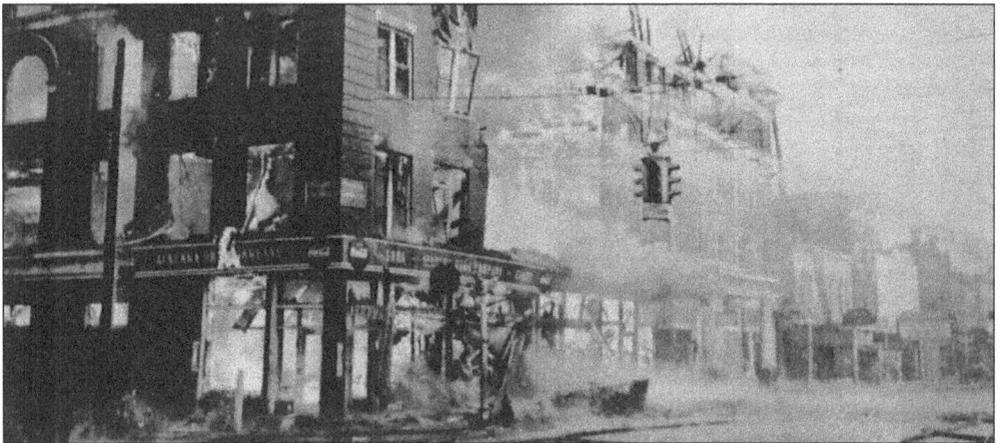

On September 15, 1944, a fire started in the Gem Beauty Shoppe in the Alabama Hotel. The hotel was also home to the Nixon Transfer and Baggage Company, the Chamber of Commerce, the Alabama Drug Company, the Anniston Jewelry Company, the Southern Railway Ticket Office, and the Alabama Barber Shop. The four-story hotel had 200 guests at the time of fire. There were two deaths—a 70-year-old man tried to escape the fourth floor with a rope made of bedsheets, which was burned by the flames, and died from injuries of the fall; and a 17-year-old bride of a Fort McClellan soldier was found in the rubble. This was one of the worst fires in the history of Anniston, and it caused approximately $200,000 in damage. (Courtesy of Roy Young.)

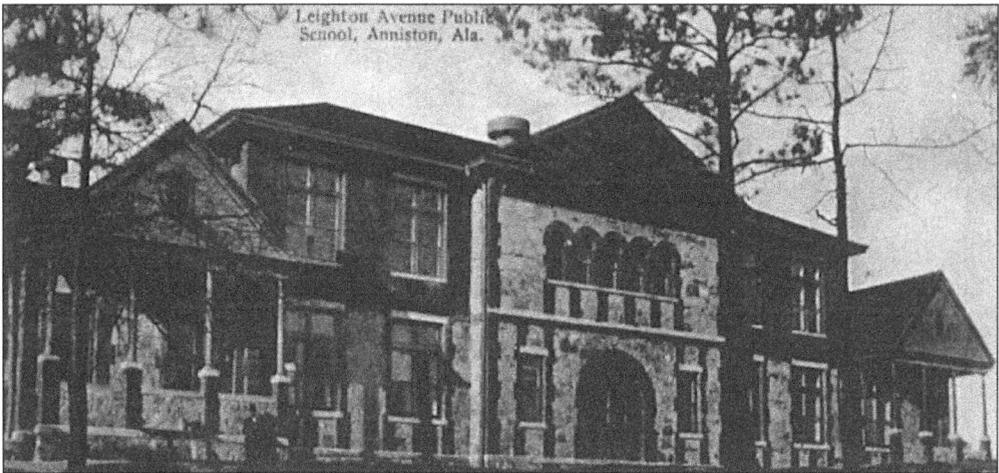

The Noble Institute for Boys was located on the hill at Leighton Avenue and Eighteenth Street, currently Stringfellow Hospital. The school opened in October 1887 as a private school funded by Samuel Noble and constructed of stone and red brick. The school, which held classes for 2nd through 12th grade, eventually revised its course of study to include not only technical classes, but also classical and business classes. The private school was not successful, so in 1896 the building was leased to the city and was operated as the Leighton Avenue Public School until the building burned in 1910. The students were then sent to afternoon sessions at Wilmer Avenue Public School. (Courtesy of Mrs. T.E. Kilby Jr.)

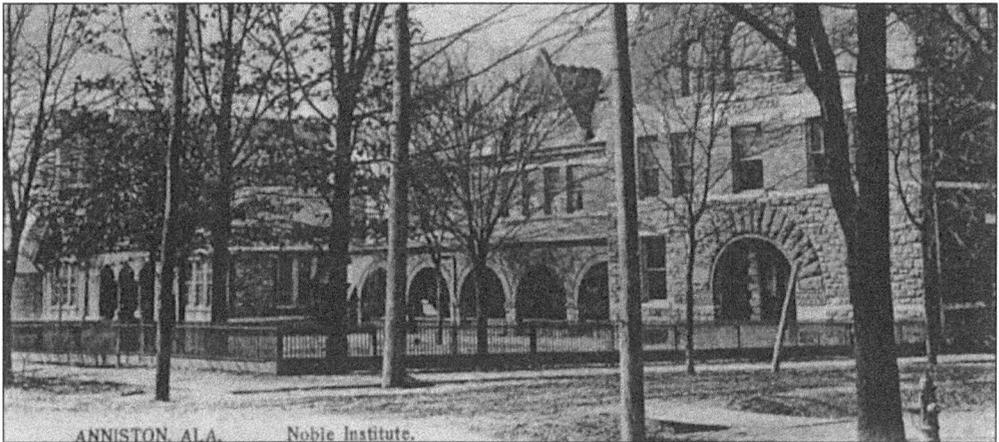

Noble Institute for Girls, a private school founded by Samuel Noble, was located on Eleventh Street and Leighton Avenue adjacent to Grace Episcopal church. The school was established in 1886 and built of stone and pressed brick at a cost of $50,000. In 1889, a memorial dormitory was built in honor of Noble. The boarding school was attended by girls from all over the South because the school provided an education from grammar school through college. Mary Bethune was the principal, and the school offered classical, scientific, and general courses in addition to special courses such as drawing, music, and foreign languages. The school burned in 1894 but was quickly rebuilt. In 1922, the school closed and was used as a rooming house and inn. In 1951, the Episcopal Day School was created. The building burned in 1965 but was rebuilt. In the 1976–1977 school year the day school merged with Anniston Academy to create the Donoho School. The students remained at this site until 1980, when the new Donoho Lower School on Henry Road was completed. The building is currently used by Grace Church for a Parish Hall and Sunday school. (Courtesy of Mrs. T.E. Kilby Jr.)

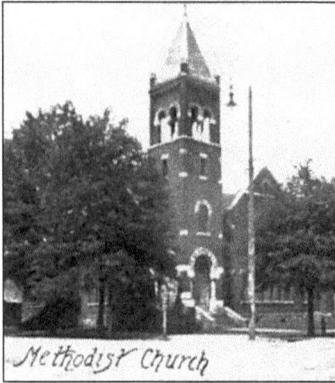
Methodist Church

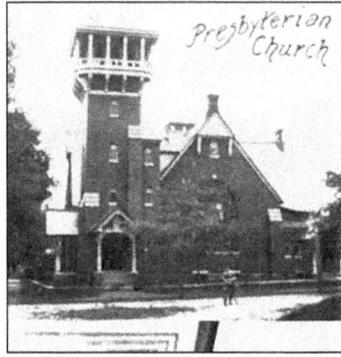
Presbyterian Church

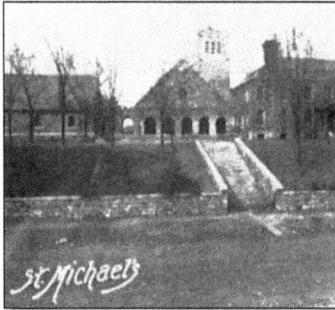
St Michaels

The First Methodist Church was formed in 1872 by local residents and workers building Woodstock furnace. On Easter 1892, the church burned and the congregation exchanged the original lots on Twelfth Street for two lots on the northwest corner of Fourteenth and Noble Streets. The church was built in 1893 and remains on the site. The First Presbyterian Church, organized in 1884, was dedicated in 1896. The tower and additions were completed in 1894. In 1959, the church relocated to a modern structure on Tenth Street and Henry Road. St. Michael's and All Angels Parish was organized in 1887. Construction on the Romanesque-style church began in 1888 by John Ward Noble, Samuel Noble's brother. Located at Eighteenth Street and Cobb Avenue, it was built to serve the employees of Woodstock Iron and others living in the area. (Courtesy of *Select Views of Anniston*.)

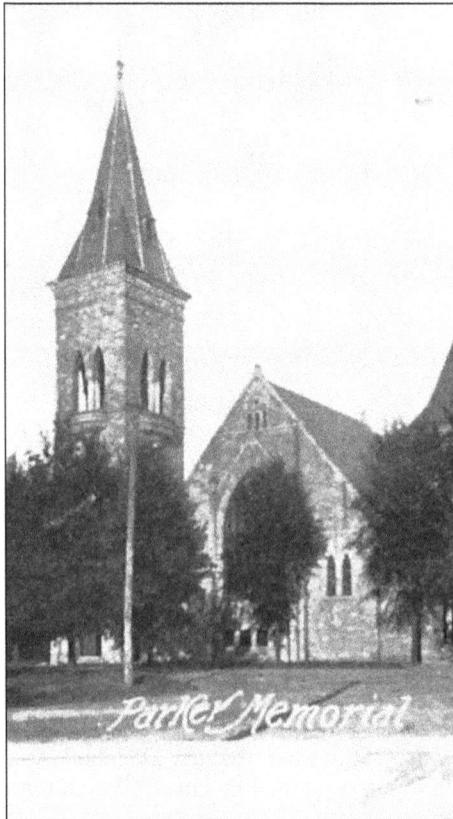
Parker Memorial

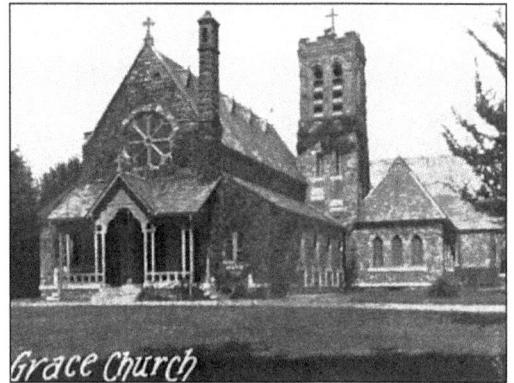
Grace Church

The Parker Memorial Baptist Church was organized as the Second Baptist Church in July 1887. The church purchased the land and voted to change the name to Twelfth Street Baptist. The cornerstone was laid in 1888, and the church was ready for occupancy by January 1889. Organized in 1881, Grace Episcopal Church was the first permanent church built by the Tylers and Nobles. Construction began in 1882 on the Gothic-style church. The first church service was held Christmas Eve, 1885, and the structure was formally consecrated in May 1886. It was located on Tenth Street and Leighton Avenue. (Courtesy of *Select Views of Anniston*.)

Temple Beth-El ("The House of God") was the only Jewish synagogue located in Calhoun County. The single-story Byzantine-style building was built in 1891 and located on the corner of Thirteenth Street and Quintard Avenue. The synagogue was built largely through the efforts of the Ladies Hebrew Benevolent Society. The church was completed at a cost of $2,700. While under construction, the congregation held weekly services, conducted by lay readers, at the Hall of the Knights of Pythias. (Courtesy of Alabama Room at Calhoun County Public Library.)

The Seventeenth Street Baptist Church was organized in 1880 as the Concord Baptist Church. A few years later the church changed its name to Galilee Baptist Church. In 1902, the church purchased the lot at Seventeenth Street and Cooper Avenue and changed its name to Seventeenth Street Baptist. The church played an important role in the African-American community. Several prominent leaders of the Civil Rights movement spoke at the church in the 1960s. (Courtesy of Russell Brothers Collection.)

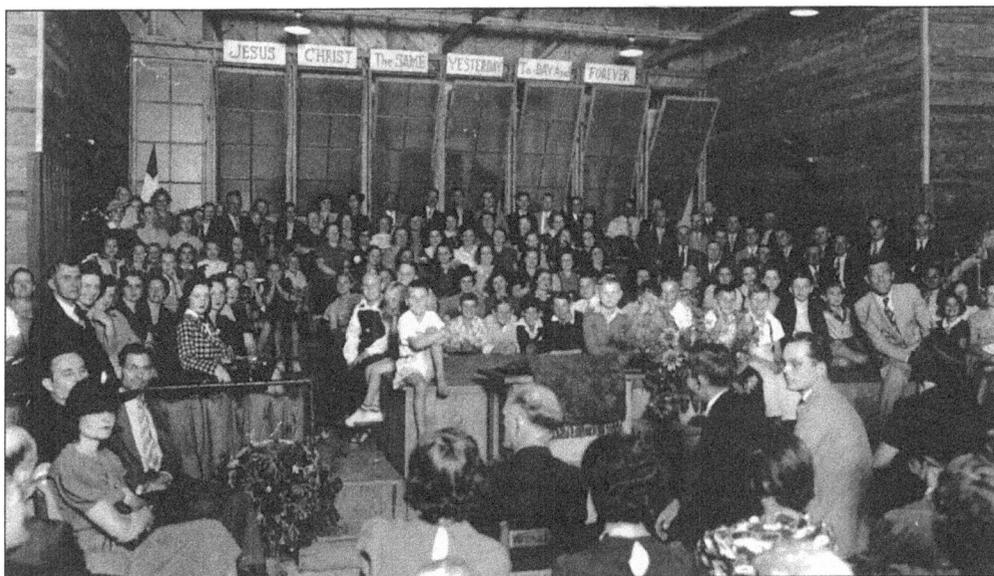

There were numerous large churches in the city, but many working-class and middle-class people formed smaller congregations. The structures were often of wood and concrete. Many sanctuaries were built with whatever builders could find during the Depression and World War II. This open-beamed wooden structure, shown c. 1939, did not have benches but hardback chairs. The churches constructed in this manner were susceptible to fire. (Courtesy of Noble Street Baptist Church.)

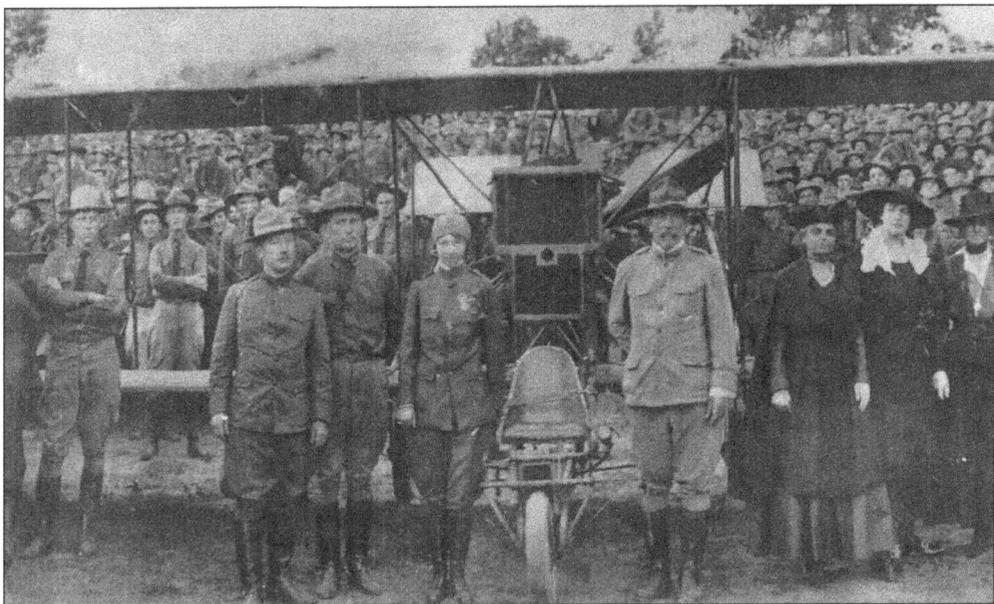

Anniston was the residence of Governor and Mrs. Thomas Kilby. Governor Kilby came to Anniston in 1887 with the Georgia Pacific Railway (later the Southern). Kilby served as mayor of Anniston, as a state senator, and as lieutenant governor before serving as governor from 1919 to 1923. It was said Kilby had one of the best administrations in the history of Alabama. Kilby married Mary Clark in 1894. Mrs. Kilby, shown with a group of Doughboys and an early aircraft c. 1918, was a native of Pell City and the mother of 3 children. (Courtesy of Mrs. T.E. Kilby Jr.)

46

Anniston High School was built in 1921 between Sixteenth and Seventeenth Streets on Leighton Avenue. This photo of the school was taken in June 1967 at a Borden's Ice Cream Eating Contest, sponsored by local radio station WHMA. In 1970, the school was moved to the Educational Park on Woodstock Avenue. The building was torn down in the 1980s. The arches from the auditorium were preserved in a memorial park on Seventeenth Street and Quintard Avenue. Gregerson's Grocery store currently occupies the site. (Courtesy of Ralph Burgess.)

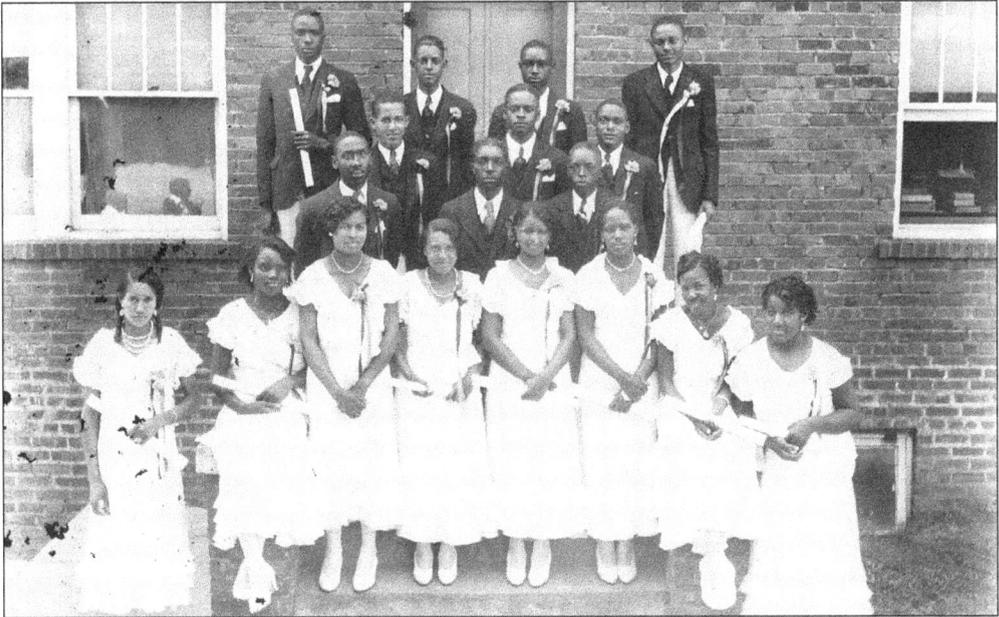

In 1885, the first free black education facility in Anniston opened with one teacher under the supervision of Reverend H.W. Conley and his wife. In 1890, the City built Pine Street School, later Seventeenth Street School, on Seventeenth Street and Pine Avenue for $4,000. Professor S.E. Moses was appointed the principal. There was the Fifth Ward and Sixth Ward schools for blacks in the 1920s. Union Hill School was opened in 1927 and remained until 1940 when it was discontinued. South Highland High School, shown in 1933, was located at the C-intersection and Highland Avenue. Public schools for African Americans usually received less funding than their white counterparts, and schools remained segregated until the 1960s. (Courtesy of Russell Brothers Collection.)

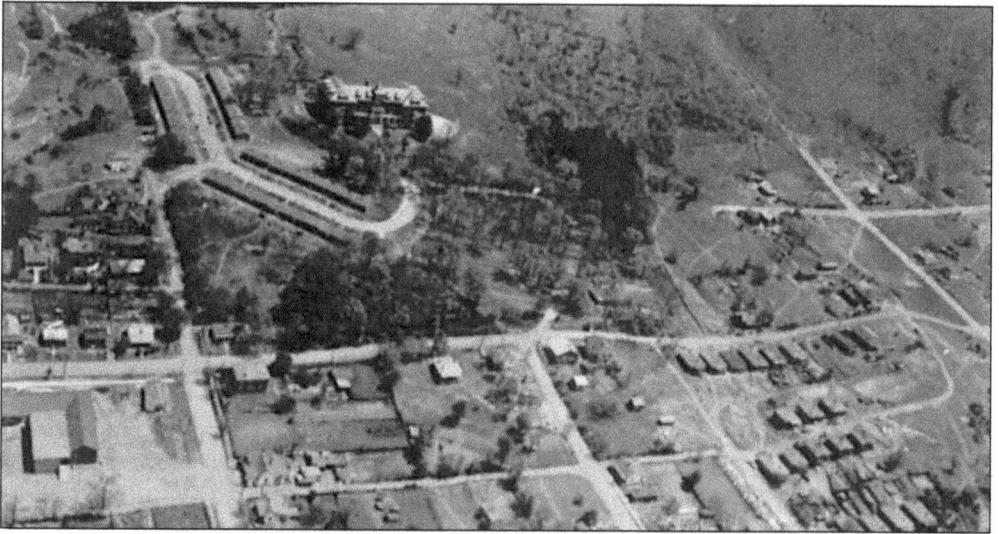

The Barber Memorial Seminary, located on Allen Avenue and Fifteenth Street in Oxanna, was a private school for the education of African-American girls. The school was built for a cost of $415,000 by Mrs. Margaret Barber, who donated the Frances E. Willard School in Piedmont. The school opened in November 1896 with 54 students but was soon destroyed by fire. It was rebuilt and reopened in 1898 under the administration of the Board of National Mission of the Presbyterian church. The young ladies were instructed in religion, domestic art, and household science. By 1920, there were 250 students. The school closed in 1942 and was torn down in 1953. It then was the site of a housing project. (Courtesy of Alabama Room at Calhoun County Public Library.)

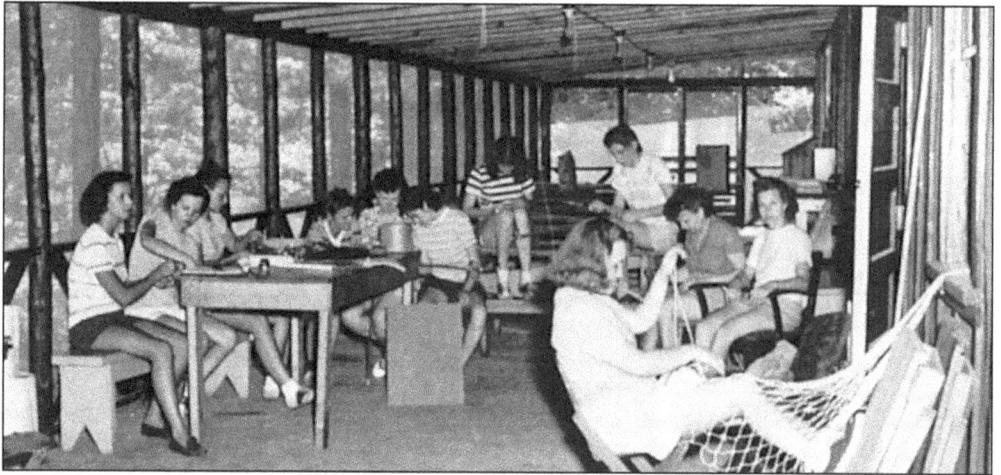

Girl Scouts was designed to help girls develop abilities of citizenship. The first troop was organized in 1912 in Savannah, Georgia. The program was directed toward girls ages 7 through 17. In 1931, the Calhoun County Council of the Girl Scouts was organized with Mrs. W.P. Acker as commissioner. The Scouts mission was to help young girls reach their potential, and one of the most effective ways to accomplish the objectives was camping. Camp Cottaquilla, shown in the 1940s, was located off White's Gap Road between Jacksonville and White Plains. The camp had a lake and common area for girls to participate in crafts, as well as hold meetings. The camp looks much the same today as it did in the 1940s. (Courtesy of Alabama Room at Calhoun County Public Library.)

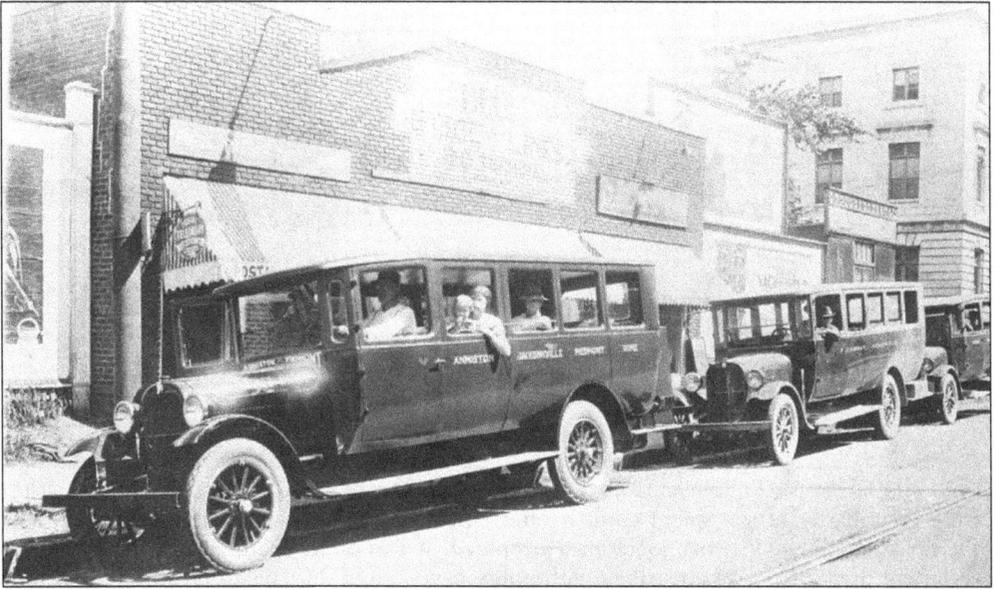

In the early 1920s, Mr. S.L. Kimberly of Piedmont operated a bus service to Anniston, Jacksonville, and Rome, Georgia. The Dixie Stage lines building was originally Lloyd's bakery on Twelfth and Noble Streets. E.C. Lloyd was born in the bakery business and worked for his father-in-law's bakery in Rome, Georgia, before coming to Anniston in 1919. He stayed briefly at the Twelfth and Noble building; since business was so prosperous, he built a new bakery at 1216 Noble Street. The building next to the stage lines was originally the Anniston Laundry. The post office was on the southeast corner. (Courtesy of Gerald Whitton.)

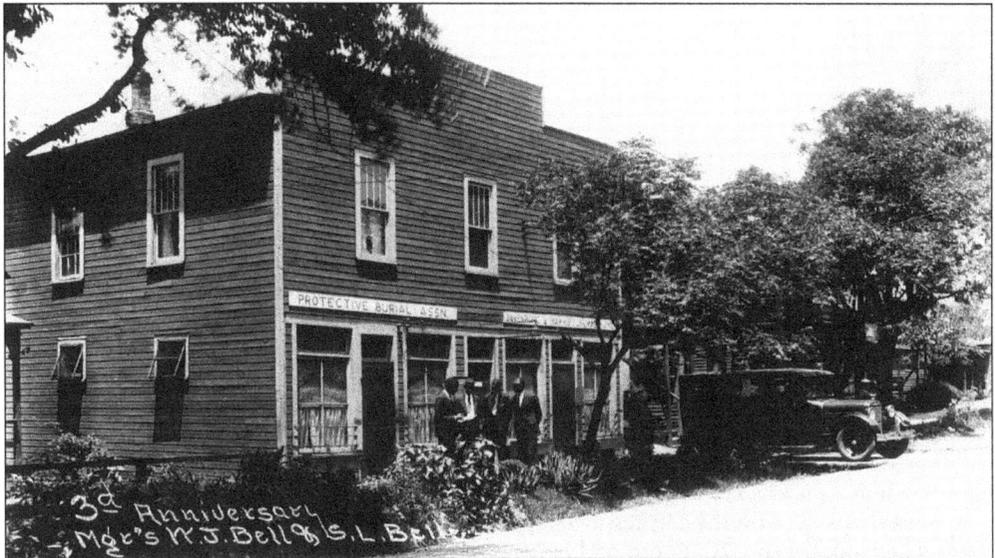

The Protective Burial Association was located at 1516 Pine Avenue in the 1930s. It was managed by Shelly L. Bell and grew out of a need for poor African Americans to have a "decent burial." Next door was the Davenport and Harris Funeral Home. Funeral homes were relatively new for this time period. When a person died in the early 20th century, the family went to a furniture store to purchase a casket. The deceased was prepared on a cooling board, placed in the casket, and then viewed in the home. (Courtesy of Russell Brothers Collection.)

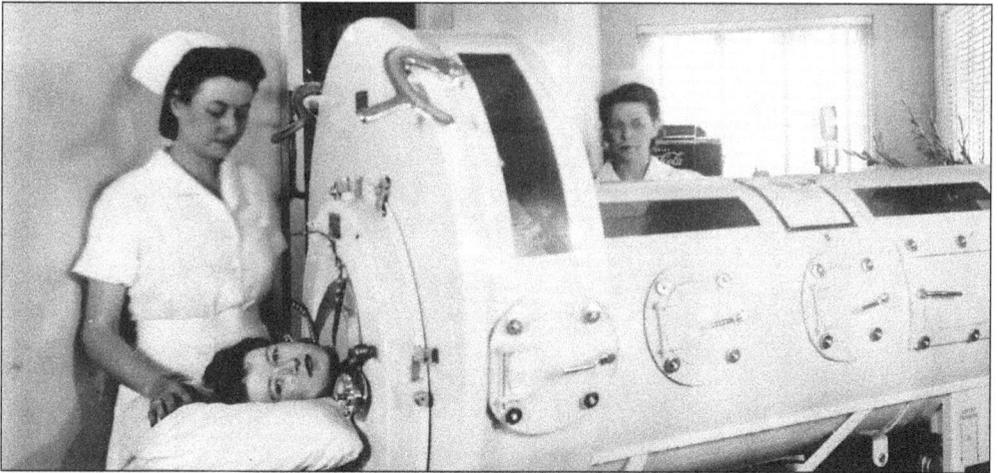

Polio, also known as Poliomyelitis, was an infectious disease caused by a viral inflammation of the grey matter of the spinal cord. It often affected children with symptoms of paralysis of various muscle groups that sometimes atrophied. It was often debilitating and resulted in permanent disabilities. When striken with polio, it was often difficult to breath, and an iron lung assisted in the breathing. In the 1940s Anniston Memorial Hospital used the iron lung, shown above, on patients. Polio was virtually eradicated in the 1950s due to a vaccine created by Dr. Jonas Salk. (Courtesy of Russell Brothers Collection.)

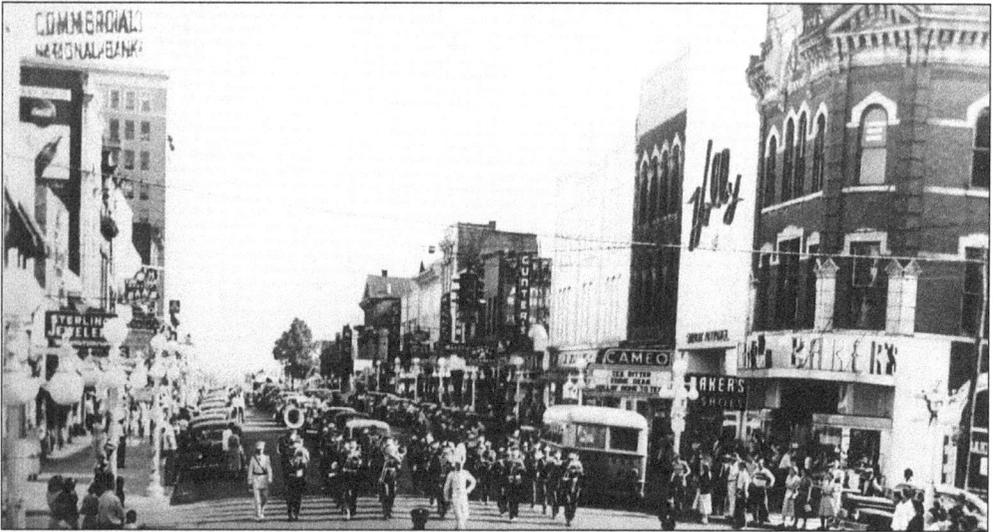

Noble Street, shown in 1950, was a bustling downtown. The Commercial National Bank building was the original site of the Woodstock company store and then a hardware store. The Liles building, as it was known, was built in 1926. It contained 164 offices and the arcade had numerous shops. During the Depression it was sold, and ultimately the bank purchased it in 1946. The bank became AmSouth and operates a bank on the first floor with tower housing offices. Across the street from the Liles building was the Noble Street Theater. The building was built in 1883 with a magnificent Italian fresco, exquisite chandelier, and theater boxes. In 1888, the theater was renovated with a capacity of 1,100 seats and space for 200 at standing room. The theater was home to touring theater companies, but with the coming of movies the house did not prosper and the building was razed in 1958. (Courtesy of Jacksonville State University Collection.)

50

Three

Jacksonville

Jacksonville, originally called Drayton, is located in the northern section of Calhoun County. In the early 1800s, settlers came to the area which was inhabited by Chief Ladiga and his Creek tribe. At the time the land was referred to as Madison, in honor of the fourth president of the United States. In 1832, the Treaty of Cusseta was signed and the Creeks seeded the remainder of the surrounding lands. In 1833, Chief Ladiga and his wife sold the section of land they owned to a land speculator and moved to the Cherokee nation near Piedmont, where they lived until their death. The land they gave up became present-day Jacksonville.

Drayton was the site of the county courthouse in 1832. The building was erected on the public square, which was the center of life in the town. In 1833, townspeople began calling the town Jacksonville in honor of President Andrew Jackson, who had camped at the Big Spring in 1814 on his way to Horseshoe Bend and had policies that benefited the common man. The town square had its first business building built in 1838 as a "house of entertainment."

Like its sister cities in the county, Jacksonville provided young men to serve in the War between the States, and a proper send off for the 10th Alabama Regiment was held at the Benton County Courthouse. The soil of Jacksonville holds the body of a fallen hero of the conflict—Major John Pelham, who was dubbed the "Gallant" Pelham, is buried in the local cemetery.

Jacksonville continued to serve as the county seat until an 1899 election, when Anniston became the permanent seat. By the 1890s, the town was home to Jacksonville Mining and Manufacturing Company, an ice plant, a telephone exchange, a power plant, the Allegheny Iron Queen Hotel, and the Tredegar National Bank to name a few. Jacksonville added a cotton mill in the early 1900s. Jacksonville saw growth again in the 1970s with the addition of Federal-Mogul, Colonial Craftsman, and Dixie Clay Company. A hospital was also built during this era. Jacksonville also serves as a college town because of Jacksonville State University.

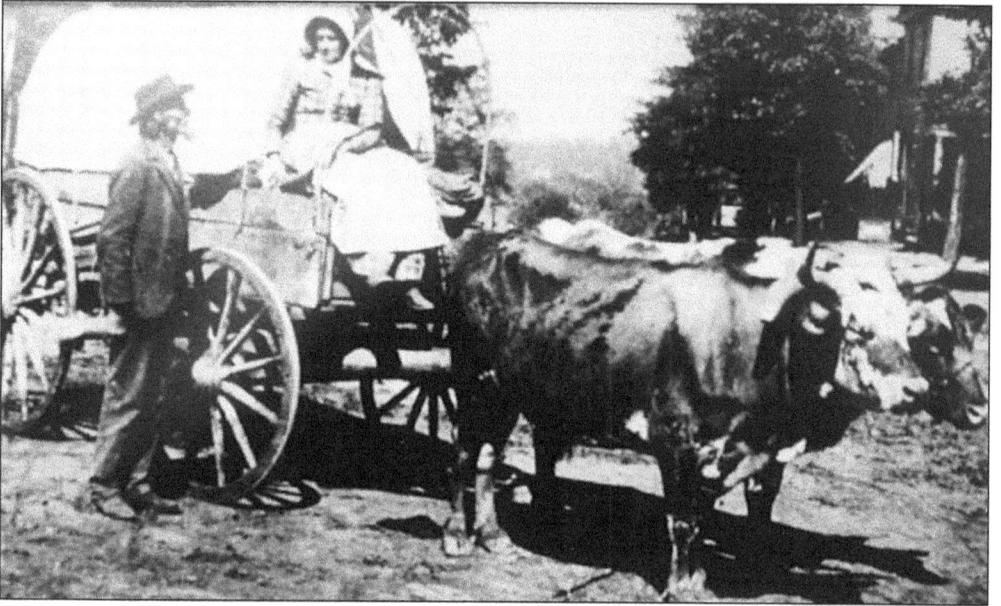

The Jacksonville square has been the center of activity since the early days of town. In 1833, the village had approximately 600 inhabitants. The courthouse was a log structure located in the center of the square. A trading house was located on the southwest corner of the square. Settlers, c. 1880s, came to Jacksonville in their covered wagons pulled by oxen. (Courtesy of John B. Nesbit in Jacksonville State University Collection.)

In 1838, Thomas Crutchfield built a two-story, 20-room tavern. He operated the building, located on Clinton Street at the corner of the public square, as a stagecoach stop. The tavern passed through many hands, but from the 1880s to the 1920s the Crow family ran a dry goods store in the building. The back area was used as a rooming house for girls attending the State Normal School. The building has housed Lou's Dress Shop and currently is the site of BG's Boutique. (Courtesy of John B. Nesbit in Jacksonville State University Collection.)

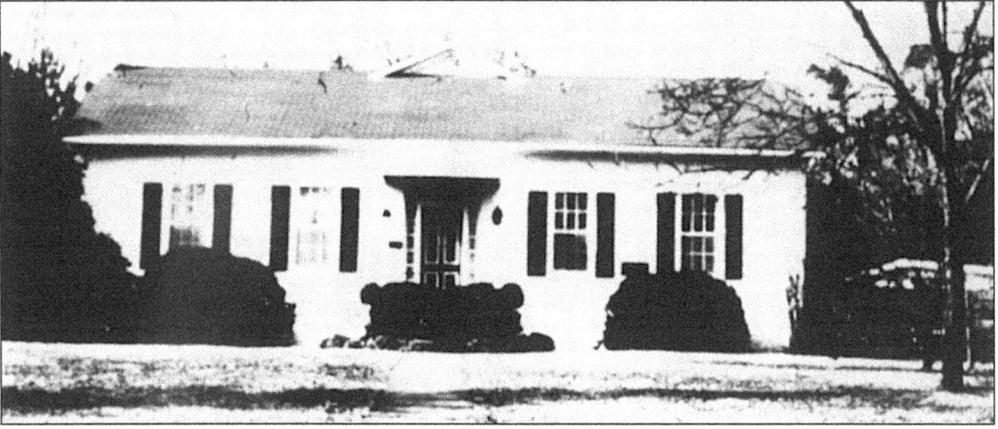

The Jacksonville Female Academy, located at 202 South Church Street, was chartered by the state in 1837. The school started with a single course taught by a Miss Thompson, but eventually grew to include three levels of instruction. For $10, girls learned English, mental arithmetic, and writing. A young lady, for $15, was taught reading, writing, arithmetic, English grammar, modern geography, history, and map reading. The most expensive tuition was $20, in which young women learned ancient geography, political history, algebra, astronomy, logic, rhetoric, elocution, philosophy, and composition. Also offered, for an additional cost, were botany, chemistry, Latin, Greek, French painting, needlework, and music. The town supported a separate male academy. Even though the same teachers were employed at both the male and female academies, instruction was thought to be better if the sexes were segregated. The academies were never a financial success. (Courtesy of Clarence W. Daugette Jr. in Jacksonville State University Collection.)

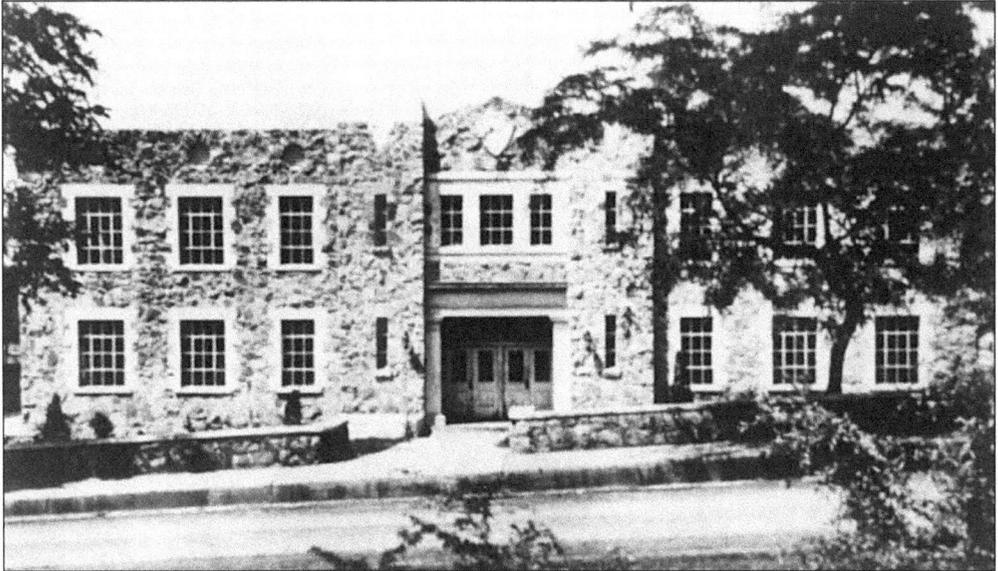

Fort John H. Forney, located on West Francis Street, was the Alabama National Guard Armory of the 167th Infantry, Company H. The building was constructed in 1937 and later served as the military science department at the college for a time. Presently, the building houses the Calhoun County Emergency Management Agency. The present National Guard Armory, Fort John Forney, is located on Highway 21 next to the Jacksonville Hospital. (Courtesy of Jacksonville State University Collection.)

The Nesbit Lake Country Club, shown in June 1911, was located at Nesbit Lake. It was not like present-day country clubs. This club was a casual gathering place for the community. Members of the community gathered for recreation, as well as boating and canoeing on the lake. (Courtesy of Jacksonville State University Collection.)

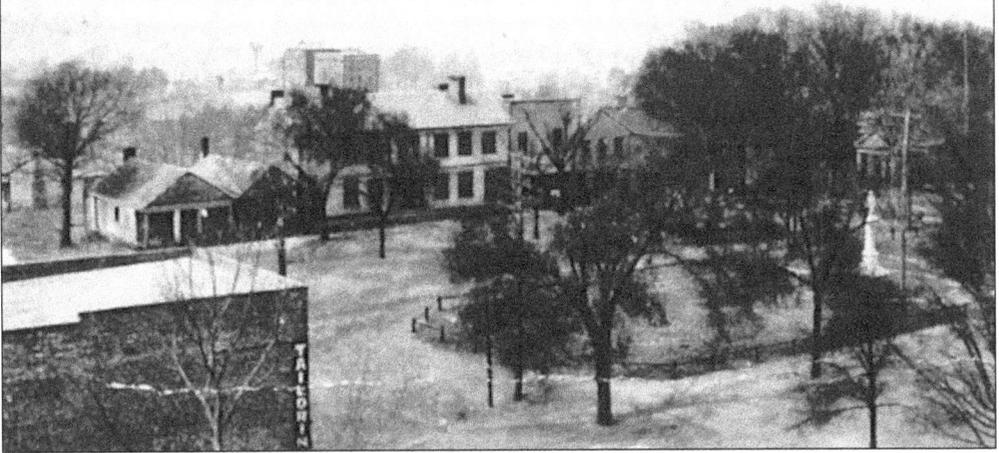

Scene on West Side of Square, Jacksonville, Ala

This view of the west side of the square was taken in the 1880s. A barber shop, on the left corner, was located next to the trading post that had been on the square since the 1830s. The trading post was run by settlers but visited frequently by the Creeks living in the area. Next was a huge wooden inn that was constructed during the antebellum building phase. Anglin's Drug Store, next to the inn, serviced the community of farmers, tinsmiths, and cobblers. At the right corner of the west side was a large building that was used during the Civil War as a stop-gap hospital for wounded arriving from the northern fronts. The small structure directly behind the monument was the office of town doctor J.F. Francis. (Courtesy of Alabama Room of Calhoun County Public Library.)

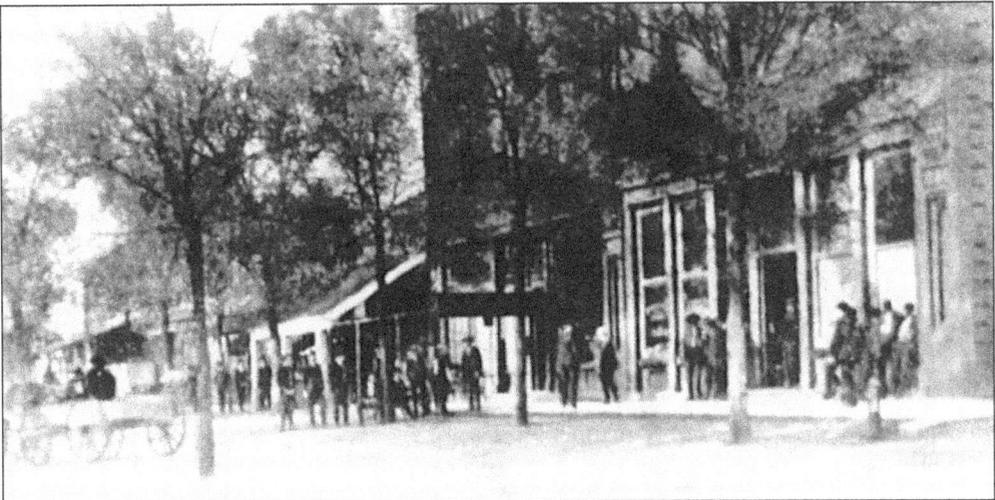

The east side of the square, shown in the 1890s, was rebuilt after the great fire in 1883. The tavern, by this time, was the Carpenter and Company store. The Tredegar National Bank's first office was located on the east side, next to the brick dry goods store on the corner. The bank was prosperous and by the 1900s had relocated to a larger building on the west side of the square. (Courtesy of Alabama Room of Calhoun County Public Library.)

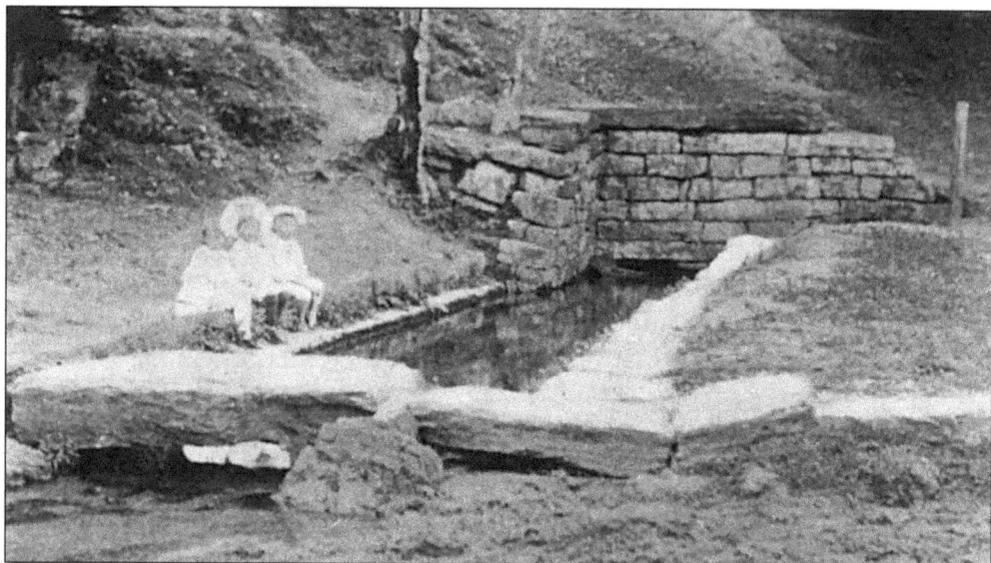

The Big Springs was located to the west of the Jacksonville square. On the way to fight the Creek Indians, Andrew Jackson camped near the spring with his army. Later, some of these men came back to settle in Jacksonville. In the 1830s, the first houses for many of the settlers were built on a hill above the Big Springs. Families and young people gathered at the spring to enjoy an afternoon picnic or music. In the early 1900s, the spring had approximately 3,000,000 gallons of water flow through it daily. (Courtesy of Mrs. T.E. Kilby Jr.)

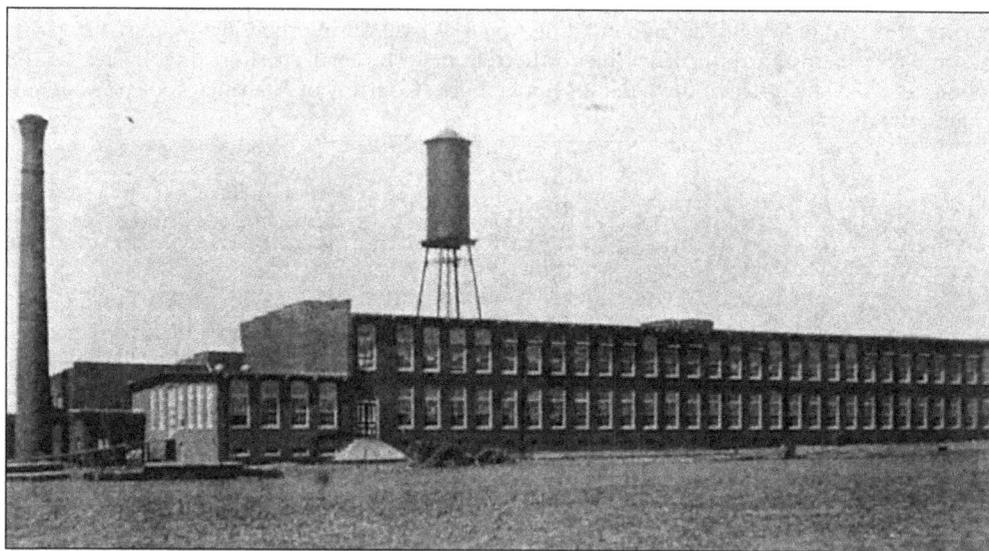

George P. Ide and a group of businessmen organized and built the Ide Cotton Mills in 1906. The first mill was located on the west side of Jacksonville on Alexandria Road. In 1910, a second mill was built at the same location. Shortly thereafter, the ownership of the mill was transferred to J.B. Henry, who changed the name to Profile Cotton Mill. In 1920, William Greenleaf purchased the mill. Profile Mill ginned the local farmer's cotton, as well as operated a cottonseed oil mill and a fertilizer plant. The mill changed ownership in 1942, 1949, and 1952 with Philadelphia and Reading, Inc. purchasing the mill in 1956. They eventually merged with the present owners, Union Yarn Mills. (Courtesy of Mrs. T.E. Kilby Jr.)

St. Luke's Episcopal Church was organized by Reverend D. Flowers in 1848. This Gothic frame building was designed by leading 19th-century architect Richard Upjohn. The church, located south of the square at the intersection of Church and Ladiga Streets, was built by slave labor in 1856. St. Luke's was consecrated in 1857 with Reverend Thomas A. Morris as rector. (Courtesy of Jacksonville Public Library.)

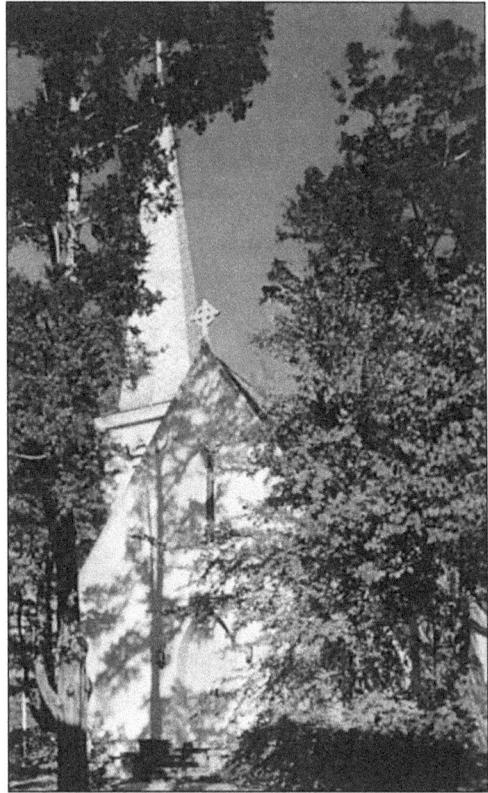

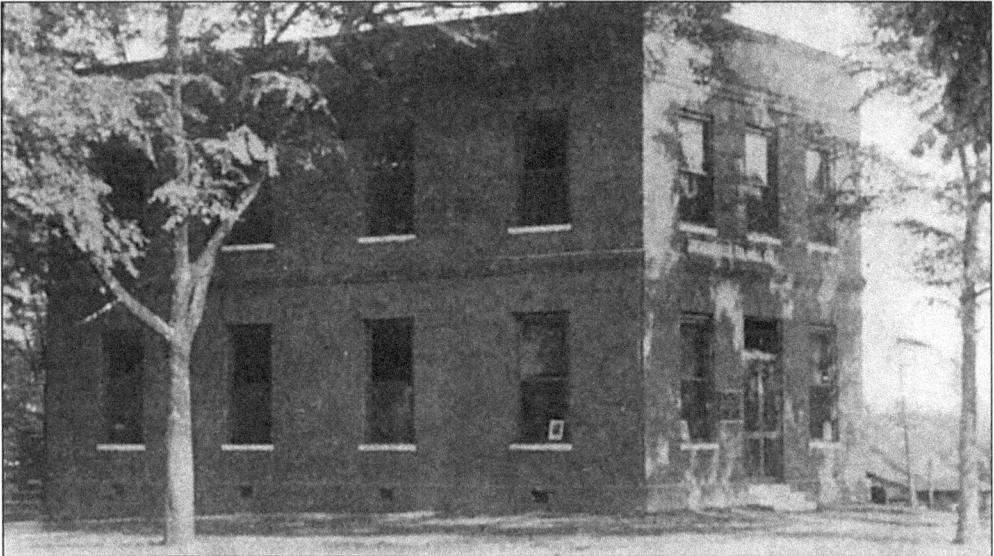

George and Henry Ide founded the town's first bank in 1890. The Tredegar National Bank was located on the east side of the square with Major Peyton Rowan as president. Careful banking practices carried the bank through the Panic of 1893. In 1902, a new and larger bank was constructed on the west side of the square. The bank's name was changed to First National Bank of Jacksonville in 1913. In the 1990s, the brick bank has been replaced by a modern structure housing AmSouth. (Courtesy of Mrs. T.E. Kilby Jr.)

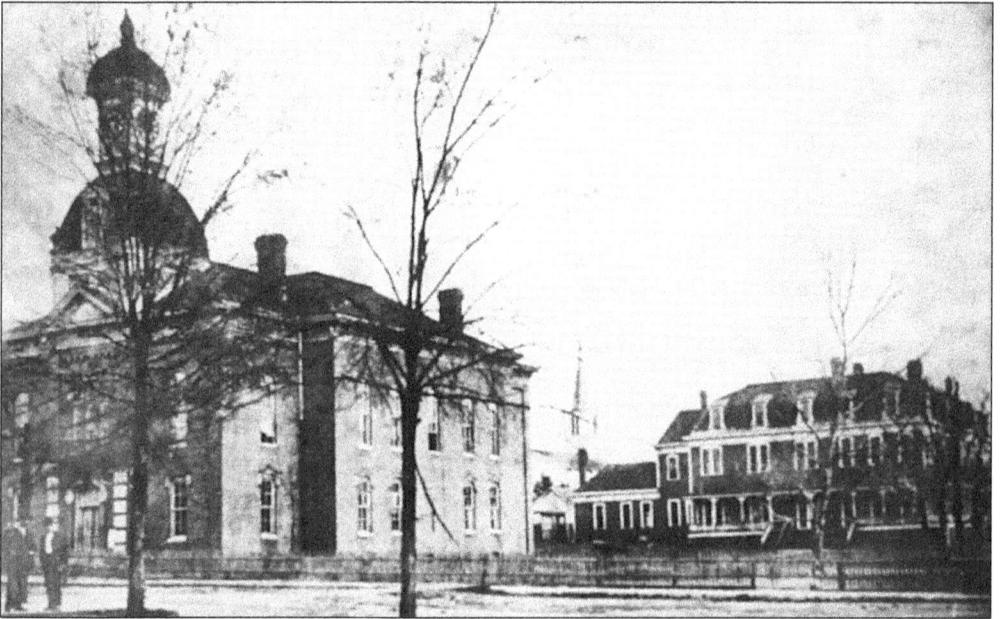

Drayton, later Jacksonville, was the site of the first county courthouse. In 1833, the courthouse was a log frame building, but by 1838 a special tax allowed for a brick structure to be built. In 1885, a modern courthouse, seen here, was built on the east side of the square on Ladiga Street. This building housed the courthouse until 1900, when it moved to Anniston. Clarence Daugette had the property transferred to the Normal School. The school held classes in the old courthouse for some time. The building burned in 1927. St. Luke's Episcopal Church and the Iron Queen Hotel can be seen behind the courthouse. (Courtesy of Jacksonville State University Collection.)

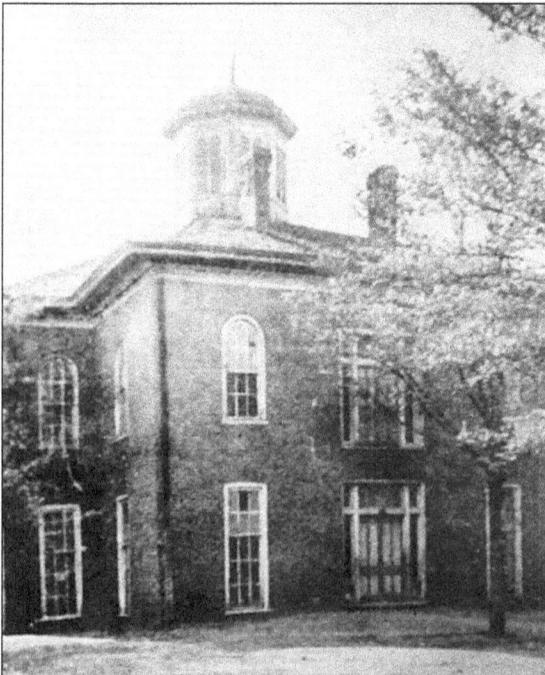

In 1869, Calhoun College was organized at a stockholders meeting. By 1871, the Jacksonville Male Academy had merged with the college. The college was a polytechnic school which included a female academy. These two schools were under the same administration, and both stayed in existence until the state legislature created the Normal School in 1883. In addition to the building, the school transferred its books, equipment, and 12 acres of land in 1883 to the Normal School. The building, shown here, was part of the old Hames Hall on the Normal School's campus. (Courtesy of Jacksonville State University Collection.)

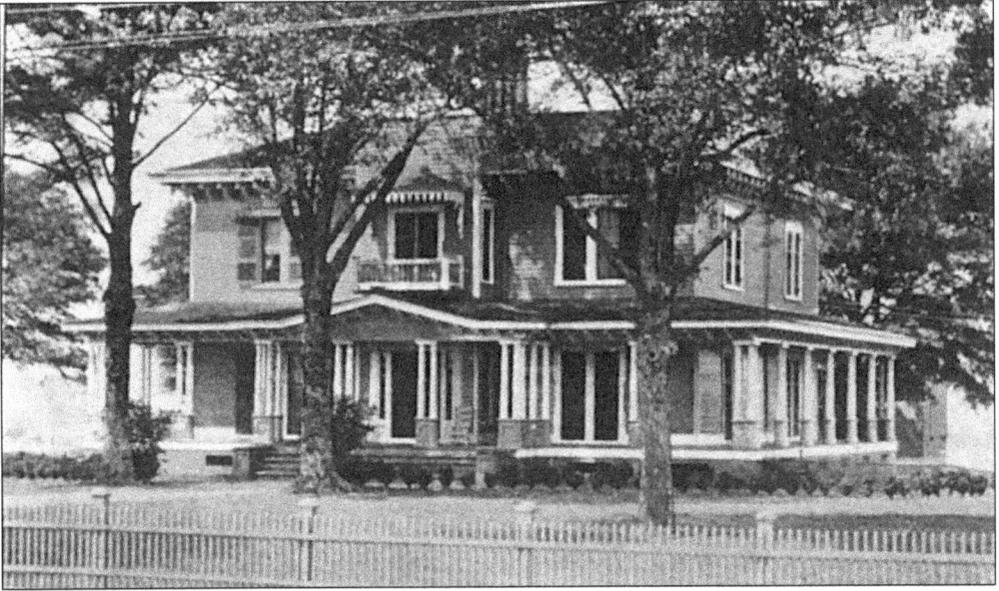

James Crook of Alexandria built "Ten Oaks" in 1850 using slave labor. In October 1864 the home was used as the headquarters of Confederate General P.G.T. Beauregard. Major Peyton Rowan bought the home in 1865. "Minerva's Hall," a private school, was conducted by Fannie Fullenwider in 1872 at the residence. The students were all cousins except for one. Descendants of Major Rowan still reside in part of the home, while a law office occupies the second floor of the house. (Courtesy of Mrs. T.E. Kilby Jr.)

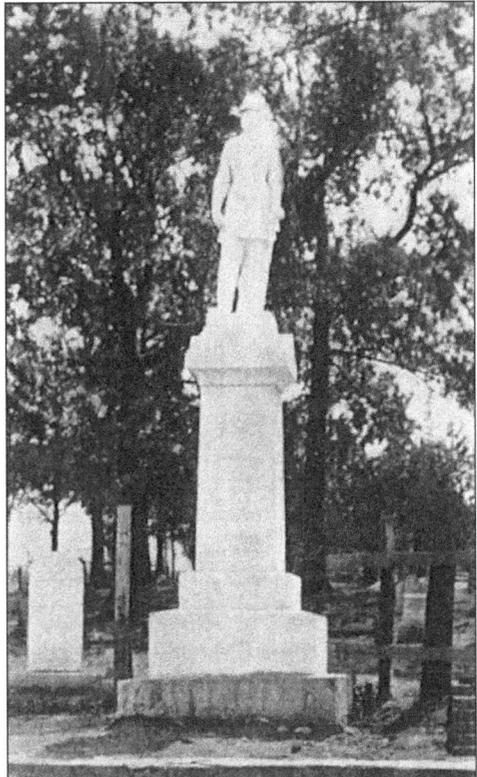

John Pelham, a native of Alexandria, was an 1861 graduate of West Point. Pelham was commissioned as a first lieutenant in the Confederate army. He rose to the rank of major as an artillery commander. On March 17, 1863, Pelham was killed at the Battle of Kelly's Ford in Virginia. He laid in state at Richmond, the Confederate capital, and then was returned home for interment in the local cemetery. Robert E. Lee referred to Major Pelham as "the Gallant Pelham." (Courtesy of Mrs. T.E. Kilby Jr.)

"Boxwood" (white house) was built by Dr. Courtney Clark when he came to Jacksonville in 1837. Clark was a physician and surgeon who was responsible for field hospitals in the Mexican War and Civil War. During the federal occupation after the Civil War, troops were billeted in the home. George Ide bought the home and remodeled it during the boom of the 1890s. The house is no longer standing. To the left of the house, out of view, was the post office, which is the present-day Jacksonville City Library. Western Union and the mercantile stores were located in what is now the AmSouth parking lot on North Pelham Road. (Courtesy of Jacksonville State University Collection.)

The Masonic Building (far left), located across from the City Library on North Pelham Road, was built in 1839. The Hiram Lodge No. 42, F. and A.M., organized in 1837 and combined with the Methodists to build this structure. The upper floor was used for Masonic meetings. The lower floor was used by the Methodists until they constructed their own church in 1888. After the Methodists left, the Masons took complete possession. This photograph shows the structure in the 1940s. Currently it is the site of a strip mall that includes a brick Masonic Lodge. (Courtesy of Jacksonville State University Collection.)

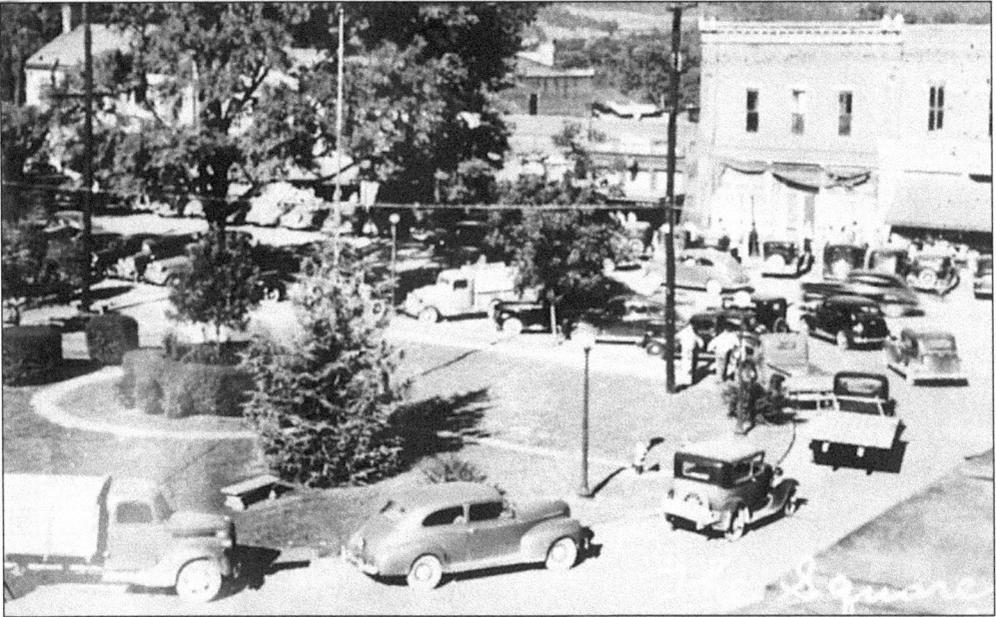

In September 1883, a horrible fire gutted about 25 buildings on three sides of the square. The fire began on the east side of the square in Dr. William Nisbet's drugstore. The tavern, on the east side, was saved due to an 18-inch fire wall. Shortly after the fire, a boom time occurred and the town's burned-out structures were replaced with brick structures. An "opera house" (far right) was built on the corner of the east side of the square on Ladiga Street. It held vaudeville performances but was a casualty of the Panic of 1893. The building housed various businesses. Located in the middle of the east side was Kitchner's Drugs, shown in the 1940s, which filled prescriptions and had a soda fountain. (Courtesy of Jacksonville State University Collection.)

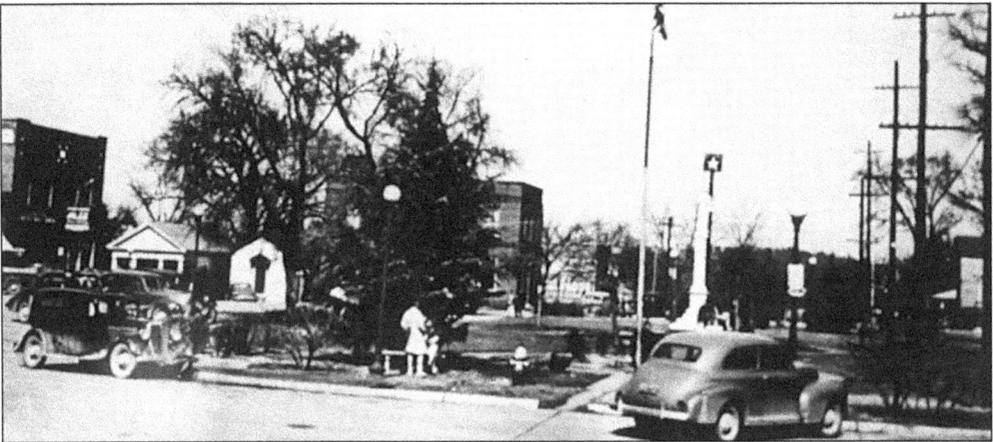

The Francis-Lawrence-Williams Office (to the left of the monument) was located behind the bank. The white, one-story building in the Palladian style was built by Dr. J.F. Francis, a family doctor who started his practice in 1850 and ran a drugstore in his office. Dr. Forney Lawrence was a dentist who occupied the office in the early 20th century. By the 1950s the office belonged, for a short time, to Dr. James Williams, a physician for the college. Eventually, the office was sold to the First National Bank of Jacksonville for historical purposes. It was removed to Gayle Street and currently operates as the Dr. J.F. Francis Museum. (Courtesy of Jacksonville State University Collection.)

61

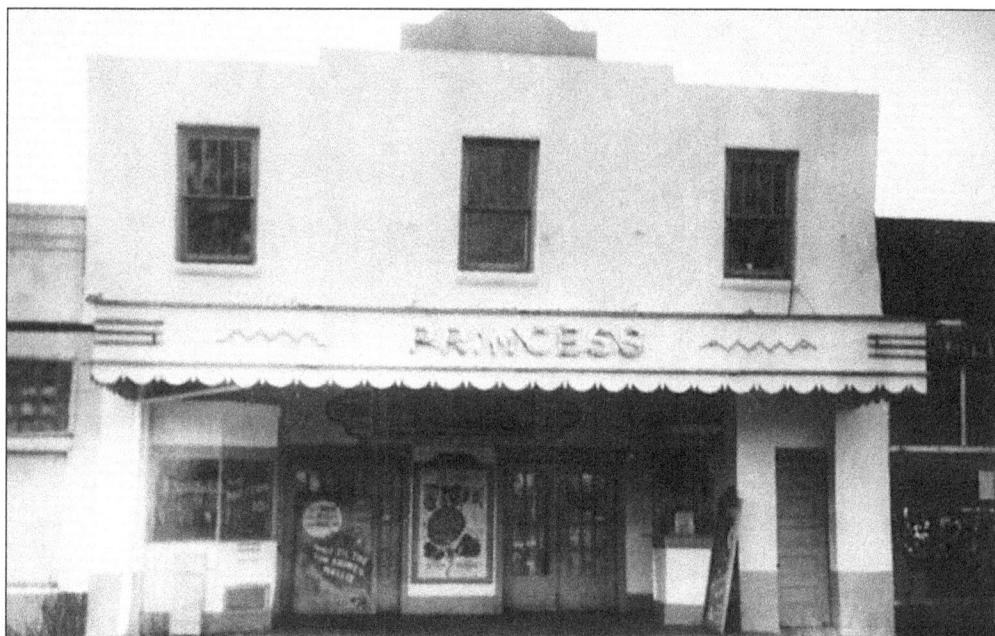

In the 1930s and 1940s, the Princess Theater was located on the west side of the square in the center of the block. The Princess ran different movies every day of the week. Each week the schedule was posted in the *Jacksonville News*. The painting on the ticket window reads, "Popcorn 10 Cents." Located to the right of the movie theater was a billiard's hall where young men played pool. (Courtesy of Jacksonville State University Collection.)

The town could not support both the college and the public school, so the Jacksonville City School building was acquired by the college in 1929. The building, located on West Francis Street next to the armory, later served as the college's ROTC building. The high school students and faculty moved their desks to the Jacksonville High School, built in 1947, on the college's property next to Stevenson Gym. In 1998, the high school moves to a new building located on Weaver Road. (Courtesy of Jacksonville State University Collection.)

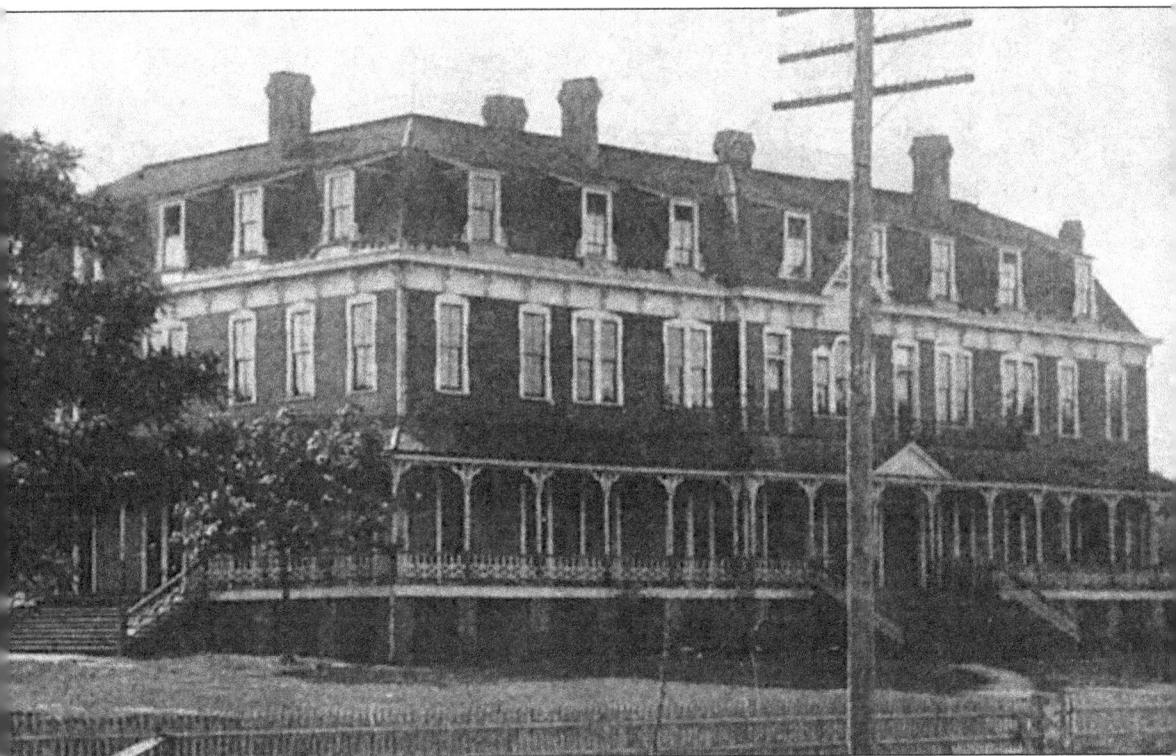

In the late 1880s, Jacksonville witnessed a boom time. The Jacksonville Mining and Manufacturing Company, founded by General Joseph Burke and Major Goldsmith B. West, constructed the Allegheny Iron Queen Hotel and 100-horse stable near the town square. By 1898, the Iron Queen, a casualty of the Panic of 1893, was rented as a dormitory for the first boarding students at the State Normal School. In the early 1900s, the name of the building changed to the Hotel Pelman. The hotel, located on South Pelham road approximately two blocks from the square, was destroyed by fire in 1917. (Courtesy of Mrs. T.E. Kilby Jr.)

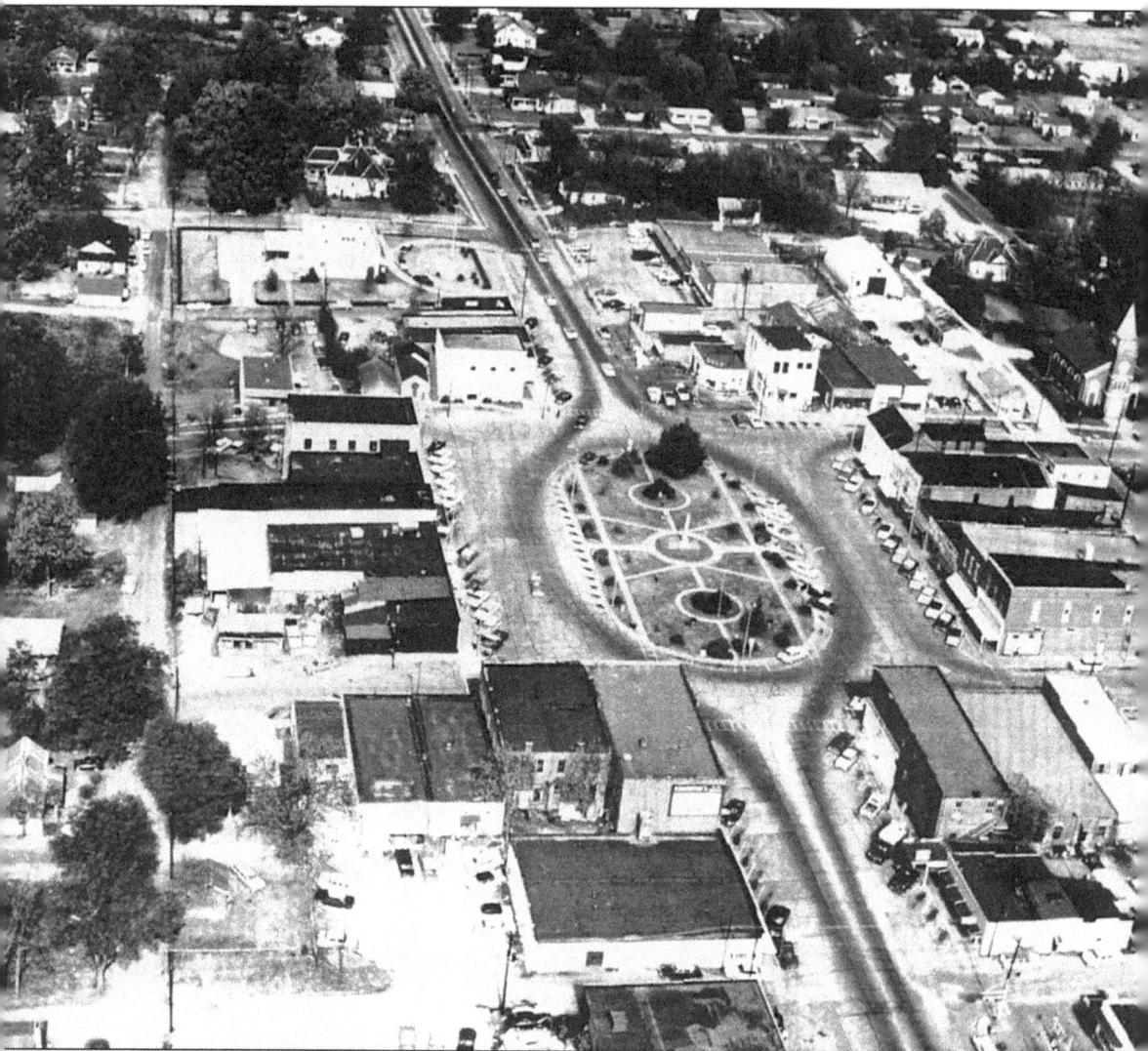

The Jacksonville square in the 1990s looks much as it did in the 1960s. The northern section of Pelham Road has developed from a residential neighborhood into commercial real estate. To the east of the square is Church Street. At the intersection of Church and Clinton Streets was the First Presbyterian Church of Jacksonville. The church was organized in 1834. Construction on the sanctuary began in 1858 using slave labor. During the War between the States, the church served as a Confederate Hospital. In 1951, the building was renovated to restore its original beauty. (Courtesy of Jacksonville Public Library.)

Four

Jacksonville State University

Jacksonville State University was created by the Alabama Legislature in 1882 as the Jacksonville State Normal School to train teachers. In addition to two-year teacher training, the Normal School was responsible for a training school for the town's children. The first session for the Normal School was 1883. As the enrollment grew, the school was able to add teachers and departments. In 1897, the state legislature allowed Jacksonville to become a separate school district with the president of the Normal School acting as the public school superintendent. Even though the Normal School had fluctuating financial resources during the late 19th century, the school was able to continue.

The early 1900s saw the addition of sports. World War I, however, changed the demographics of the student body. The men were called into service and the enrollment saw more female students than males. The school saw an increase in buildings during the 1920s but the biggest change was its becoming a teacher's college.

In 1929, the school became Jacksonville State Teachers College. This change meant the school was now a four-year college which could award a B.S. degree, as well as use a quality point system. During the Great Depression of the 1930s, Jacksonville State still managed to grow and add subjects and buildings. The 1930s also witnessed the college's move to its present location, north of the town square. World War II again took many of the men as soldiers, but women continued to attend the Teachers College.

The next change in Jacksonville State came in 1957, when the school became Jacksonville State College with the addition of the first graduate program, a master's degree in elementary education. Nine years later the state legislature promoted the school to university status, where it remains today. In addition to the main campus in Jacksonville, the university operates centers in Gadsden, Fort McClellan, Anniston, and Oxford.

In 1883, Jacksonville State Normal School opened its doors with a mathematics teacher, an English teacher, and a primary school teacher. The school was established as a training school to professionalize teaching. The first 15 years of the school were successful. Enrollment grew and the early presidents of the college established the best curriculum available under financial and educational restraints. In 1899, Clarence W. Daugette was named president of the Normal School. During the school's early years, a training school was also operated. The primary school was attended by the children of the town for a tuition of 75¢ a month. By 1910, the Normal School had 434 students, both profession and primary. (Courtesy of Mrs. T.E. Kilby Jr.)

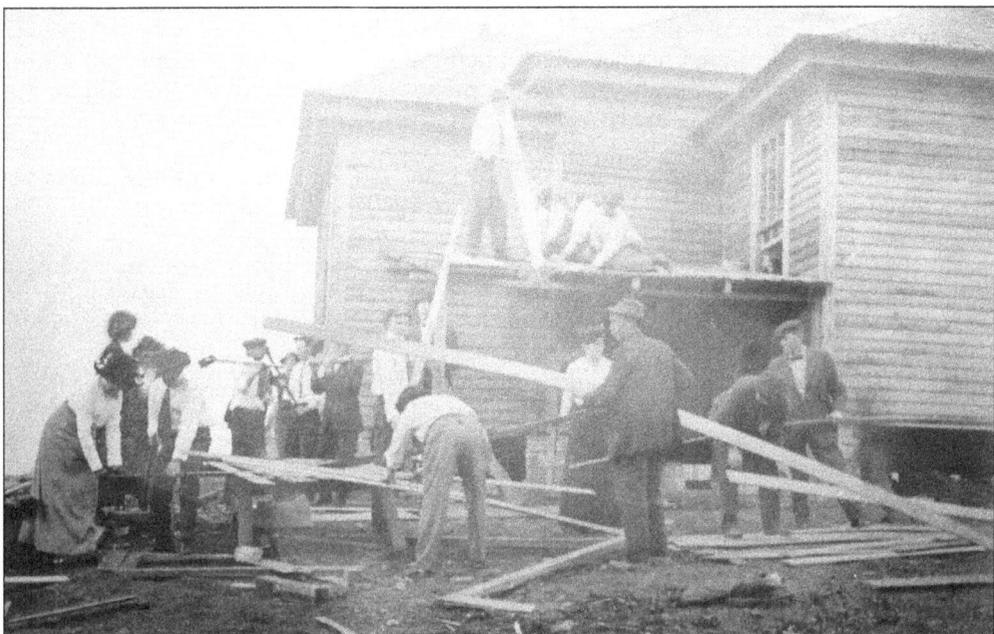

Many rural areas in Calhoun County did not have adequate schools for their children. The community of Merrellton, located north of Jacksonville, was established in 1884 and named for postmistress Adelia E. Frank's daughter Merrell. The Normal School students are shown here in the early 1900s constructing a school for the children of Merrellton. (Courtesy of Jacksonville State University Collection.)

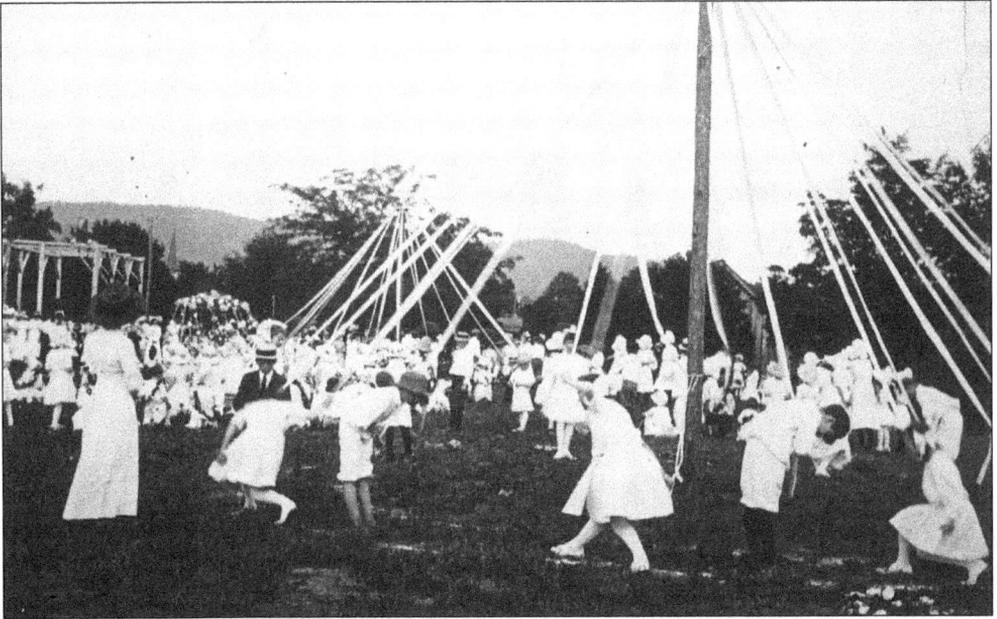

In the 1912–13 school year, the Normal School held a play festival for the rural schoolchildren from Calhoun County. The children circled the May Pole. The king of the May was chosen as part of the festivities with the king choosing his queen. Kathleen Daugette, the president of the Normal School's daughter, took part in the activities. (Courtesy of Jacksonville State University Collection.)

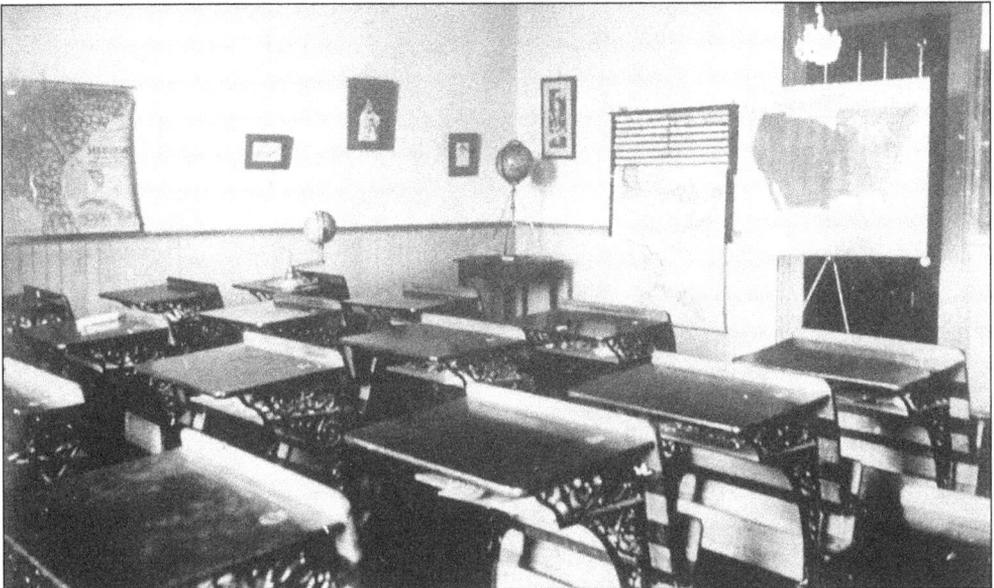

Students at the Normal School had classrooms much like the ones still used today. In the early 1900s, expenses for the students could be held to about $100. Notes for tuition could be signed on the condition of payment of the tuition within two years of graduation or by teaching. Later the provision was changed where a student agreed to teach 18 months in a public school or repay the loan within five years of leaving the school. (Courtesy of Jacksonville State University Collection.)

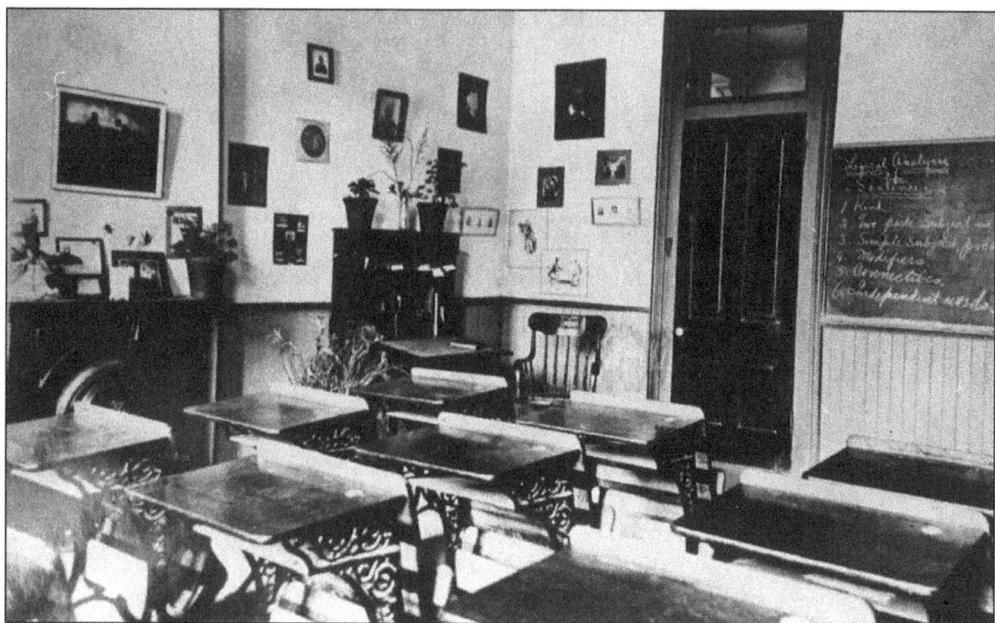

Since the faculty of the Normal School was small in 1900, teachers often taught more than one subject. W.J. Beeson served as both the history and English instructor and received a salary of $630 per year. English and history were considered essential subjects. The lesson on the board reads, "logical analysis of sentences." (Courtesy of Jacksonville State University Collection.)

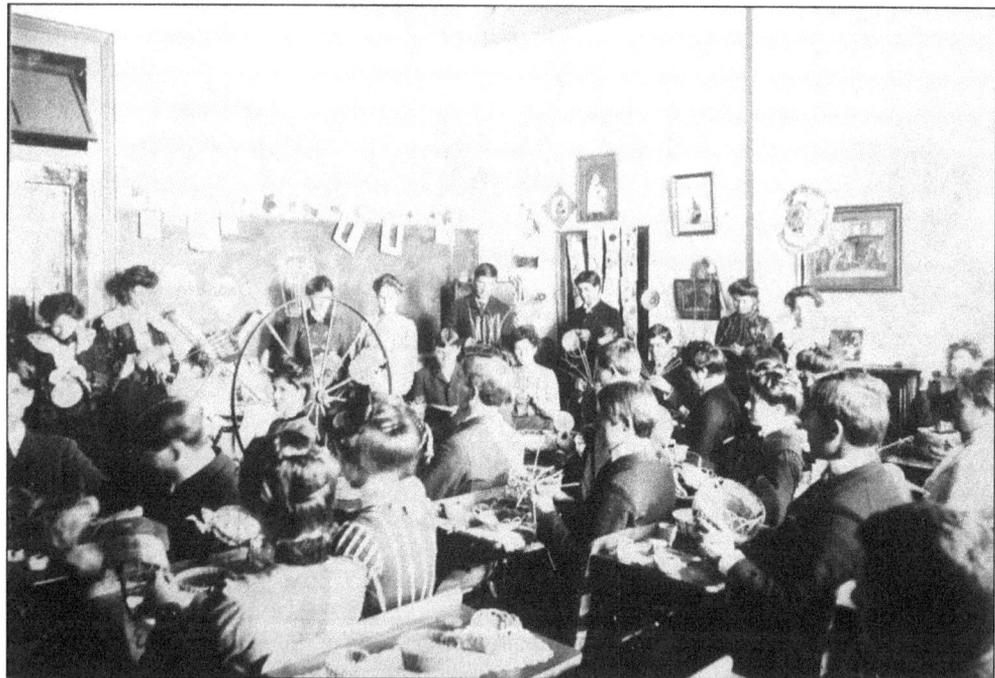

The Normal School offered manual training courses in teaching industrial arts. Students took courses in woodworking where they built period furniture. They also were taught caning and upholstering. Weaving was taught to both male and female students. (Courtesy of Jacksonville State University Collection.)

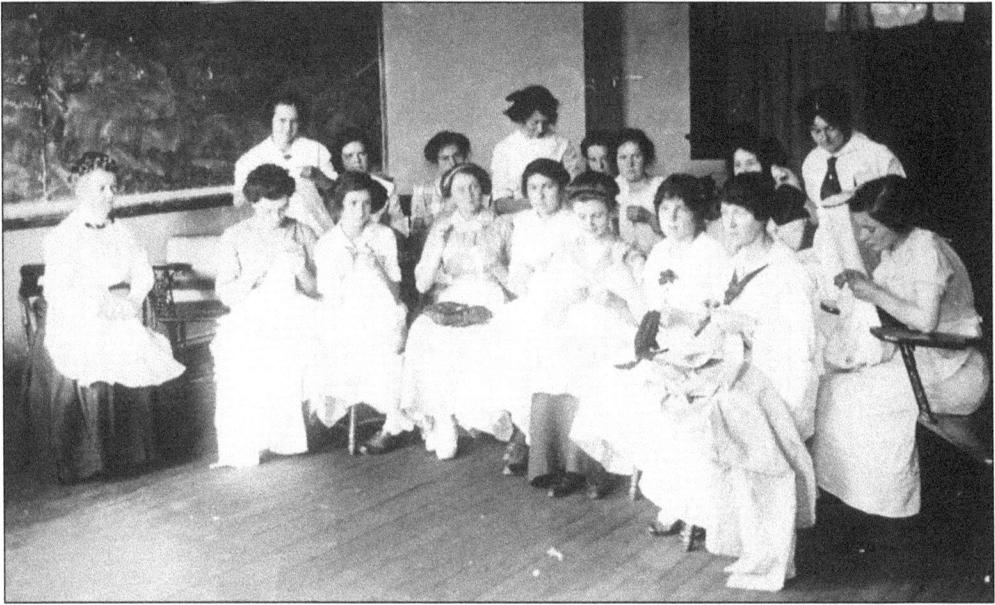

Home economics was another subject taught at the Normal School. These 1913 pictures show a sewing class and cooking class. The students of household economy were taught plain sewing, machine sewing, as well as the study of textiles and how they related to health. Cooking and food study were a part of the home economics curriculum. Even though classes were coeducational, young women who were students at the Normal School in the early 1900s were held to a strict code. When girls walked with boys, they were always accompanied by chaperons. Girls were allowed to receive gentlemen callers only on Sunday afternoon. Young ladies could not remain out late or go out during the week without the permission of the president. The only exception made was for prayer meetings. (Courtesy of Jacksonville State University Collection.)

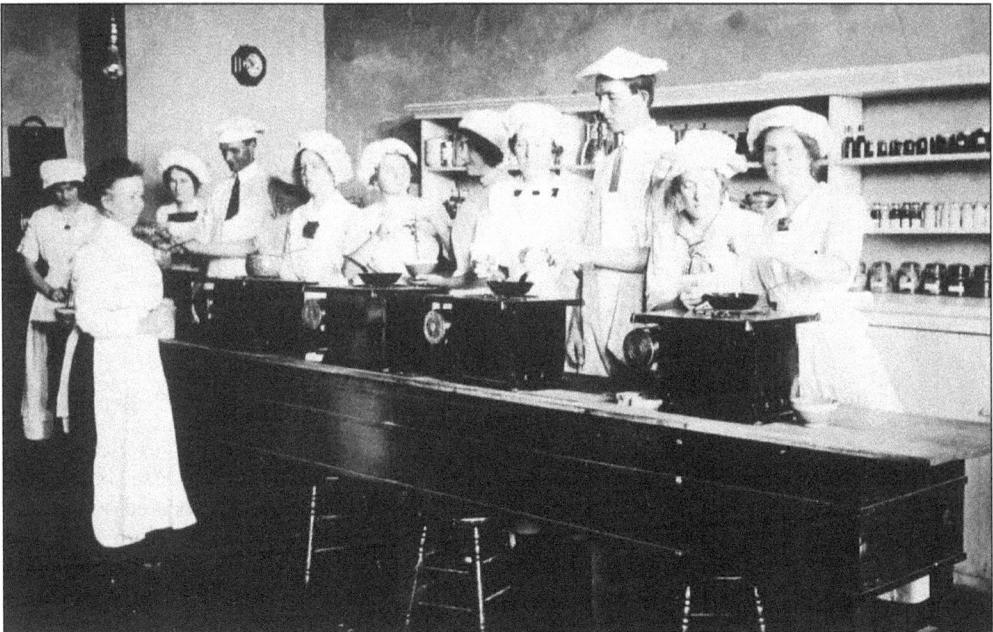

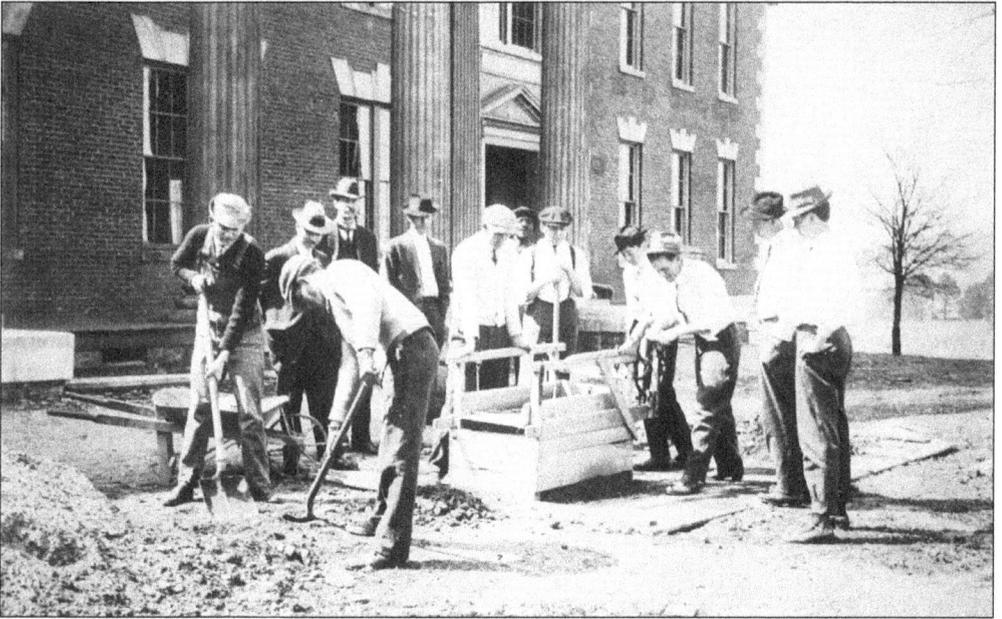

Some of the teachers at the Normal School not only taught at their schools, but also had to assist in their construction. In 1913, young men were taught a class in concrete work as part of the manual training. (Courtesy of Jacksonville State University Collection.)

In 1903, the Chapel of Hames Hall was elaborately decorated. Hames Hall, located on College Street near the present-day elementary school, had been transferred to the Normal School in 1883 and was originally the main building of Calhoun College. In 1908, the hall was remodeled and enlarged with help of the town of Jacksonville. (Courtesy of Jacksonville State University Collection.)

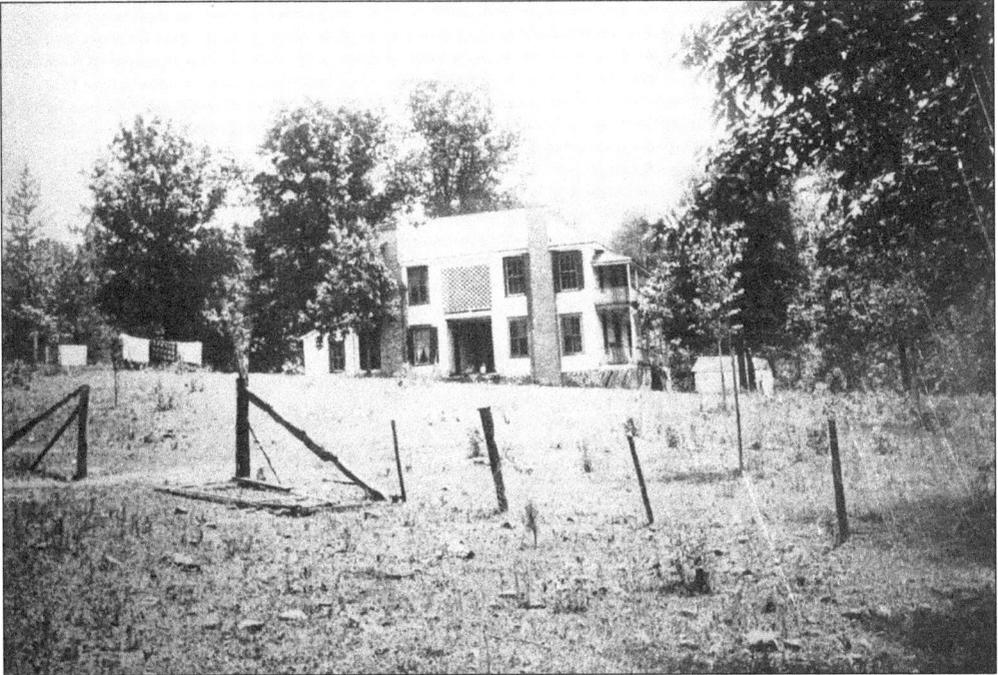

Fannie Atkins gave a farm, located about 2 miles south of Jacksonville, to the Normal School. This donation was noted in a 1917 school bulletin. She gave the farm in memory of her husband, David, to help young men receive an education. The farm, which included a 10-room house on 123 1/2 acres, furnished fresh vegetables and milk for the school. Surplus food was canned to use in the winter. (Courtesy of Jacksonville State University Collection.)

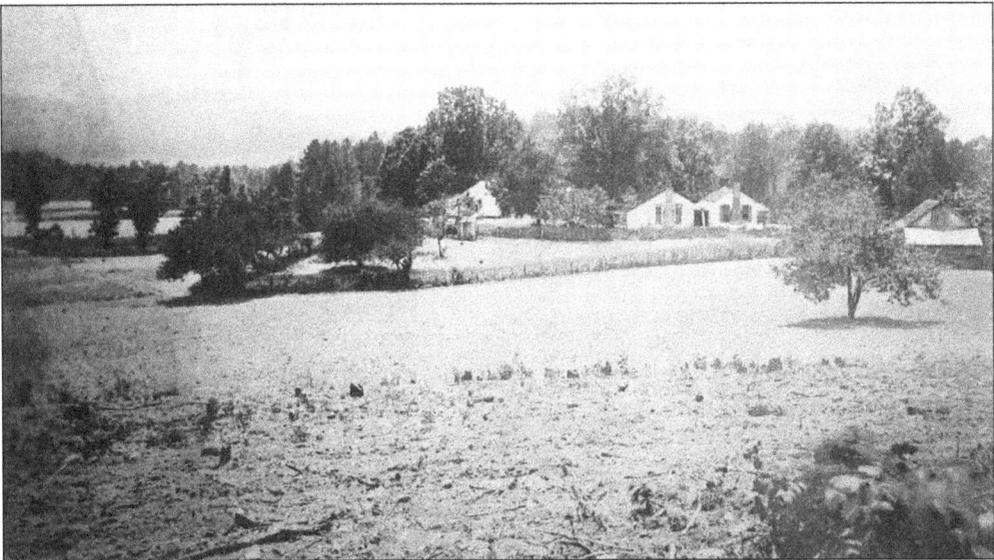

Male students at the Normal School could stay at the farmhouse for free. Farm work was available for a limited number of students. There were four additional buildings on the property. Water was furnished by a force pump. A modern sanitary dairy was constructed soon after the farm was given to the school. The agriculture teacher at the Normal School looked after the farm three days a week. (Courtesy of Jacksonville State University Collection.)

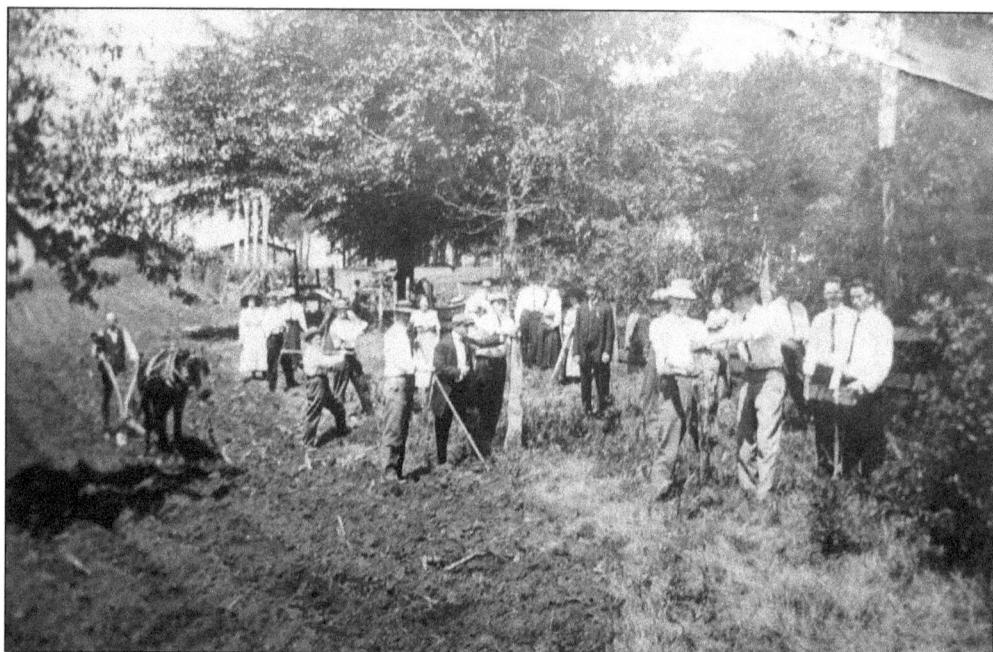

Agriculture was a required subject for schoolteachers, since most would teach in rural areas. The farm was used for instruction and training. In the 1910s the farm had 44 head of cattle, 72 hogs, 40 goats, 2 mules, a mare, and the necessary farming tools. Photographs of activities at the farm were published in the school bulletins. (Courtesy of Jacksonville State University Collection.)

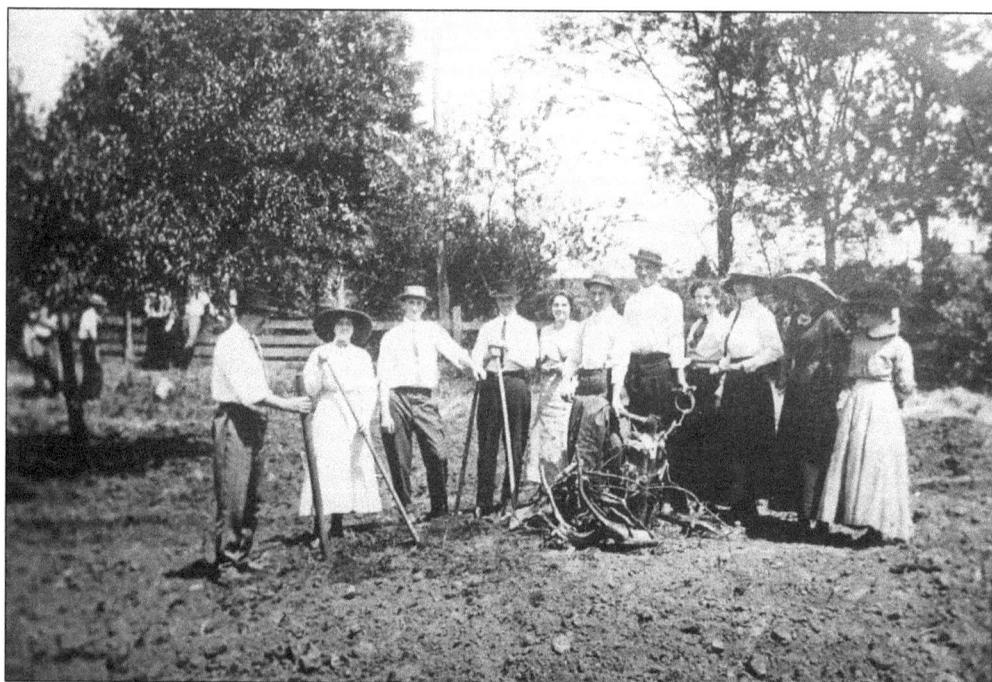

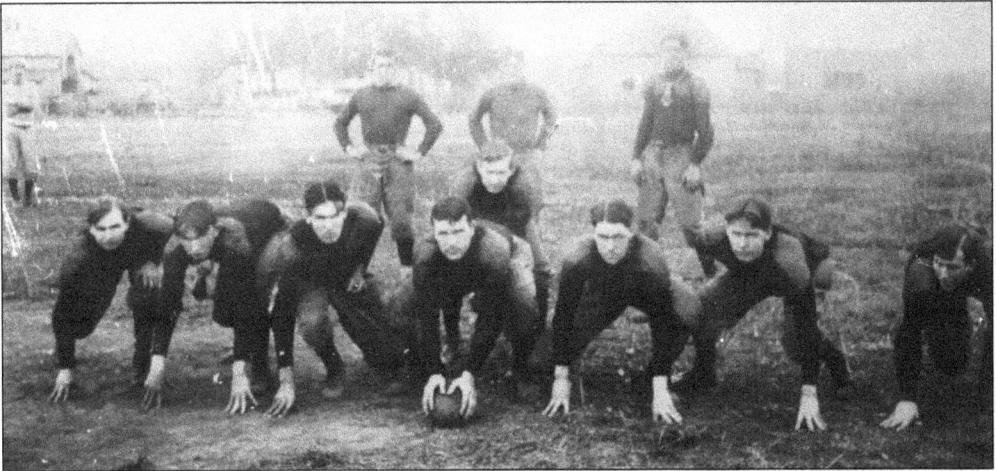

The Normal School was playing football possibly as early as 1903, the first record of a game. The 1910 football team is shown above practicing for a game. The "necklaces" around the necks were early noseguards, and physicians were in attendance at games in case of accidents. (Courtesy of Jacksonville State University Collection.)

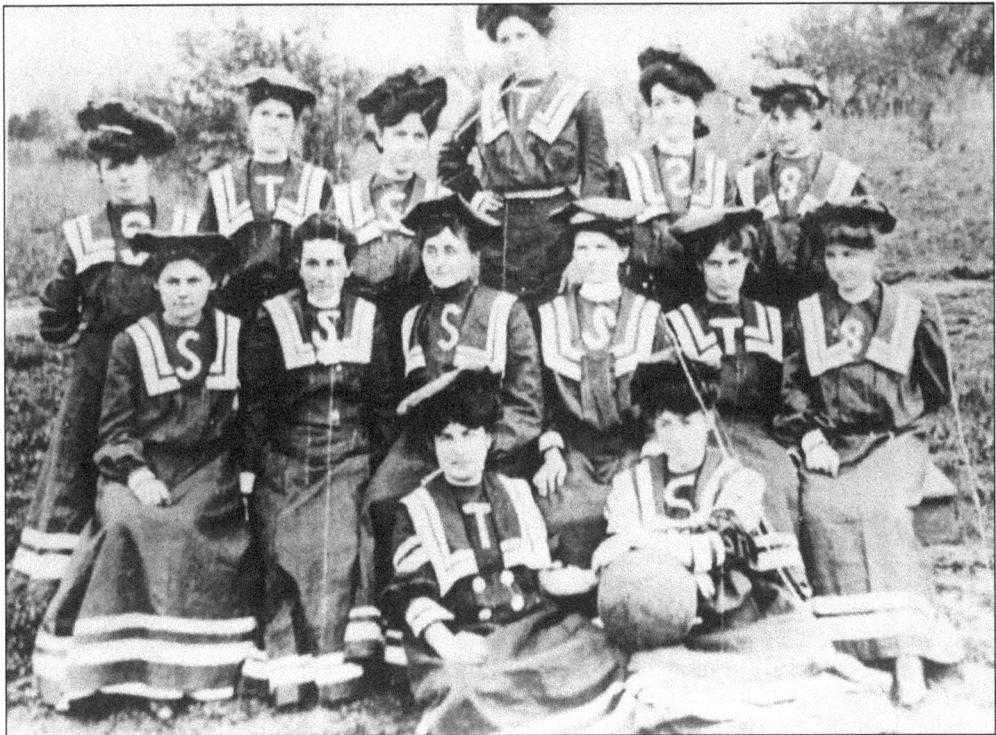

Physical culture, prior to 1900, was a private course offered for an extra fee. In 1900, it was added to the curriculum and was meant to create a harmony between the mind and body. Other exercise was considered at the school, so the first women's basketball team, shown in 1902, was created. The women were divided into two squads—the Tumblers and the Scramblers. The Victorian era dictated that the young women be completely covered and modest in their uniform. The women wore dresses to play instead of shorts and shirts. (Courtesy of the Merrill family in Jacksonville State University Collection.)

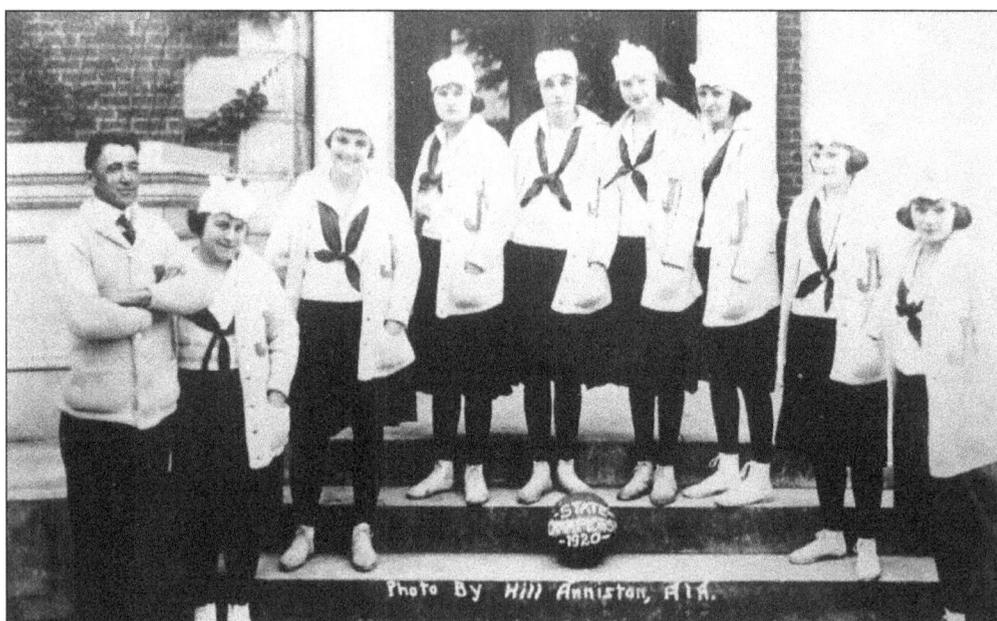

Physical culture classes of the 1900s no longer separated boys and girls. By the 1910s physical exercise involved all the students and were generally held after chapel sessions. Not only did views on exercise change but also the exercise uniform. The women's basketball team, shown with their 1920 championship, wore shirts and shorter skirts. The school also offered tennis and volleyball courts and indoor baseball for women. (Courtesy of Jacksonville State University.)

In the summer of 1918, President Woodrow Wilson began using colleges as training camps for the U.S. Army. The Students Army Training Corps (SATC) was under the Committee on Education and Special Training in Washington. Jacksonville Normal School constructed a barrack and unit with 200 men. An army officer came to the school to give military drill to the SATC candidates. Just as the unit got started, the signing of the Armistice on November 11, 1918, was announced. World War I was over and so was the SATC. The army left the building and it was remodeled as a dormitory for men. The school applied for a Reserve Officer Training Corps (ROTC) in the fall of 1919. The old high school served as the ROTC building for many years. The current ROTC building, Rowe Hall, is located at the corner of Church and Eighth Street Northeast. (Courtesy of Jacksonville State University Collection.)

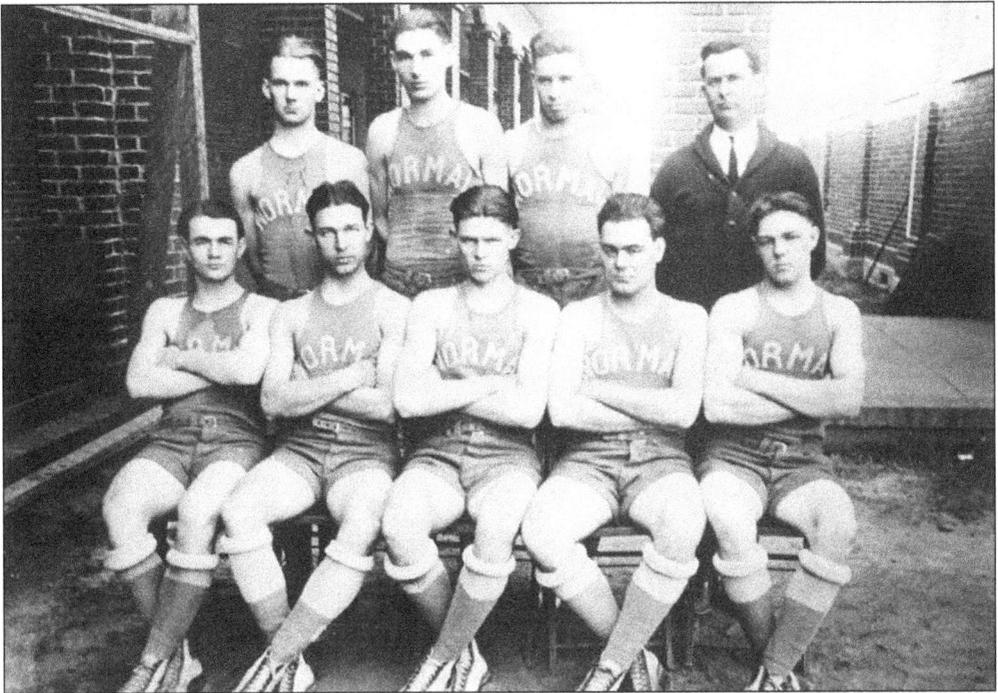

Basketball was a recreational activity offered to both male and female students. The men's team won a championship during the 1923–24 school year. President Daugette's son Clarence is pictured on the far right of the men's team picture. Coach C.C. Bush was replaced by Allen Shelton in 1924. Shelton handled the basketball tournaments in the late 1920s. The first tournament saw 42 teams come to Jacksonville and was so successful it continued for many years. (Courtesy of Jacksonville State University Collection.)

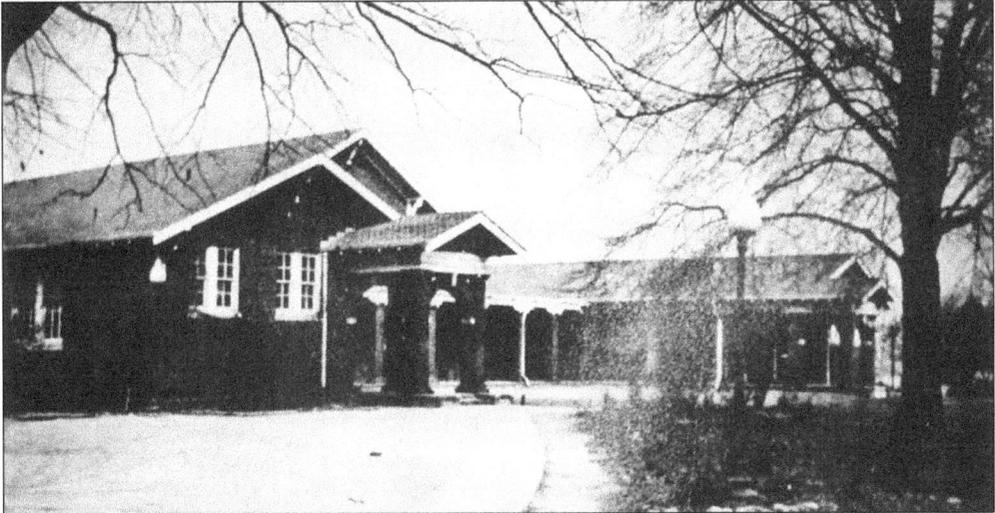

Kilby Hall was built in 1921 as a training school for the State Normal School. It was named in honor of Alabama Governor Thomas E. Kilby, who was governor when the legislature appropriated $30,000 to build the hall. The building has been added to and remodeled and is currently part of Kitty Stone Elementary School. (Courtesy of Jacksonville State University Collection.)

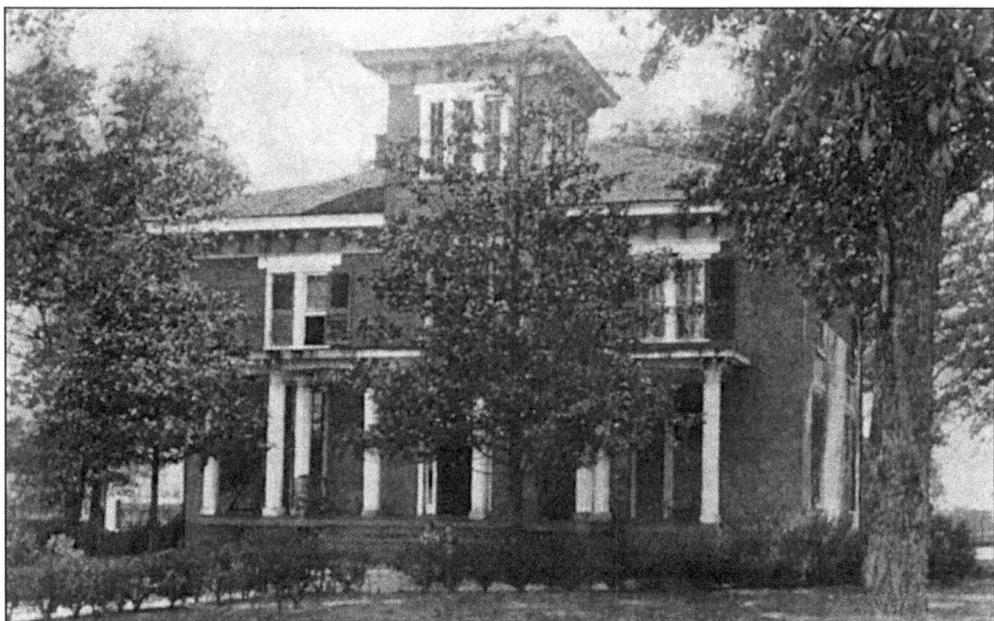

"The Magnolias" was built about 1850 by Judge Thomas Walker. In 1903, the home was purchased by Dr. Clarence Daugette, president of the Normal School from 1900 to 1942. He remodeled the home and it remained the home of the Daugette family. (Courtesy of Mrs. T.E. Kilby Jr.)

Forney Hall was built in 1927 for $75,000 without state-appropriated money. The men's dormitory had 76 rooms and several small apartments with private baths. A water tower was located behind the building. Shown in 1949, the building is decorated for students returning to school. It was located on College Street behind Kitty Stone Elementary School and presently is used for housing. (Courtesy of Jacksonville State University Collection.)

76

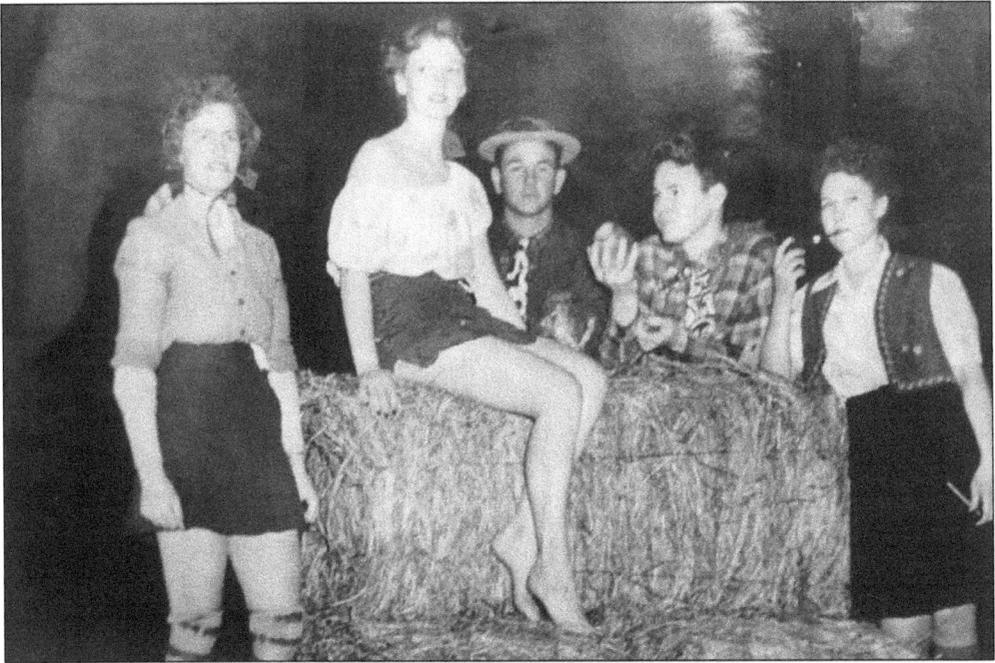

Dances were a large part of social interaction at Jacksonville State Teachers College in the 1930s and 1940s. The dances often had themes like the Sadie Hawkins Barn Dance. Party-goers were judged on who had the best costume. The winners of the barn dance costumes are shown here. (Courtesy of Jacksonville State University Collection.)

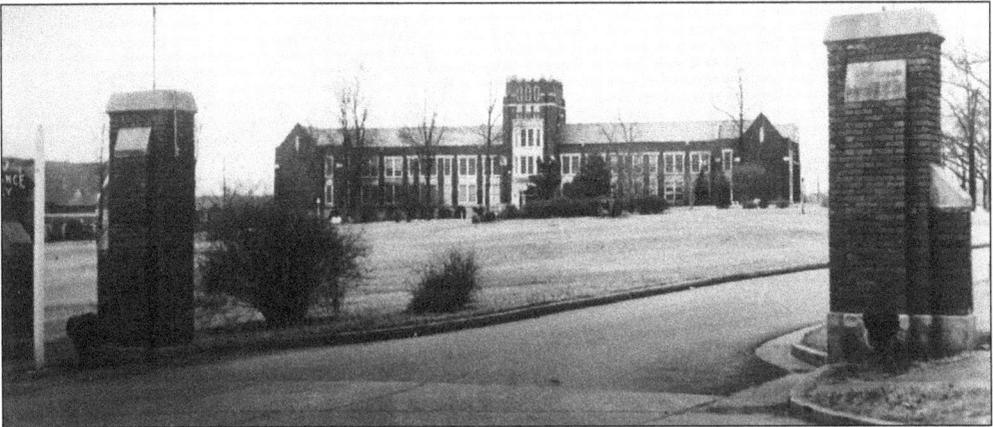

In 1929, Jacksonville State Teacher's College became a four-year institution that awarded bachelor's degrees. This change from a normal school to teachers college heralded the arrival of the quality points system. In the 1930s, the college moved to its present location. The school acquired General Joseph Burke's estate located on a hill a mile from the old campus on the square. In 1930, Bibb Graves Hall was built on the hill at a cost of $300,000. The building has served many purposes for the school. In the 1930s, the library was on the third floor over the entrance. Teachers did not have offices but were provided only a small desk with a built-in wooden cabinet in their classrooms. In the 1940s, "the Hub," the college bookstore and confectionery, was located on the first floor. Bibb Graves Hall currently serves as the main administration building with computer science classes taught on the third floor. (Courtesy of Jacksonville State University Collection.)

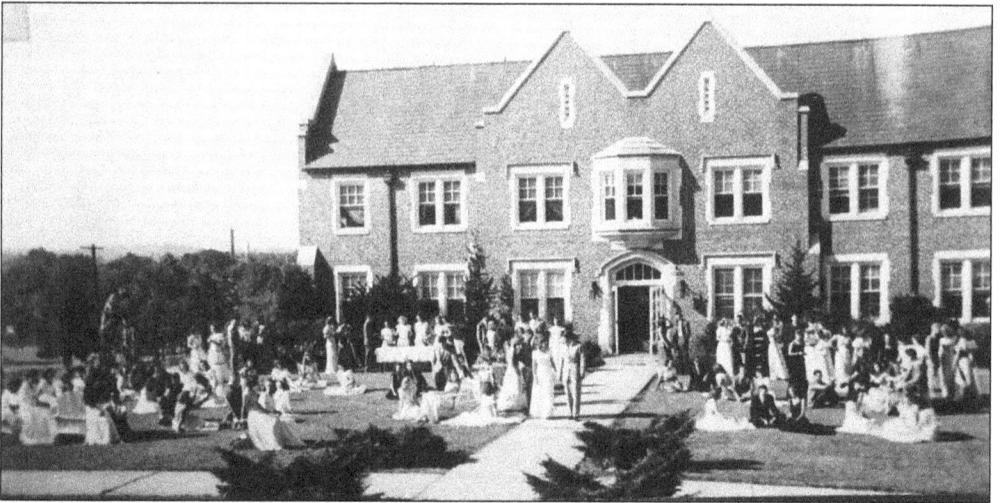

Abercrombie Hall, located on the quad behind Bibb Graves Hall, was constructed in 1939 as the first apartment dormitory. The female dormitory had suites that included two bedrooms, a kitchenette, and dining area. The building was fireproof and the cost for board was $7 a month. Two girls shared each suite. (Courtesy of Jacksonville State University Collection.)

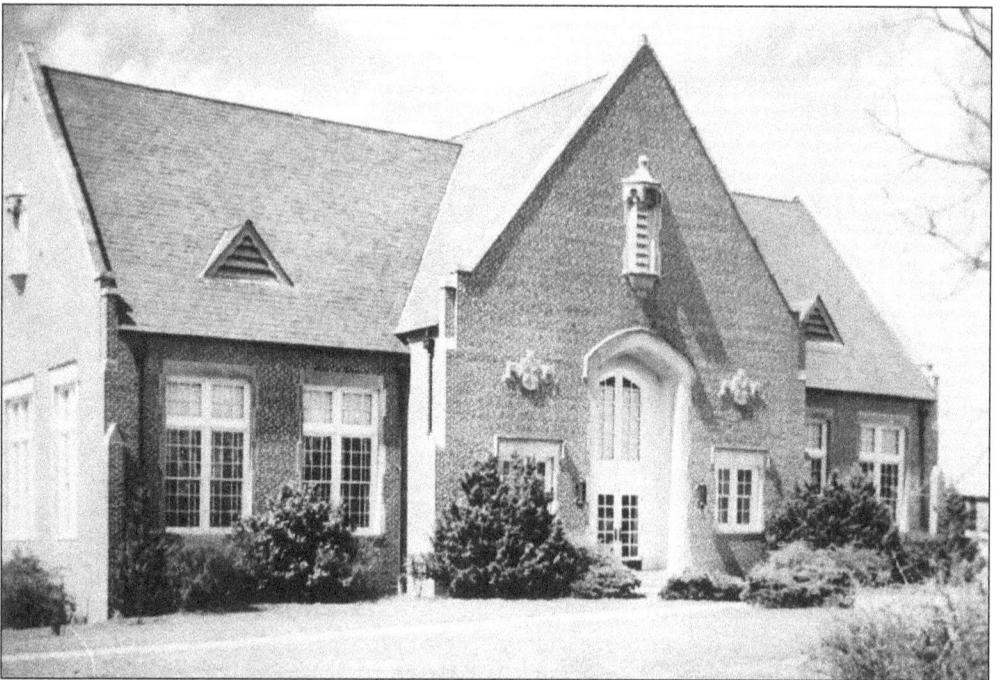

In 1939, Ramona Wood Library was built on the campus in cooperation with the Public Works Administration and housed 50,000 books. The library collection increased in the 1960s to include 400,000 bound volumes in addition to other library materials. The collection is currently housed in the 12-story Houston Cole Library on the east side of Highway 21. The Wood building was remodeled for use as the Education Building. (Courtesy of Jacksonville Sate University Collection.)

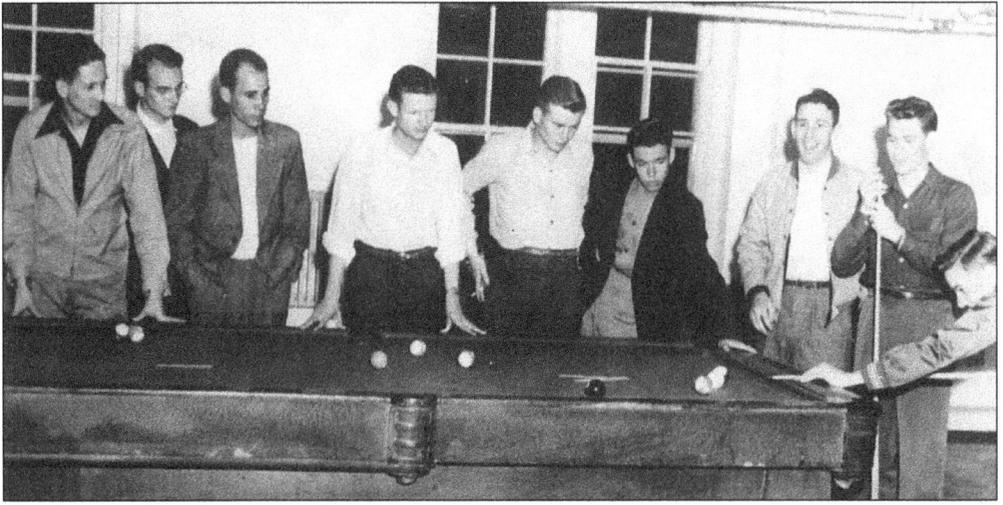

In the 1930s and 1940s, young college men found recreation in playing pool in their dormitory. The coeds retired to their dorm rooms to read the *Teacola*, the school newspaper. (Courtesy of Jacksonville State University Collection.)

In the 1930s, the football field had no bleachers. Spectators walked up and down the sidelines at the College Bowl to watch the games when the school was known as the State Teachers College Eagle Owls. After the Great Depression, bleachers were added to the stadium. Paul H. Snow, Class of 1932, was a generous member of the Alumni Association. When he died in 1957, a scholarship was established in his memory. In addition to the scholarship, the football field was named Paul Snow Stadium. In the 1950s, Jacksonville State University's football team became known as the Jacksonville State University Gamecocks. The football team was Division II National Champions in 1992. (Courtesy of Jacksonville State University Collection.)

Jacksonville State Teacher's College cheerleaders, shown in the 1940s, held a pep rally for the men's football team. During wartime the student body was overwhelmingly female, but men were on campus and participated in sports and cheerleading. Weekend football games provided entertainment for many in Calhoun County. (Courtesy of Jacksonville State University Collection.)

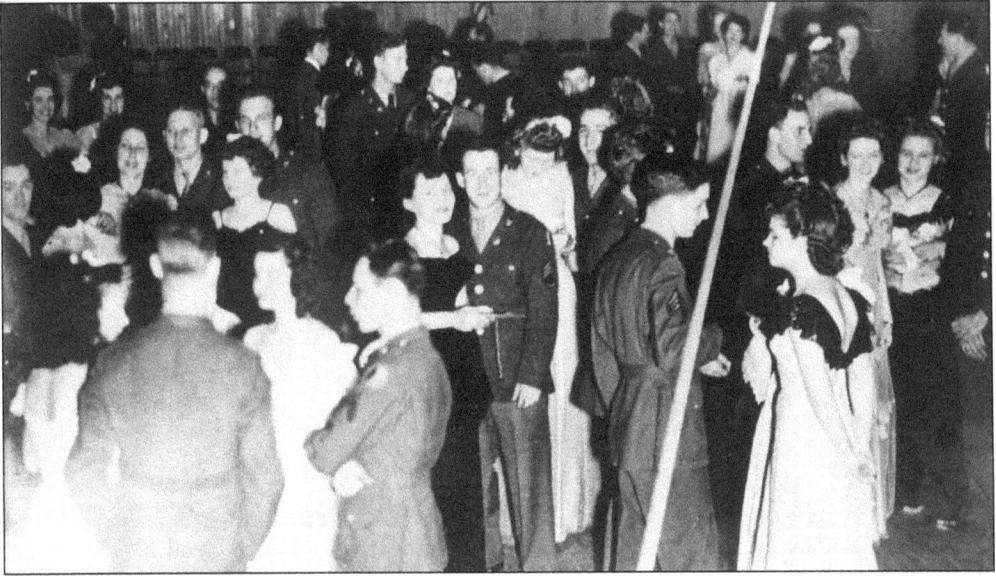

During World War II, students at the Teacher's College were predominantly female. USO dances were sponsored at the college. Young ladies found escorts with service men on leave or just down the road at Fort McClellan. Many of the young soldiers returned to the college on the G.I. Bill. Some of the young men had no interest in being teachers, so the school offered courses in engineering, law, medicine, dentistry, and other professional fields. These courses were transferable to other schools so that the young men could complete their degrees. (Courtesy of Jacksonville State University Collection.)

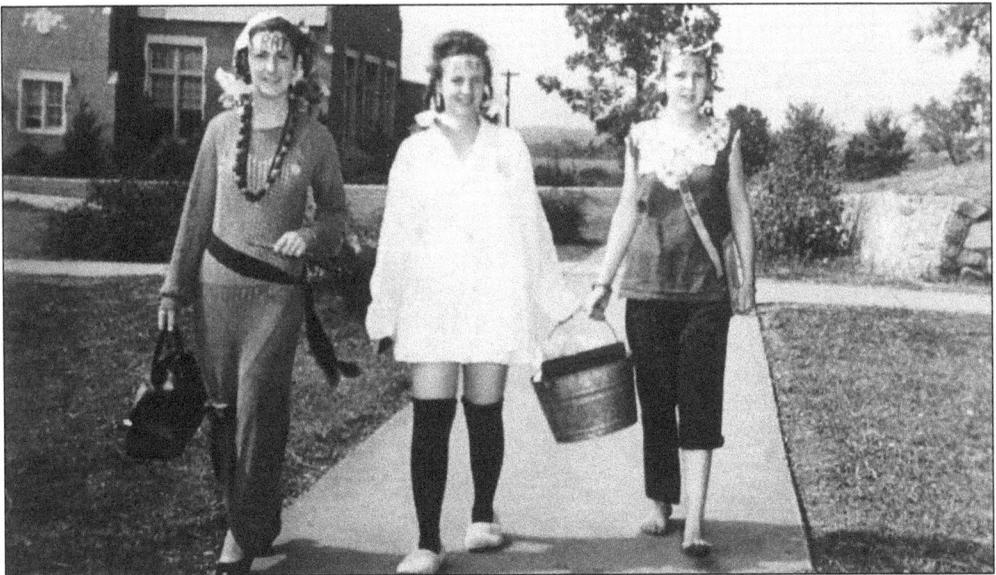

The Greek system was part of college life. Sorority pledges, shown in 1943, were called rats. They participated in hazing, no longer a legal activity, which included dressing in unusual outfits suggested by their "Big Sisters." Once the co-eds passed the tests put forth, they were accepted into the sorority. Jacksonville has a reputation for Greeks and non-Greeks having a history of peaceful coexistence on campus. (Courtesy of Jacksonville State University Collection.)

The Dramatics Club was organized in 1927 by English instructor Lance Hendrix. The school produced one play a year. A 1940s production of *H.M.S. Pinnafore* (above) was presented in the recreation center on the Jacksonville Square. Today, plays are presented on campus at a modern facility, the Ernest Stone Performing Arts Center. (Courtesy of Jacksonville State University Collection.)

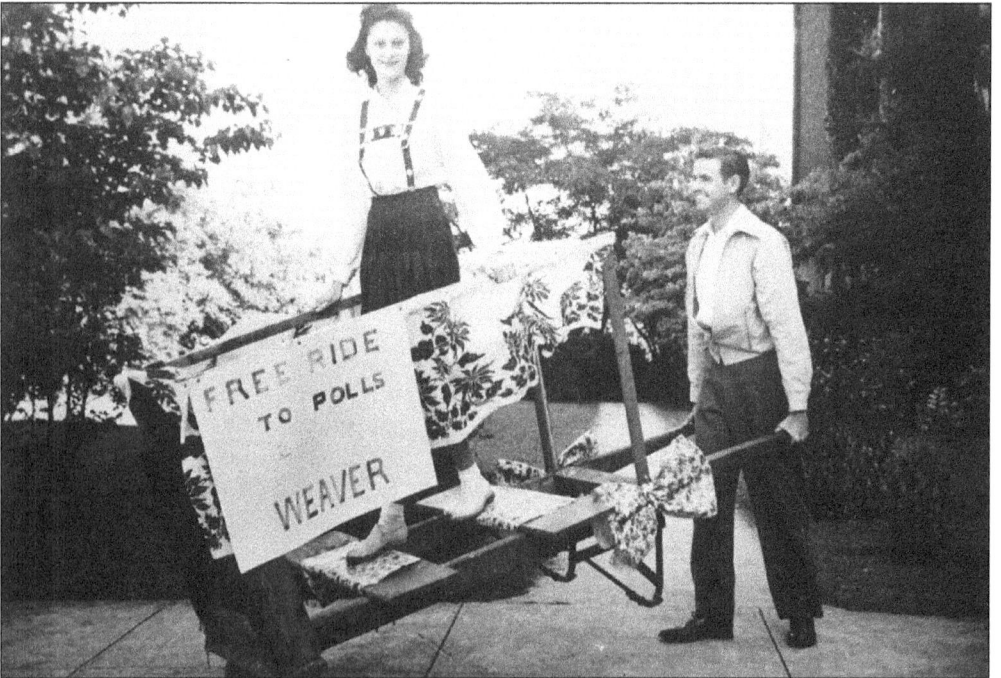

Politics was an important part of the social life on campus. Students actively campaigned for offices in the student government. In the 1940s, a candidate named Weaver was soliciting votes by promising a free ride on a makeshift wheelbarrow if the rider voted for him. (Courtesy of Jacksonville State University Collection.)

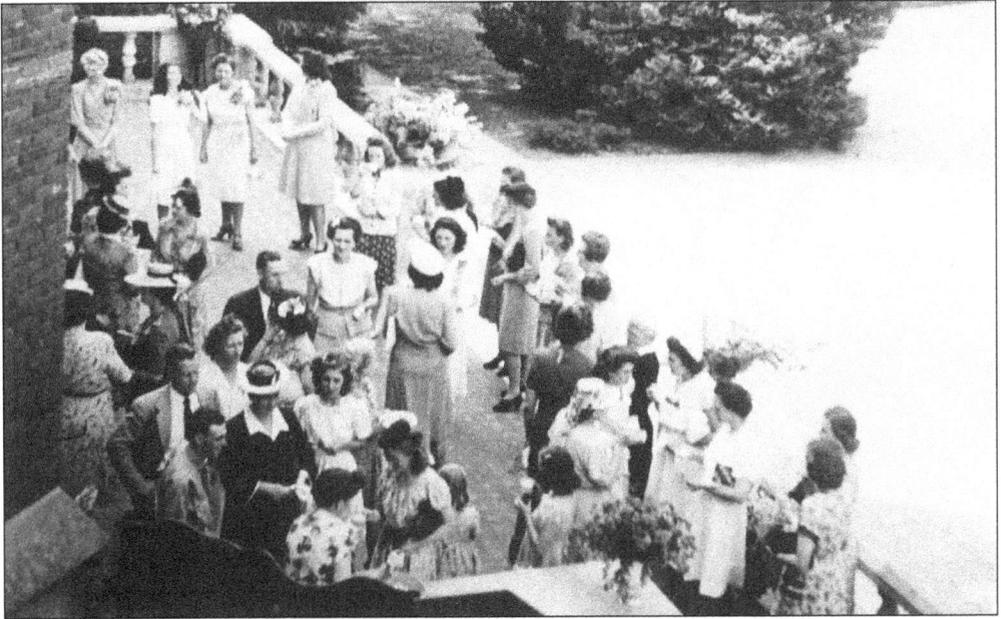

In the 1940s, social graces were emphasized to the young ladies at the teacher's college. "Tea Time Chats" were held in the lounge and on the porch of Bibb Graves Hall. At these teas, the wife of the university president and faculty members talked informally with the girls. The teas were held between four and five in the afternoons. (Courtesy of Jacksonville State University Collection.)

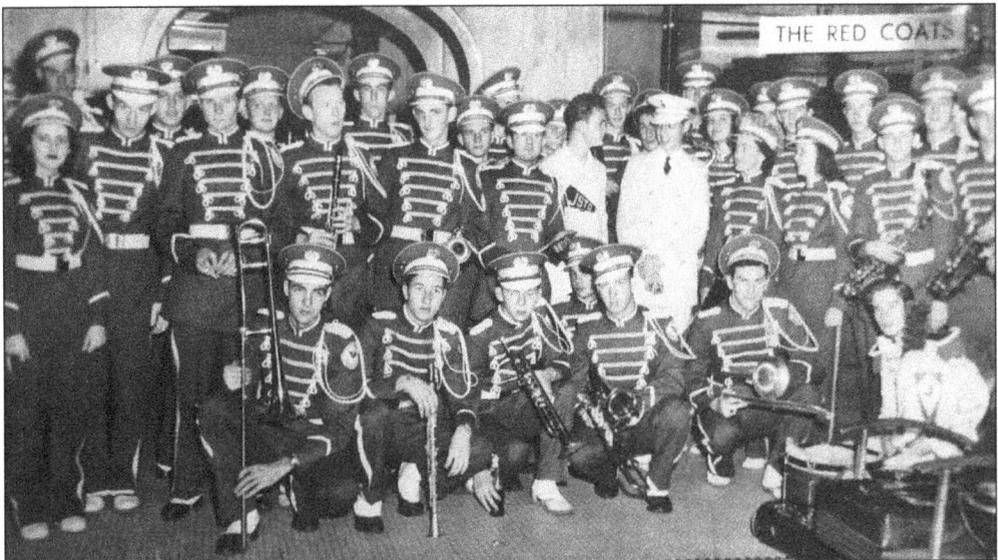

Music classes were a part of the school from the beginning. The marching band, the Red Coats, were part of the pep rallies and football games. The band, shown c. 1949, changed through the years and became known as the Marching Southerners. The entire band performed at half-time shows of the football games. A dance troupe became part of the band in the 1950s. (Courtesy of Jacksonville State University Collection.)

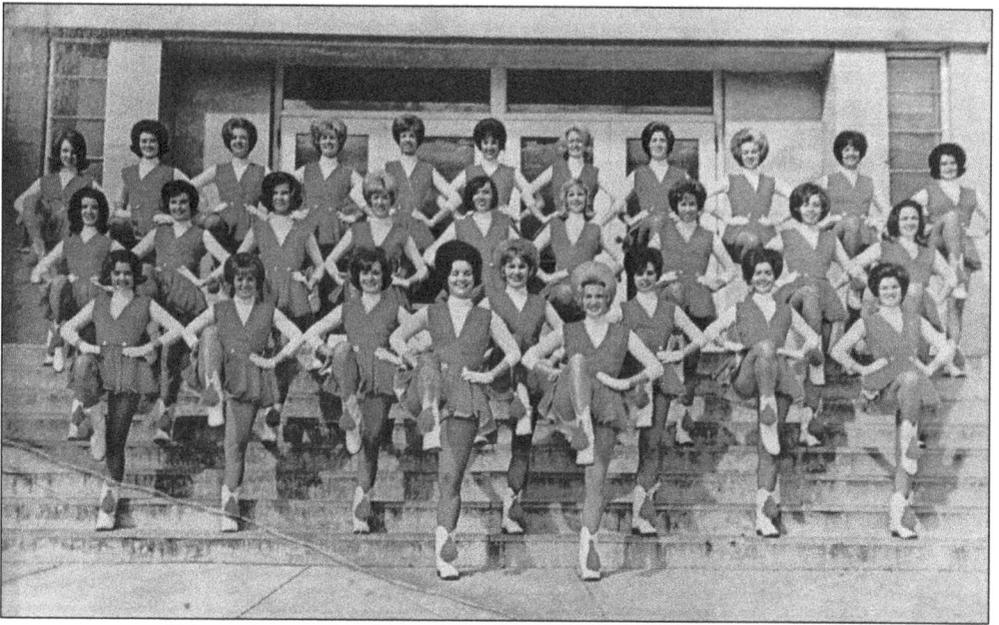

The Marching Ballerinas were added to the band in the 1950s. This precision dance team, shown in the 1960s, was choreographed for many years by Zenobia King Hill. A few of these young women went on to teach dancing classes to young girls in their hometowns. The Ballerinas costumes have changed along with the choreography, but they remain a part of Jacksonville State University. (Courtesy of Roy Young.)

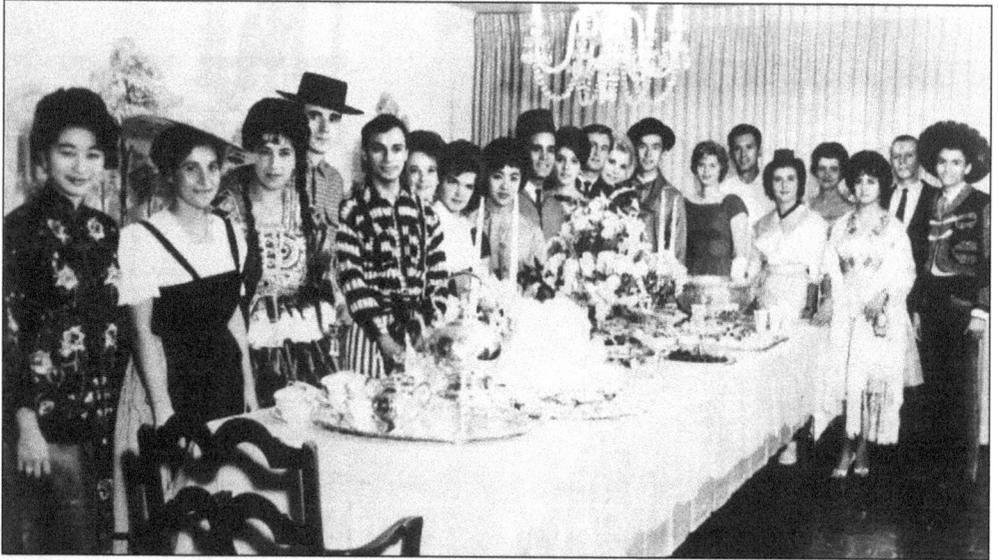

The International Program started in 1946 in a classroom in Bibb Graves Hall. In 1947, the program was moved to a small house and then a year later to a house on the site of Sparkman Hall. The program then moved to the International House located on North Pelham Road at the intersection of Highway 204. The foreign exchange students at the college were provided 20 dorm rooms, 3 dining rooms, and guest rooms. The students dressed in traditional costumes, shown in 1962, and prepared meals from their home countries to serve. (Courtesy of Jacksonville State University Collection.)

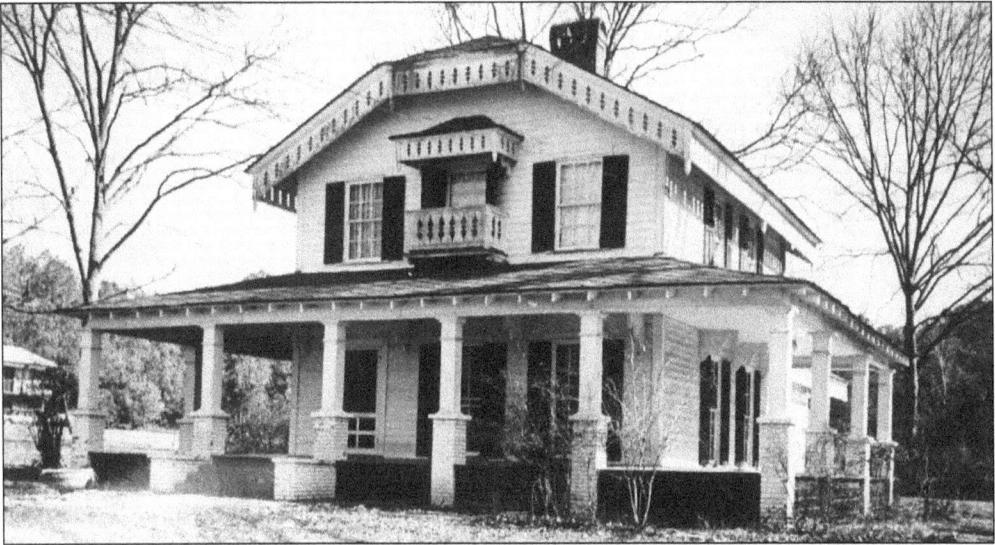

The Alumni house, located on North Pelham Road, was originally built as a Swiss Chateau, with the porch added later. The antebellum home was the residence of Dr. and Mrs. William Bellamy after the Civil War. The Bellamys conducted the Brookside School, a predominantly female academy, in the house at the rear. In the early 1900s, Dr. John Rowan purchased the home. He served as the college and Profile Mill physician for 30 years. In 1909 the house was sold to Alfred Roebuck. In 1981, the university purchased the property and uses it for the headquarters of the Alumni Association. (Courtesy of Jacksonville State University Collection.)

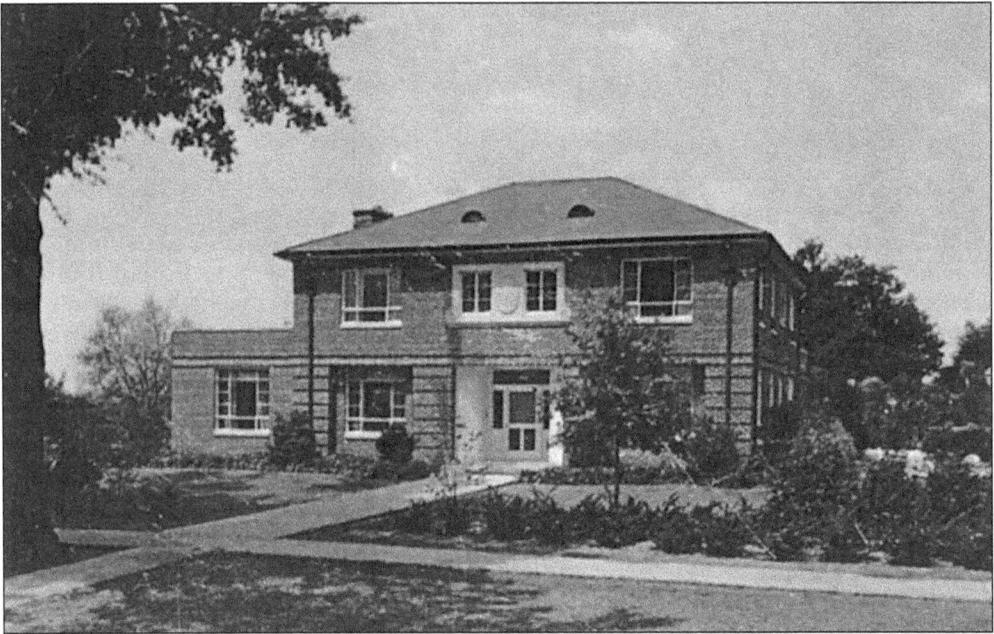

The President's Home was built near the driveway entrance on University Circle in 1949. The structure cost $40,000 to build. Houston Cole was the first president of the college to occupy the home. A portico and driveway were added sometime later. (Courtesy of Jacksonville City Library.)

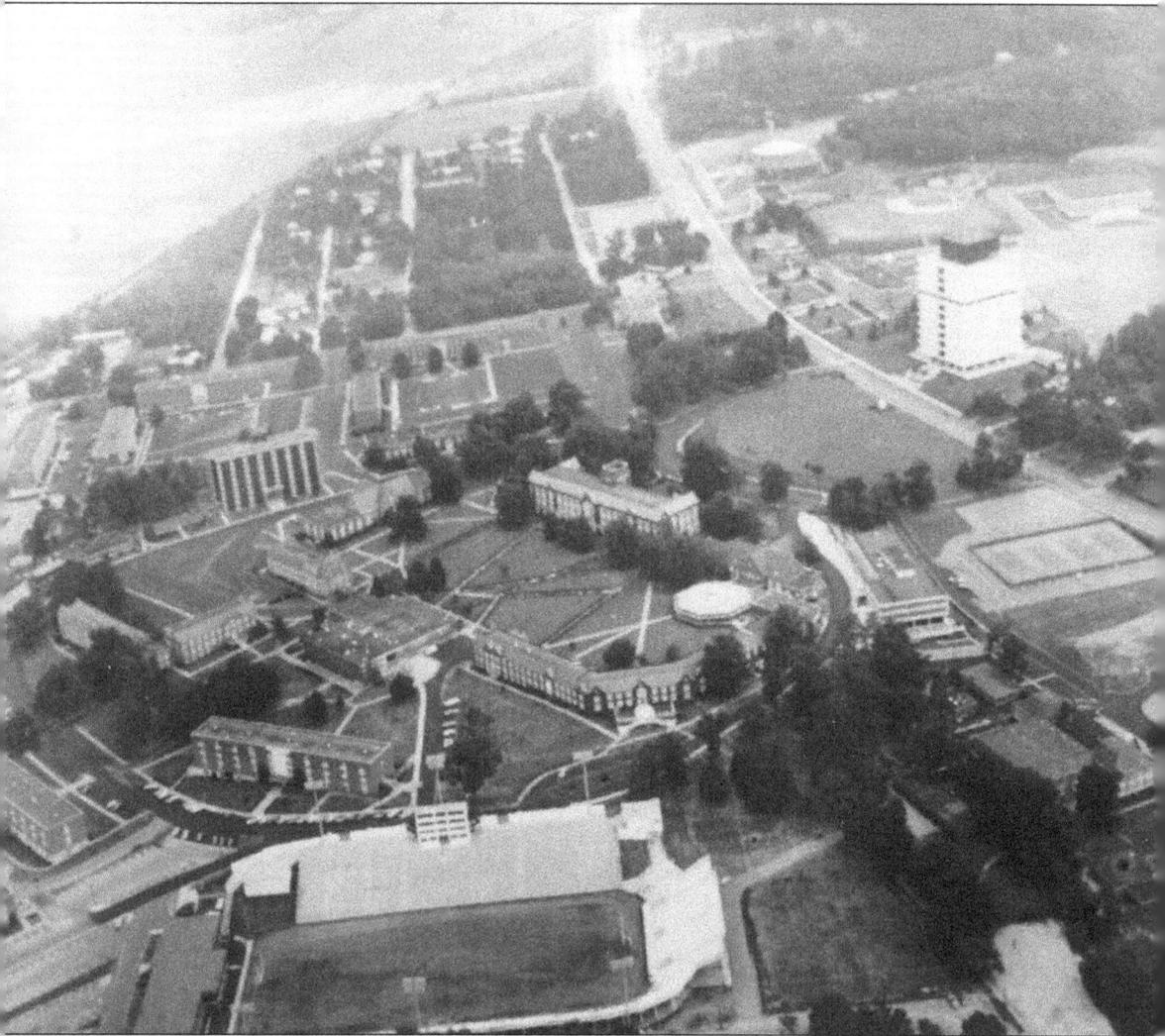

Jacksonville State University has grown from its humble beginnings as a normal school. The sprawling 318-acre campus is bisected by Highway 21. JSU grants both bachelor's and master's degrees and has a student body of approximately 9,000. (Courtesy of Jacksonville State University Collection.)

Five

Piedmont

Piedmont is located in the northernmost part of Calhoun County. Settlers, many from Cherokee County, came here in the 1830s. By 1832, they had established a justice of peace and constables to protect them from Native Americans living in the area. In that same year New Hopewell Baptist Church was founded on Tarpin (Terrapin) Creek, on the edge of a plain where two stagecoach routes crossed. By 1837, the post office was located in the home of Postmaster William Acker. In February 1842, settlers referred to the area, by now a small but growing village of three families, as Griffin's Creek. Teachers arrived in the early 1840s to educate the children and more churches were founded. In September 1851, the name of the small town was changed to Cross Plains.

Like the rest of the towns in Calhoun County, Cross Plains supplied young men for the Confederate forces during the Civil War; like most towns in the South, Reconstruction proved to be a difficult transition for Cross Plains. The Selma, Rome, Dalton Railroad resumed pre–Civil War building and completed tracks to Cross Plains in 1868. The railroad selected Patona, southwest of Cross Plains, as the site of their headquarters and general offices, as well as machine shops and car manufacturing works. The railroad built 100 homes, churches, and schools in the area for both black and white laborers.

In 1869, William Luke was sent from Canada by the American Missionary Society to join the staff of Talladega College. The Selma, Rome, Dalton Railroad needed a teacher for the children of black laborers at Patona, and Luke was suggested for the position. This upset the town of Cross Plains so much that Luke's life, as well as that of the general superintendent of the railroad, was threatened. As a result, in 1870 a large group of blacks attacked the "unoffending" white men and women. The appointed constable arrested four blacks and charged them with firing into a crowd. He also arrested Luke and charged him with inciting the blacks to commit the act. All five men were held by guards. During the night of July 11, 1870, men of the town, who were disguised, came armed with pistols and shotguns and demanded the release of the prisoners to them. Luke and two of the black men were found hanged, and the other two black men were shot to death. Because of this incident, a shadow was cast over Cross Plains. It hurt the business and industry of the town, so in 1888 the town changed its name to Piedmont to help erase the stigma of what had taken place.

After the name change, Piedmont witnessed a boom time. By 1912, Piedmont had several hotels, the Frances E. Willard School, an insurance agent, two dentists, an undertaker, a black smith, a general store, a livery stable, and a cotton mill, among numerous other businesses. The town also had two railroad depots, belonging to the Selma, Rome, Dalton and the Seaboard Railroads. Piedmont, despite its growth, remained a small town throughout the 20th century. In the 1990s Piedmont has grown, though not in the downtown area. Like many old downtown areas, Piedmont's downtown has been left while other areas—particularly around the Highway 278 and Highway 9 interchange—have been developed.

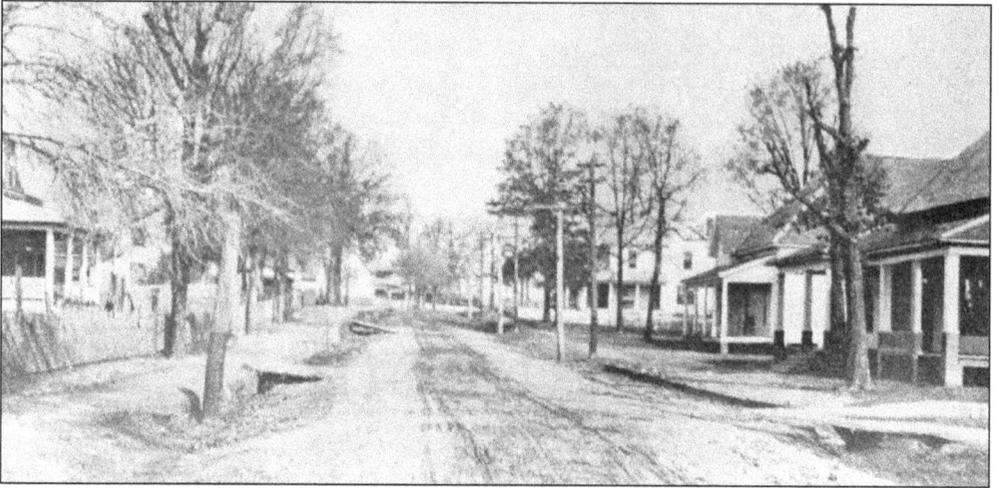

Center Avenue ran north and south through downtown Piedmont. In the late 1800s, J.P. Woolf erected his two-story wooden frame business on the west side of Centre Avenue. Eventually, Woolf moved the building to the back of the lot and used it for a warehouse. He then built a three-story building. His general store served the farm families in the community by supplying fertilizer and other items needed for crops. Located behind the store was a wagon yard and cotton gin. Also on the west side of Center Avenue was E.J. Webb Drug store, located just north of the Seaboard depot. (Courtesy of Gerald Whitton.)

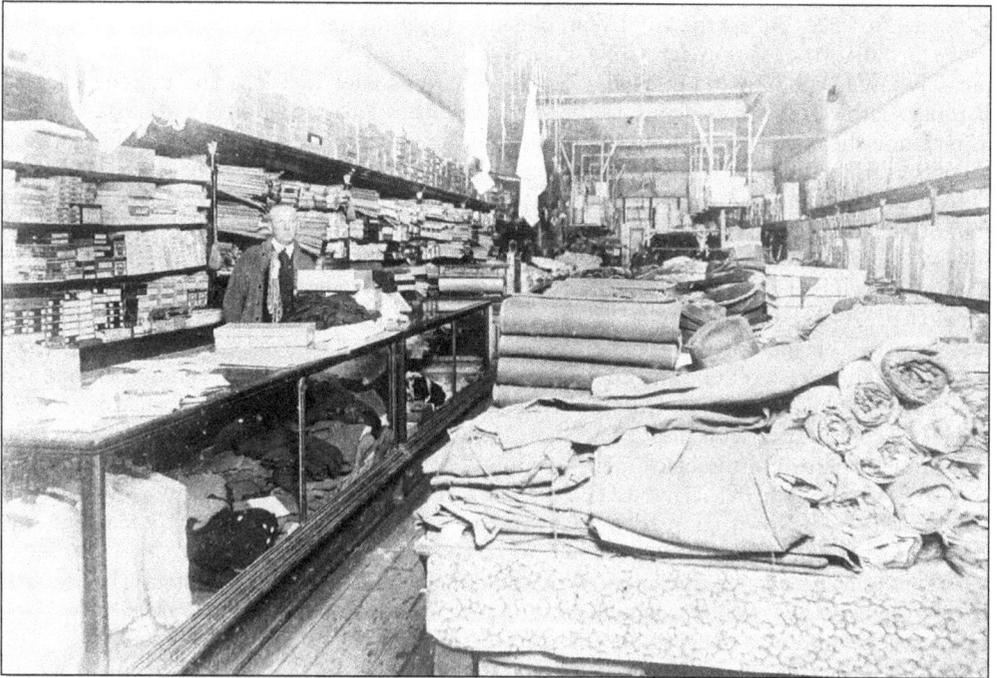

Wilson's General Store, shown in the 1920s, was located in downtown Piedmont. The store offered a variety of merchandise to the customers. In the 1920s, most women still made their families' clothes by hand so cloth was a popular item. The small general store of the "early days" was the forerunner of the modern department store. (Courtesy of Gerald Whitton.)

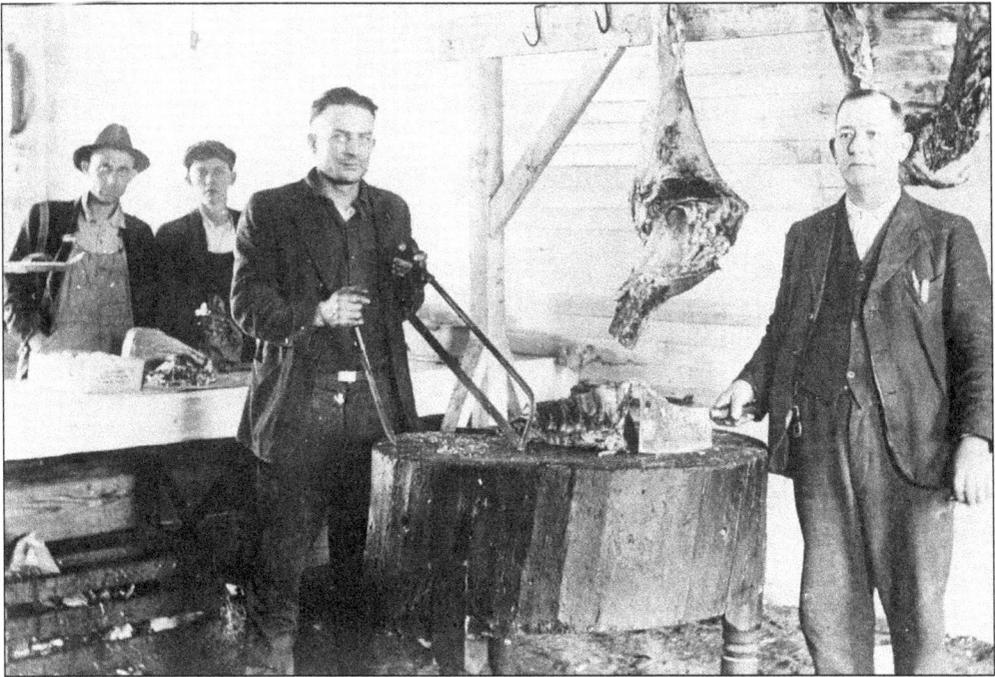

Kinds Meat Market, shown in 1921, was in downtown Piedmont. Mr. Kinds (on the left) was a skilled meat cutter. A butcher provided an important service to the community. The way the meat was prepared affected the taste; therefore a good butcher could make a handsome profit. Once chain grocery stores became popular in the 1940s and 1950s, butcher shops could not longer compete and many closed their doors. (Courtesy of Gerald Whitton.)

Ladiga Street ran east and west through downtown Piedmont. This view looking east shows the two-story frame house (right) that belonged to the Cowan family and was later torn down. The post office was erected on the site. The cottage next to the Cowan house was reportedly the first post office in Piedmont. It was torn down in 1973. This photo was taken prior to 1915. (Courtesy of Gerald Whitton.)

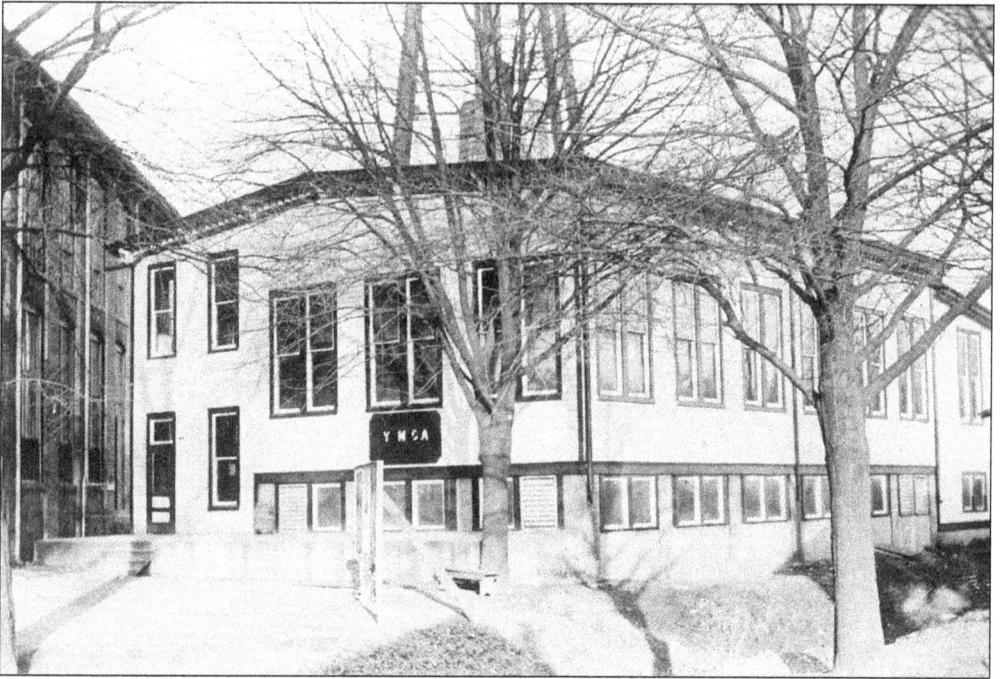

The Young Men's Christian Association was founded in 1844 by George Williams in London, England. In 1851, the first American YMCA was built in Boston, Massachusetts. The program emphasized the high standards of Christian character through group activities and citizenship training. The YMCA provided physical, educational, social, and religious services. The Piedmont YMCA, shown here, was built in 1922 and located on Barlow Street. (Courtesy of Gerald Whitton.)

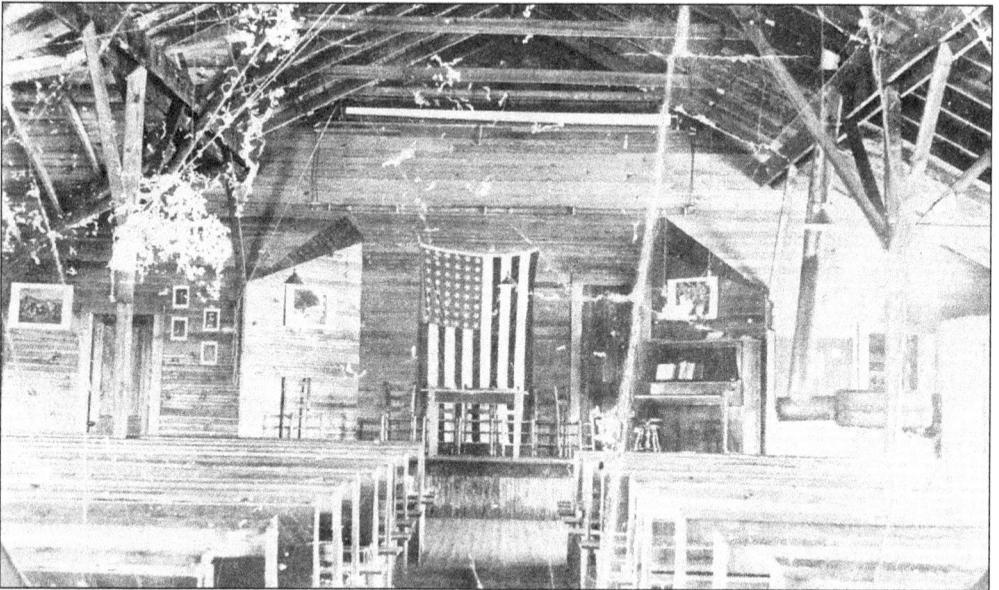

The Piedmont YMCA included a swimming pool and movie theater. In the winter months a wooden floor was placed over the swimming pool so the area could be used for indoor activities. (Courtesy of Gerald Whitton.)

Christ Episcopal Church was built in the fall of 1883 as a mission of St. Luke's Episcopal Church in Jacksonville. The church's floors, doors, and furnishings were made of heart pine. The construction cost for the 125-seat church was $1,400. Reverend James Smith served as the first rector. The congregation remained small, and by 1933 the church held its last service. The building sat vacant until December 1977, when it was moved to Albertville and once again used as an Episcopal church. (Courtesy of Gerald Whitton.)

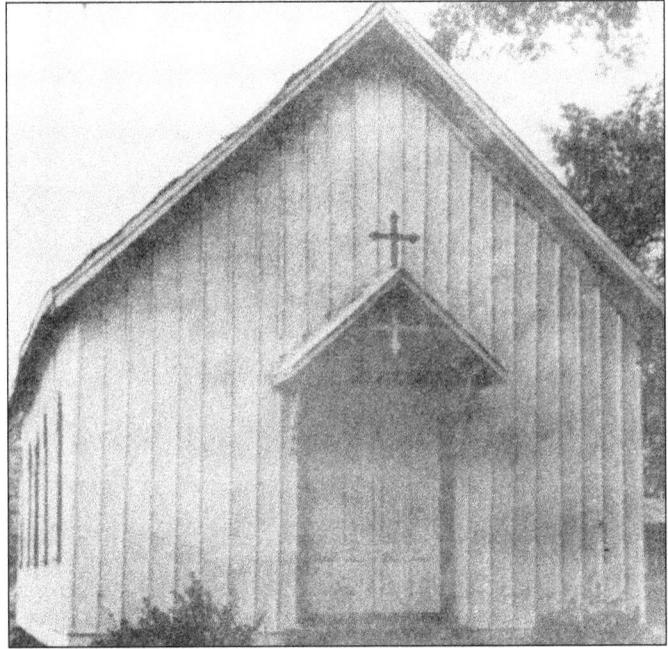

The Methodist church, south, was organized in 1867 and its congregation worshiped in the old school on Center Avenue. The original First Methodist Church of Cross Plains was built in 1868, and Reverend M.T. Moody was the pastor. This structure was demolished to build the above facility in 1898. The sanctuary for the First Methodist Church was located on North Church Street. (Courtesy of Gerald Whitton.)

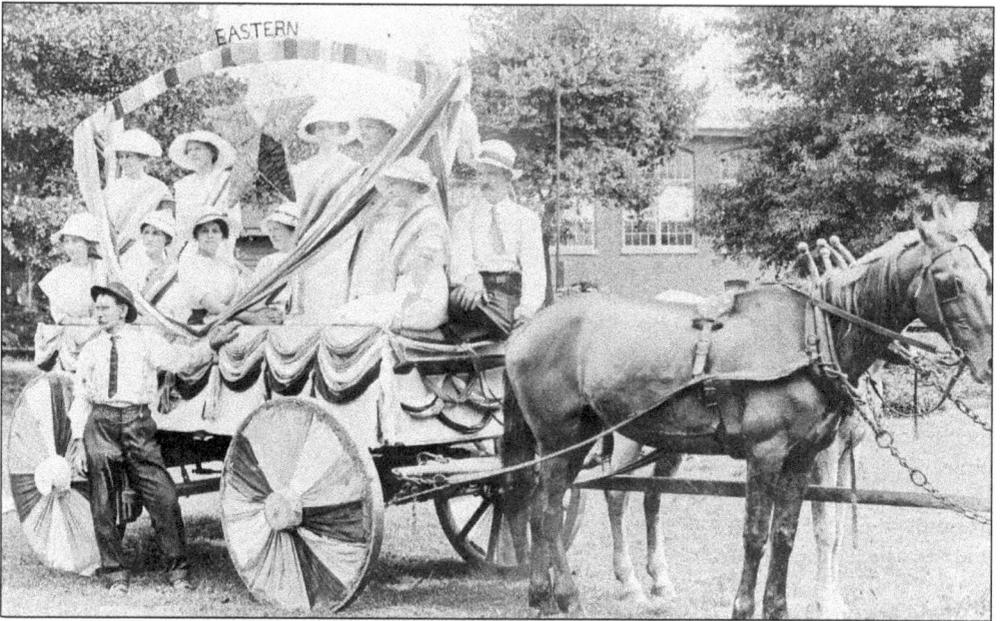

In 1849, the Masons organized the Lozahatchee Lodge No. 97 in Piedmont. The third floor of the Woolf building on Center Avenue was the site of the Masonic Hall. The ladies auxiliary was the Order of the Eastern Star. Because of the patriotic nature of Southerners, the Fourth of July was celebrated in grand style. The Piedmont Order of the Eastern Star's float participated in a Fourth of July parade in 1915. (Courtesy of Gerald Whitton.)

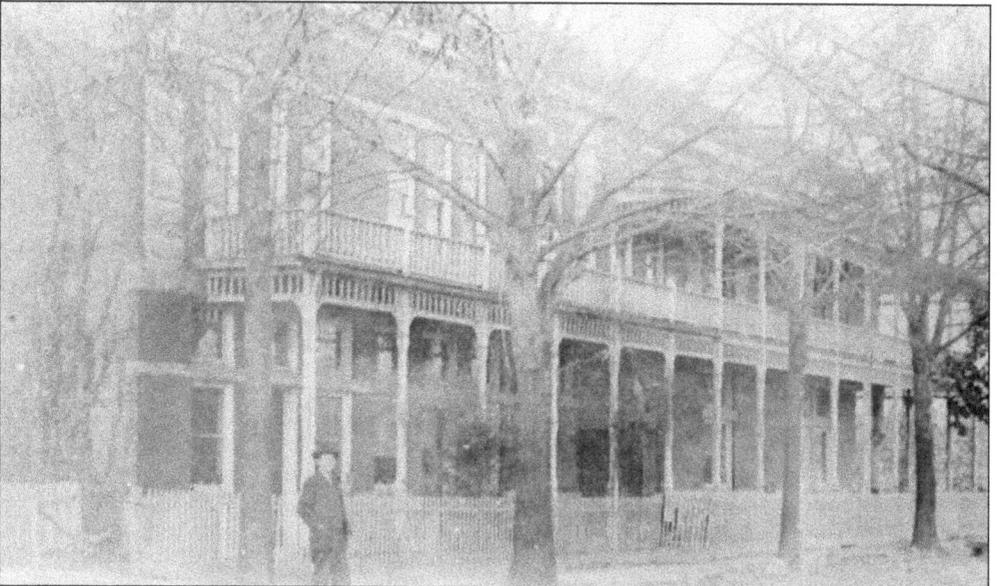

This building was the First National Bank of Piedmont. It later became the Allgood Building and was sold to the City as a school. Dr. J.P. Allgood, in the foreground, was a surgeon dentist who came to Cross Plains in the 1880s to practice, and he remained until 1936. His office was located near the Seaboard Railway depot. Dr. Allgood charged $2 to $3 for gold fillings, and extracting a tooth in his office cost 50¢, while outside the office it was $1. The doctor's ad said, "All work guaranteed to your satisfaction." (Courtesy of Gerald Whitton.)

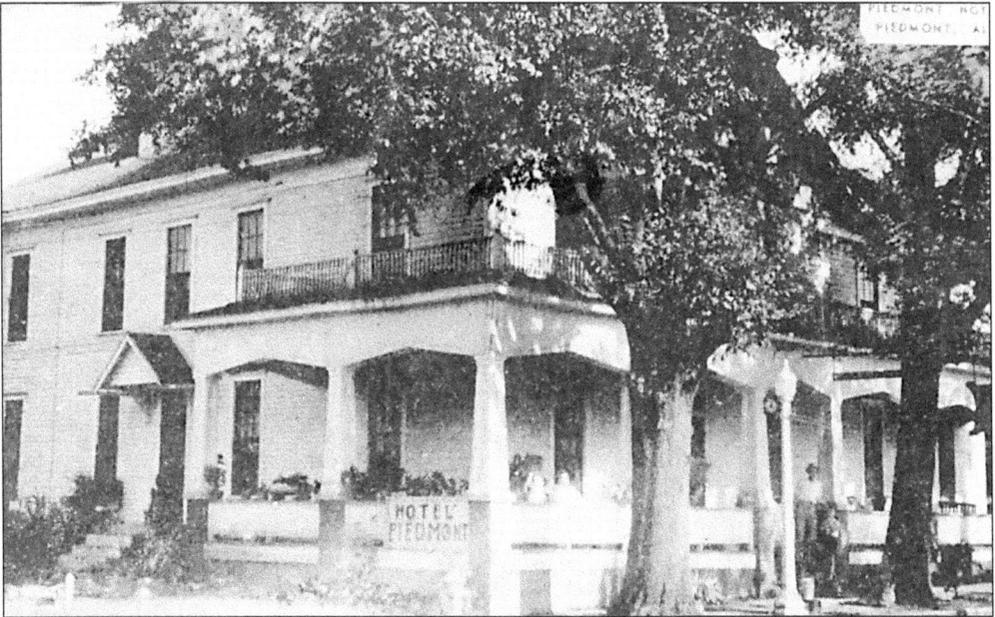

The Piedmont Hotel was built by F.M. Formby around 1868, when the town was still known as Cross Plains. The hotel was three stories and built of virgin pine and iron square nails. It was originally known as the Albert House, and just before its demise in 1983 it was known as the H & H Rooming House. The hotel was located at the corner of Front Street and Centre Avenue, across from the old Southern Railway depot. Some of the first residents in the hotel were families, schoolteachers, train passengers, and "drummers," also known as traveling salesmen. (Courtesy of Gerald Whitton.)

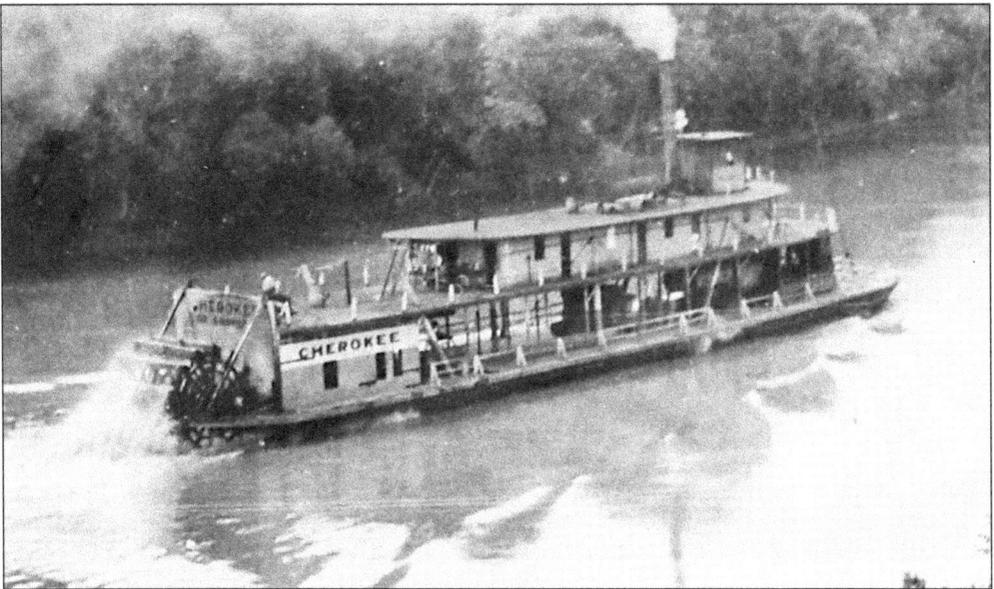

Water travel was one of the most efficient means of travel until cars and dependable roads were built in the 1910s. The steamer *Cherokee* sailed the Coosa River, which borders Calhoun County on the west. In 1917, the boat ferried passengers and cotton to Rome, Georgia. (Courtesy of Gerald Whitton.)

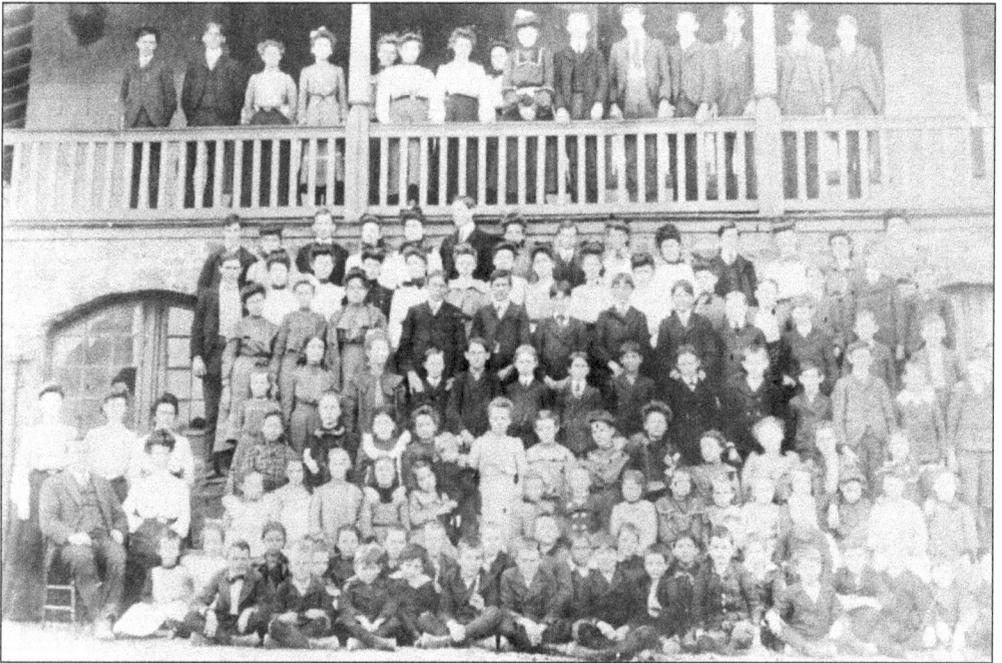

In 1880, Major Samuel Belding built a magnificent hotel on 4 acres of land northwest of the center of the town. The "Boom Time Hotel" had a basement constructed of stone, and the four floors were wood frame with shingle siding. When the land boom was over, the hotel closed its doors and the building sat vacant. Mrs. Margaret A. Barber of Philadelphia, who funded the Barber Seminary in Anniston, bought this building and donated the land and building to the city for a school. She gave the donation on the condition that the school be named for Frances E. Willard, the president of the Women's Christian Temperance Union from 1879 to 1898. The faculty and students of the school are shown here in 1906. (Courtesy of Gerald Whitton.)

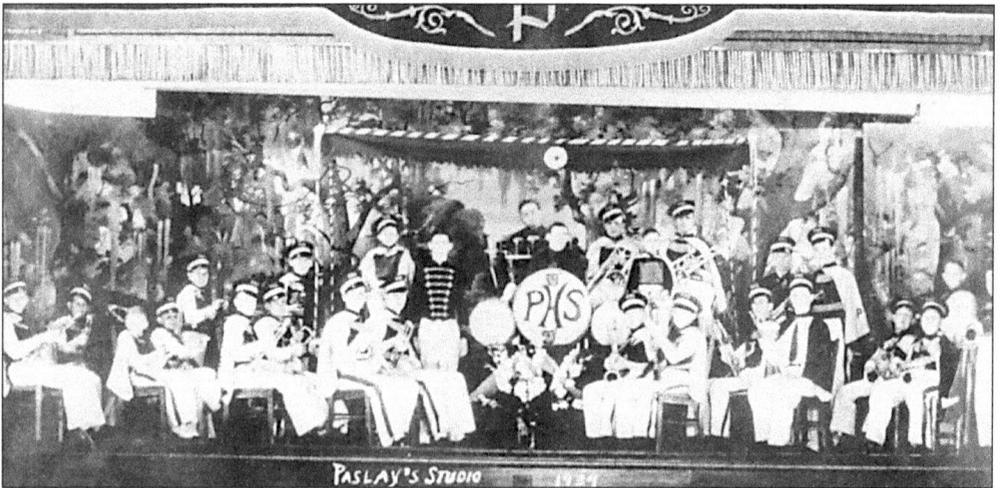

In 1900, the Alabama State Legislature created the Piedmont School System. The Piedmont High School was built in 1930 at a cost of $65,000. It contained 9 classrooms and a faculty of 11 to teach 304 students. The high school also had a gymnasium, a home economics department, a library, and an auditorium. The stage of the auditorium had a painted mural on the walls. (Courtesy of Gerald Whitton.)

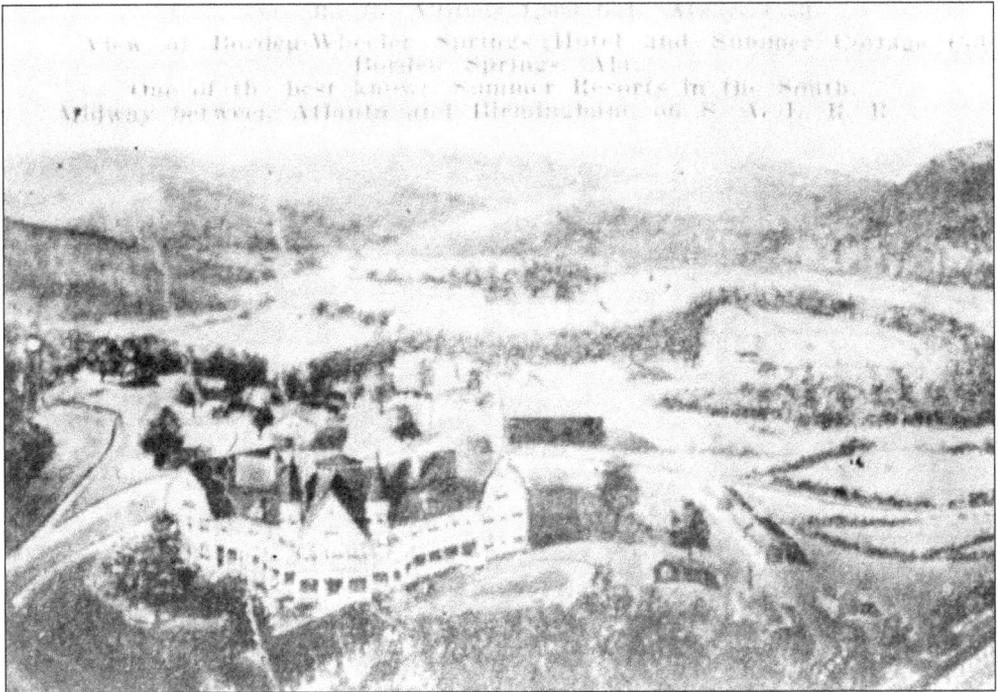

Borden Springs, east of Piedmont, was part of Calhoun County until 1866. In the 1890s the Borden-Wheeler Company built a hotel at the springs, which were discovered by John Borden. The hotel had 125 rooms, 9 concert pianos, running hot and cold water, electricity, a large outdoor swimming pool, a dance pavilion, and a golf course. Numerous chefs prepared the guests' meals. The hotel burned in 1935. (Courtesy of Gerald Whitton.)

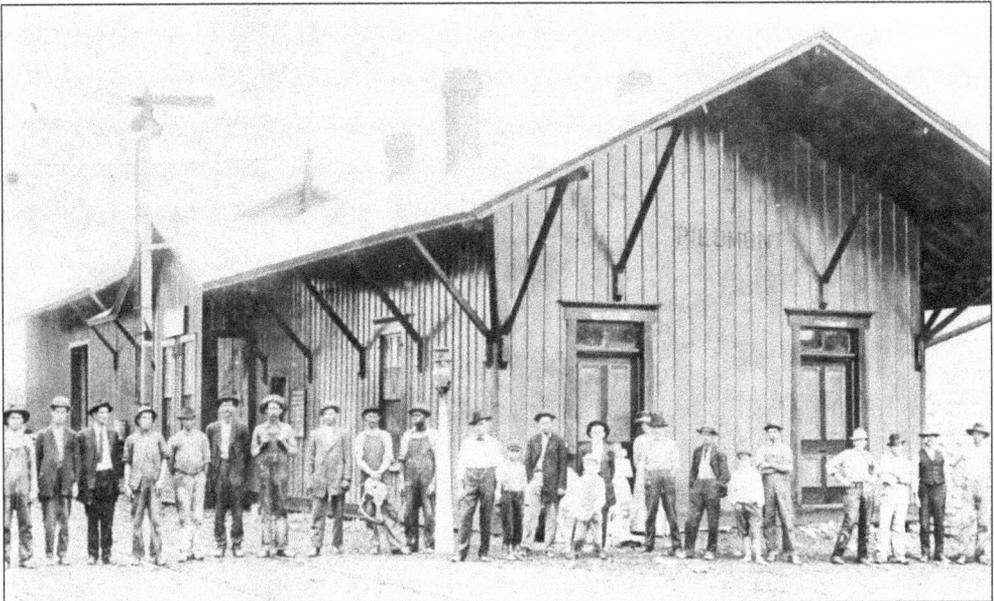

The Seaboard Railway Depot was built in 1885. Originally, the tracks to this line ran from east to west Alabama. Eventually the track run was changed and the railroad ran from Cartersville, Georgia, to Pell City, Alabama. (Courtesy of Gerald Whitton.)

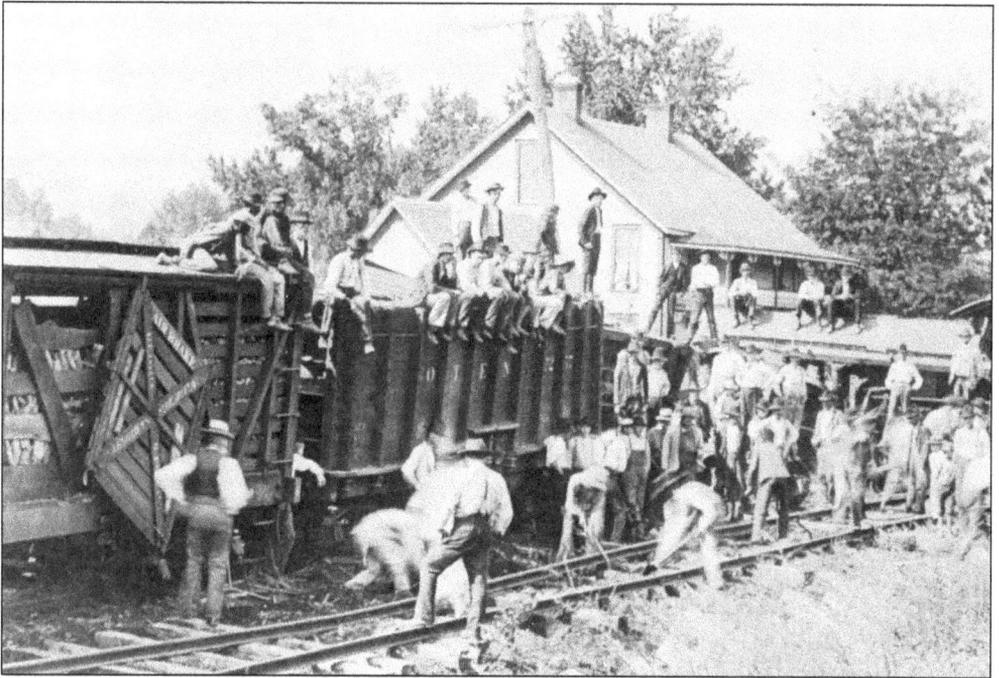

The derailment of the Southern Railroad in 1905 provided "entertainment" for the citizens of Piedmont. The derailment was at the intersection of North Church Street. The brakeman, who was from Anniston, was the sole casualty. (Courtesy of Gerald Whitton.)

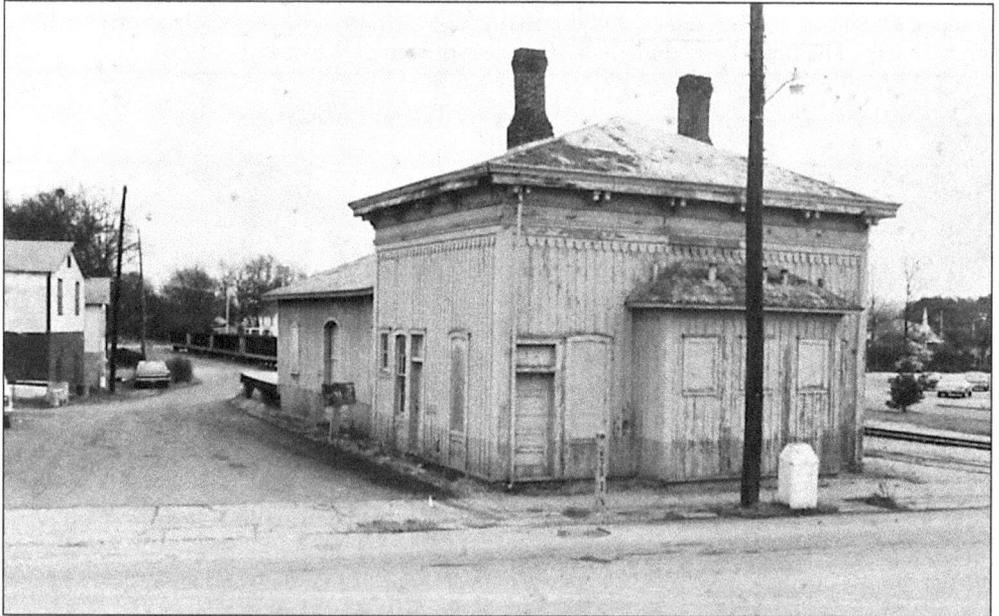

The Selma, Rome, Dalton Railway came to Piedmont in 1868 and sold tickets out of a local store. The depot was built on Centre Avenue across from the Piedmont Hotel. In 1884 the Southern Depot was wired for electricity and contained four water closets (rest rooms) and two waiting rooms (which were segregated). The office closed in the mid-1960s. It currently houses a museum. (Courtesy of Gerald Whitton.)

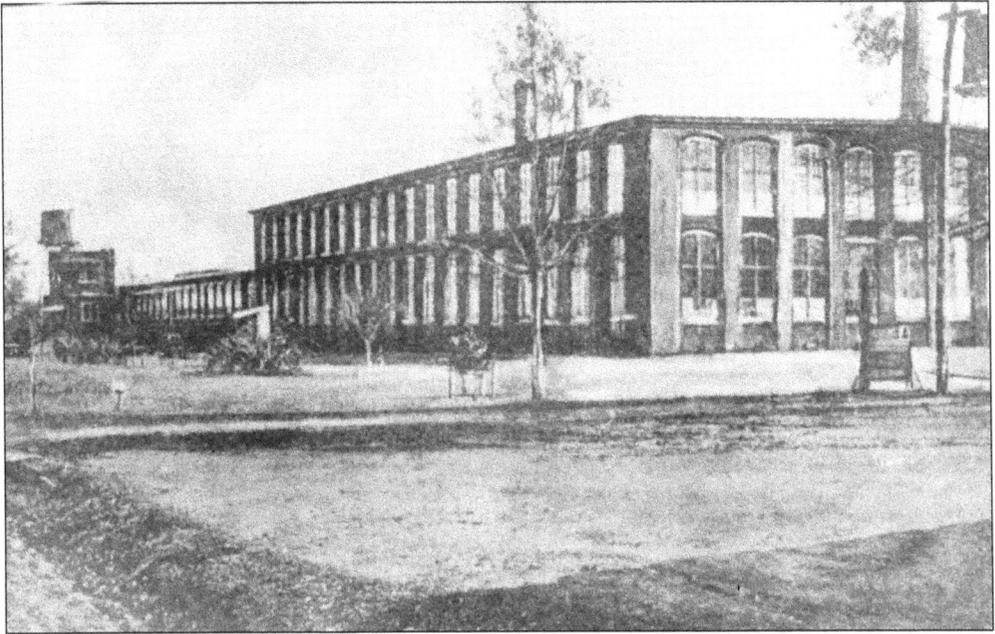

In 1891, the Coosa Manufacturing Company was founded by Albert G. Thatcher and Jacob Barlow. The mill was designed for spinning cotton and started with 500 spindles. In the fall of 1896, Coosa was consolidated with Barlow and Thatcher Spinning Company. In 1902, Mill No. 2 was built for making combed yarns. By 1919, No. 4 Mill was built, and by 1951, the mill had a capacity of 143,000 spindles. (Courtesy of Gerald Whitton.)

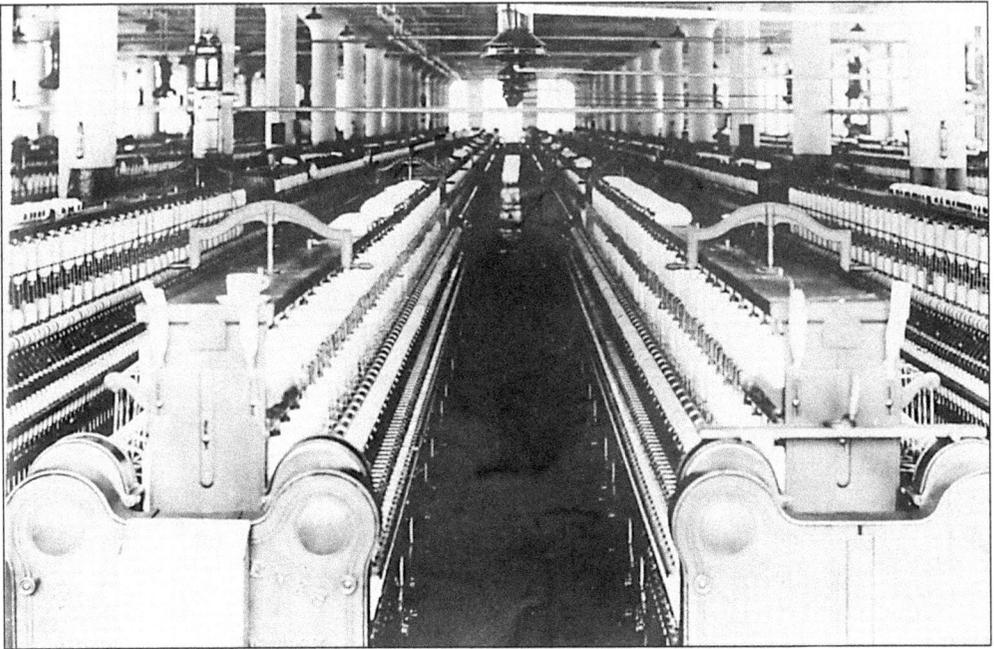

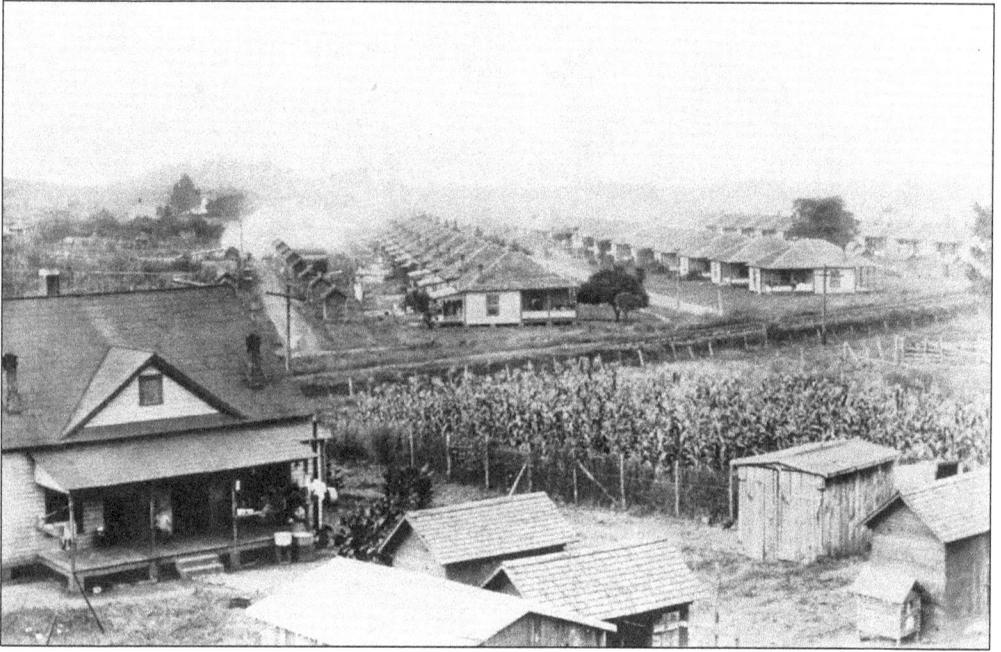

The Standard-Coosa Thatcher Company mill village was founded in 1892. The houses were built identically with each house having four rooms. In addition to the homes, the mill built a YMCA with an indoor swimming pool. The mill YMCA ran a full-time schedule. The mill also had its own grade school and hospital. (Courtesy of Gerald Whitton.)

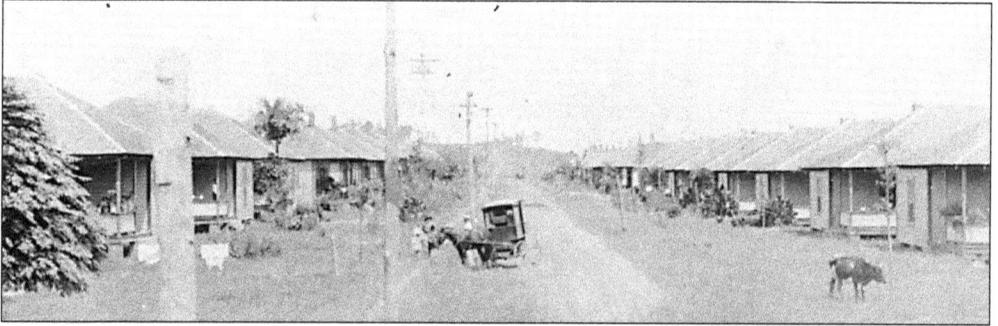

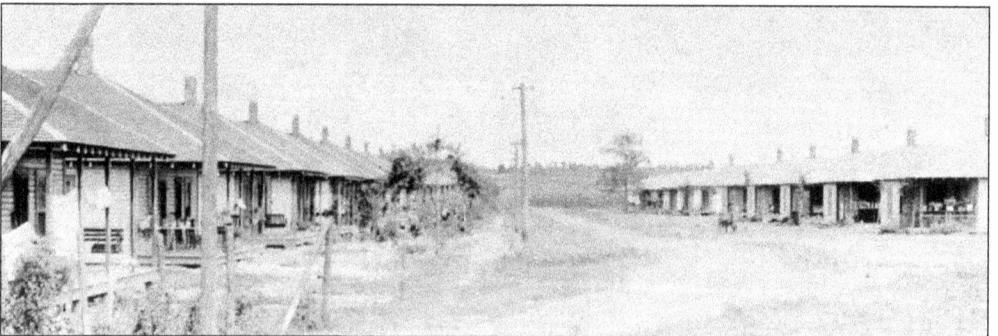

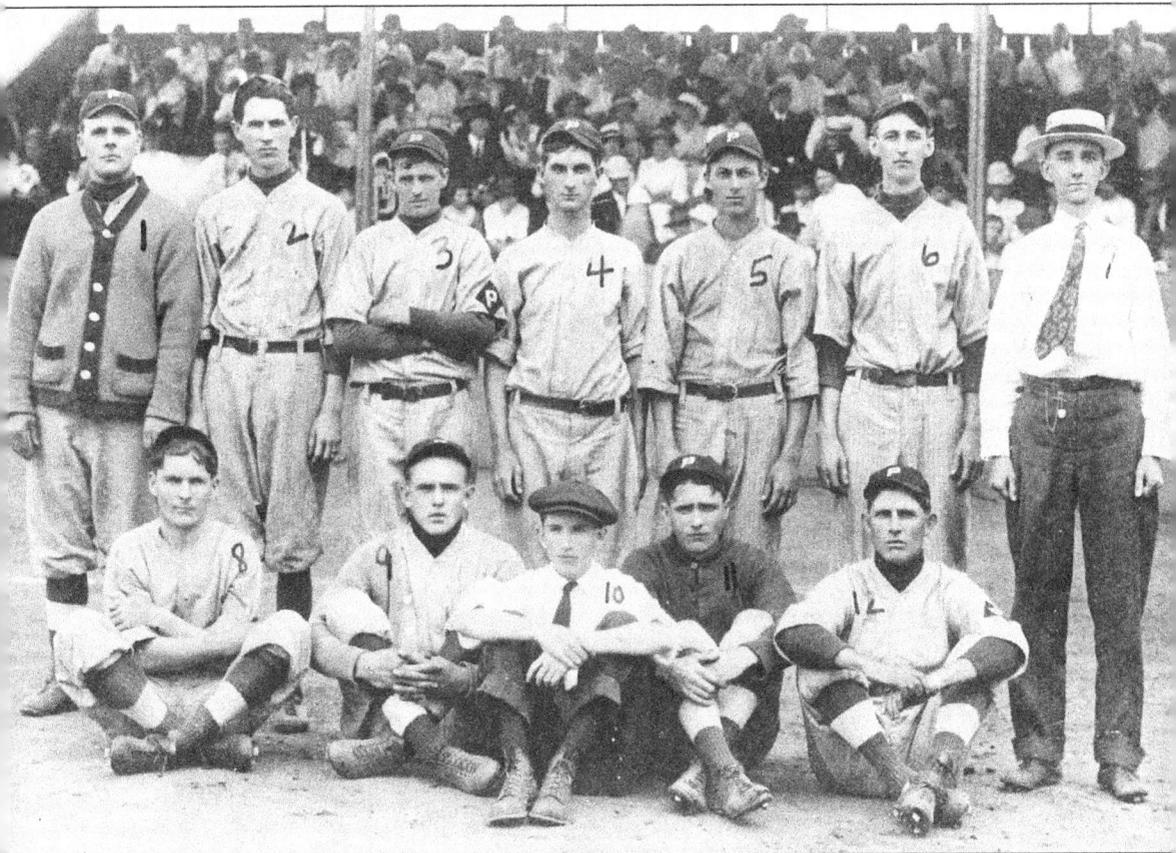

Baseball, "America's national pastime," was created by Alexander Cartwright in 1845 when he compiled the rules of the game. Many eastern cities fielded teams and during the Civil War soldiers taught the game to troops from other states, helping baseball spread around the country. In 1876 the National League was formed. By the early 1900s baseball was a popular recreational activity. Companies often fielded teams to compete against the teams of neighboring industries. Coosa Mills fielded a team, and they played on a field adjacent to the mill. (Courtesy of Gerald Whitton.)

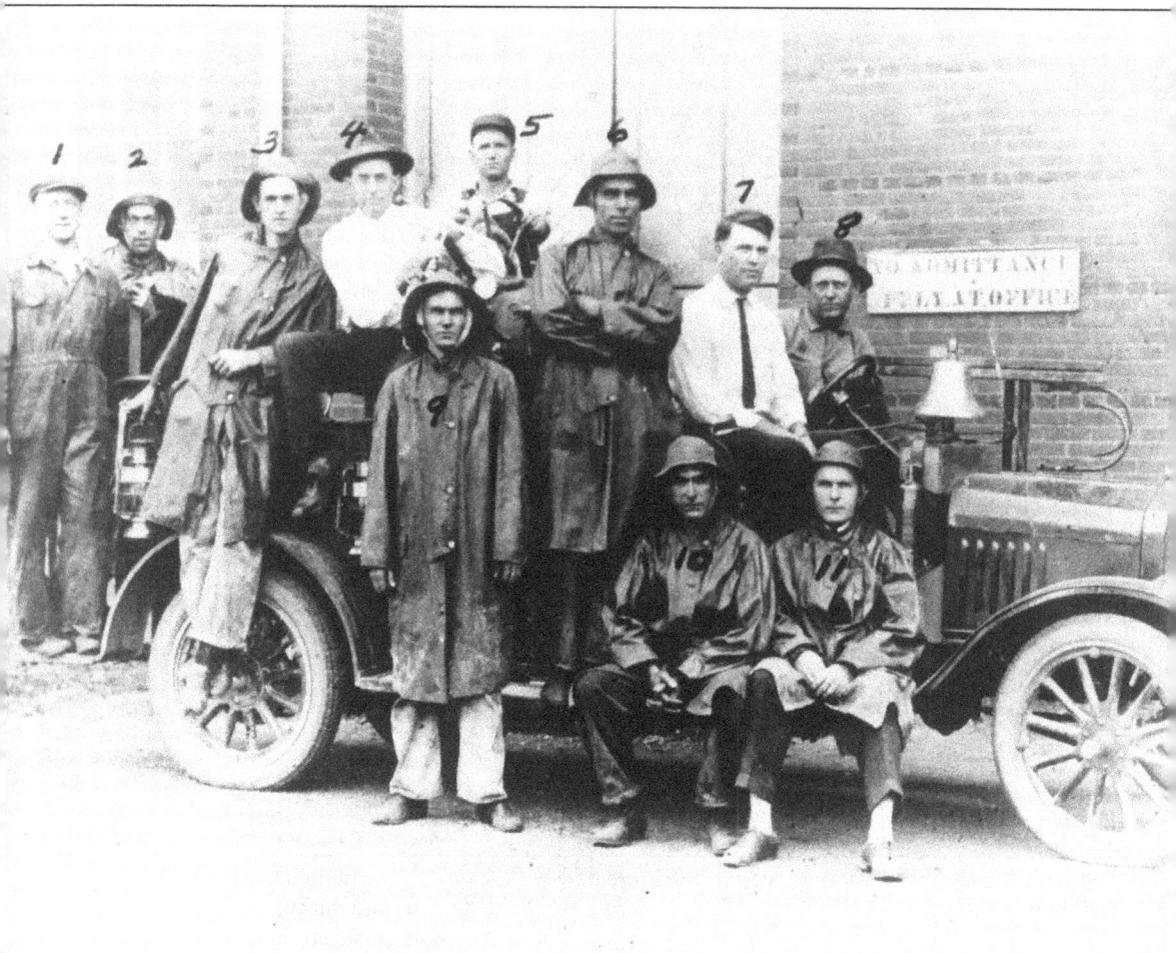

Life in mill villages was self-contained. Even though the mill was within Piedmont, the company supplied many services to their employees. The 1921 Coosa Mill Fire Department is shown here with their fire engine. (Courtesy of Gerald Whitton.)

Six

Fort McClellan

Fort McClellan is located between Anniston and Jacksonville. The earliest known military post for the U.S. Army in Calhoun County was an artillery range located across from the present-day fort in Blue Mountain. Camp Shipp was used in 1898 to train soldiers for the Spanish-American War. Starting in 1912, the National Guard came to the area and used the site for training maneuvers until, in 1917, Major Charles P. Summerall was sent by the War Department to arrange for the purchase of the area as an artillery range. On March 17, 1917, the War Department purchased approximately 19,000 acres of farmland.

The U.S. entry into World War I hastened the need for the land. The government took possession of the area immediately and constructed a camp, named in honor of Major General George Brinton McClellan, the head of the Union army from 1861 to 1862. In August 1917 troops moved into the camp and helped finish the construction. In 1918 and 1919, the camp served as a demobilization center for troops returning from the war. The area was used as an annual training camp for the Fourth Corps until 1929.

On July 1, 1929, the camp retained permanent status and was designated as Fort McClellan. The building of permanent structures continued, many of which were built by the Works Progress Administration (WPA). The fort served as a military post, as well as the District Headquarters for the Civilian Conservation Corps (CCC), a New Deal agency to relieve the unemployment of young men through conservation and building projects.

Due to the increase in military personnel during World War II, additional buildings and an additional training area became necessary, so Pelham Range, located where Morrisville and Peaceburg had been, was acquired. Fort McClellan trained the 27th Division of the New York State National Guard for deployment to the Pacific and the 92nd Infantry (Negro) Division for deployment to Italy. In addition to training these divisions in the early days of the war, the fort became a training replacement center and home for numerous POWs. Fort McClellan was deactivated on June 30, 1947, retaining only enough personnel for ground and building maintenance.

In January 1951, the post was reactivated as the home of the Chemical Corps School and a replacement training center for the Chemical Corps. At the same time, the Women's Army Corps (WAC) training center needed a permanent home. Construction for both the Chemical Corps and the WAC began in 1951 and was completed in 1954. In 1962, the Noble Army Hospital was added as a permanent medical center. The U.S. Army Military Police School moved to Fort McClellan in 1975. Three years later, the colors for the Women's Army Corps were retired due to co-ed training.

After surviving several rounds of base closing hearings, Fort McClellan was placed on the list. It is set to close September 30, 1999, ending Calhoun County's and the U.S. Army's successful partnership to make the base and the county the "Showplace of the South."

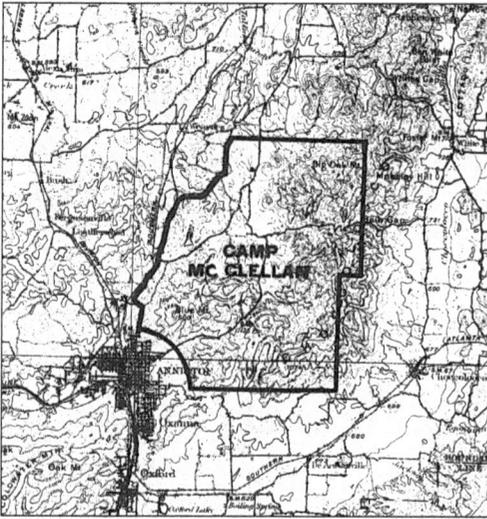

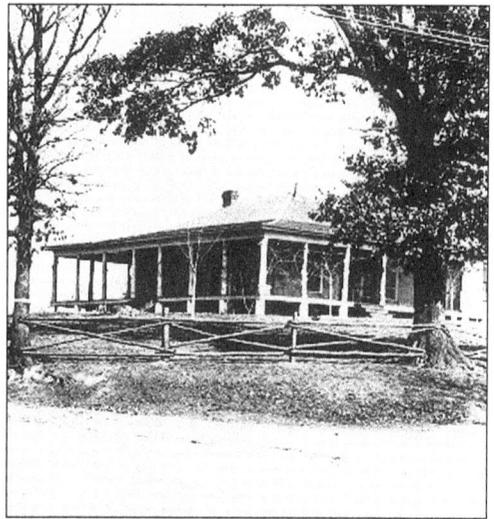

Left: In March 1917, the federal government, at the urging of Major Charles P. Summerall, decided to purchase the land between Anniston and Jacksonville as the site of a military camp for artillery training. The contract deeded 18,952 acres of farmland to the United States government for $247,000. Almost immediately after the purchase, the U.S. entered World War I and the need for a camp on the site hastened. (Courtesy of Fort McClellan.)

Right: By June 1917, the U.S. Army had immediate needs for a portion of the land, so owners were paid higher prices for their land to compensate for planted crops. The total cost of the land rose to $383,400 for the acreage. Some of the homes left by the farmers were incorporated in the camp's layout. One of the oldest houses on post, shown in 1918, was remodeled to house visiting dignitaries staying at Fort McClellan. (Courtesy of Fort McClellan.)

Colonel Charles L. Dulin was the constructing quartermaster in charge of Fort McClellan in June 1917. Dulin selected the northwest quadrant of land to build the camp on for several reasons. The area was fairly level, well drained, close to the tracks of the Southern Railway, and was connected by roads already in place. The colonel hired a large local labor force and began construction on the camp. In July 1917, when John O. Chisholm and Company, who were contracted for building construction, arrived from New Orleans, Dulin's crews had completed seven mess halls. The crews worked rapidly and built approximately 40 buildings a day. By August, construction was complete enough to move in troops. This early building phase of camp saw more than 900 structures completed. (Courtesy of Fort McClellan.)

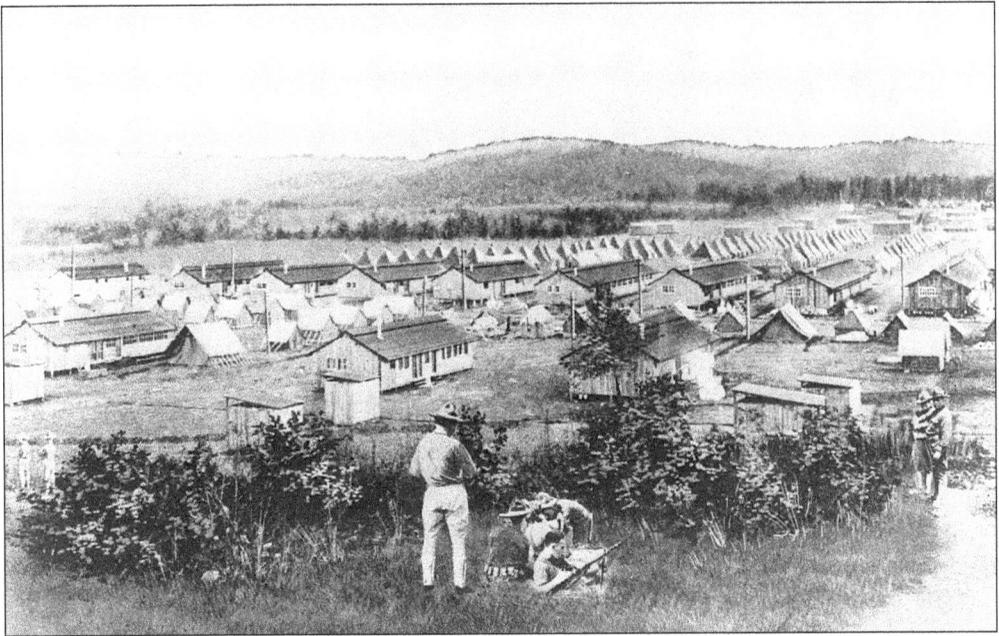

The base was built to house both a permanent army camp and a National Guard camp. The National Guard camp was laid out carefully. The latrines and showers were located closest to the creeks and 800 feet away were the mess halls followed by the columns of tents. The 29th Division of the National Guard was the first to train at Camp McClellan. The soldiers, under the command of Major General Charles G. Morton, were from New Jersey, Virginia, Delaware, and the District of Columbia. Because of the diverse geography, the men called themselves the "Blue and Gray." In June 1918, the 29th received orders sending them to fight in France. (Courtesy of Fort McClellan.)

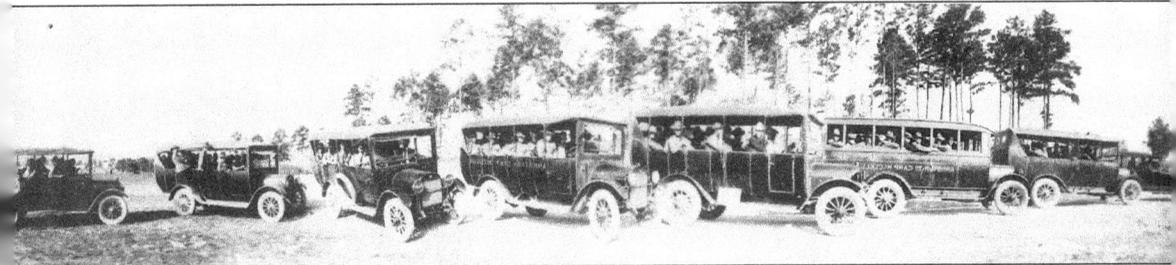

"Goin' to Town. Goin' to Town" was a familiar call of the jitney drivers. They ferried the young soldiers to and from Anniston for 5¢ a ride. The post was a desolate place for the young men, so they welcomed the opportunity to go into Anniston for some relaxation. When fighting overseas, soldiers were often heard imitating the Southern twang of the jitney drivers calling for passengers to amuse their compatriots. (Courtesy of Fort McClellan.)

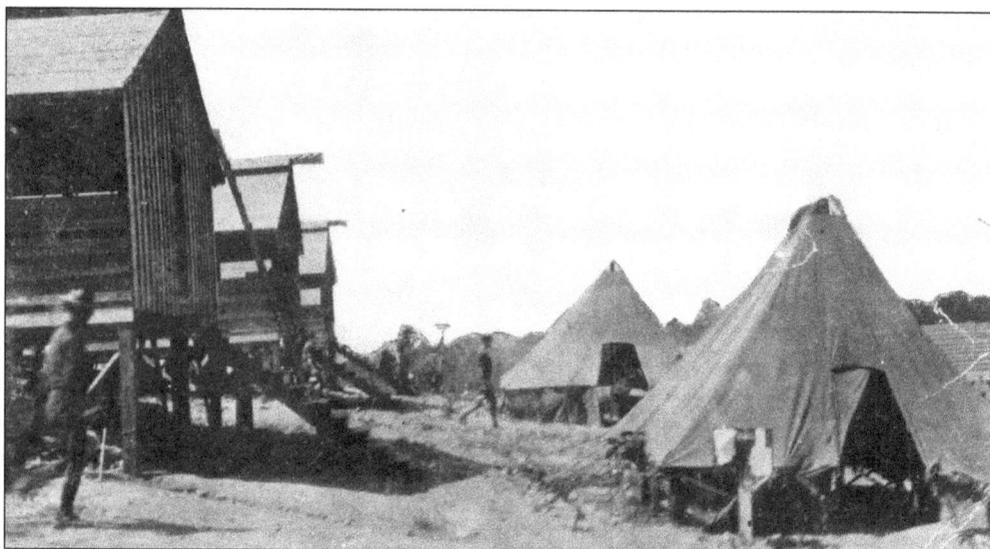

Soldiers' tents were erected in close proximity to the mess shacks. The mess shacks were long, narrow wooden buildings at the end of a line of tents. The tents were floored, included a stove or heater, and were constructed of a frame with a canvas covering on top. (Courtesy of Fort McClellan.)

In 1917, this regimental street was one of the main thoroughfares through the camp. It cut through part of the "tent city" where the 29th Division was encamped. (Courtesy of Fort McClellan.)

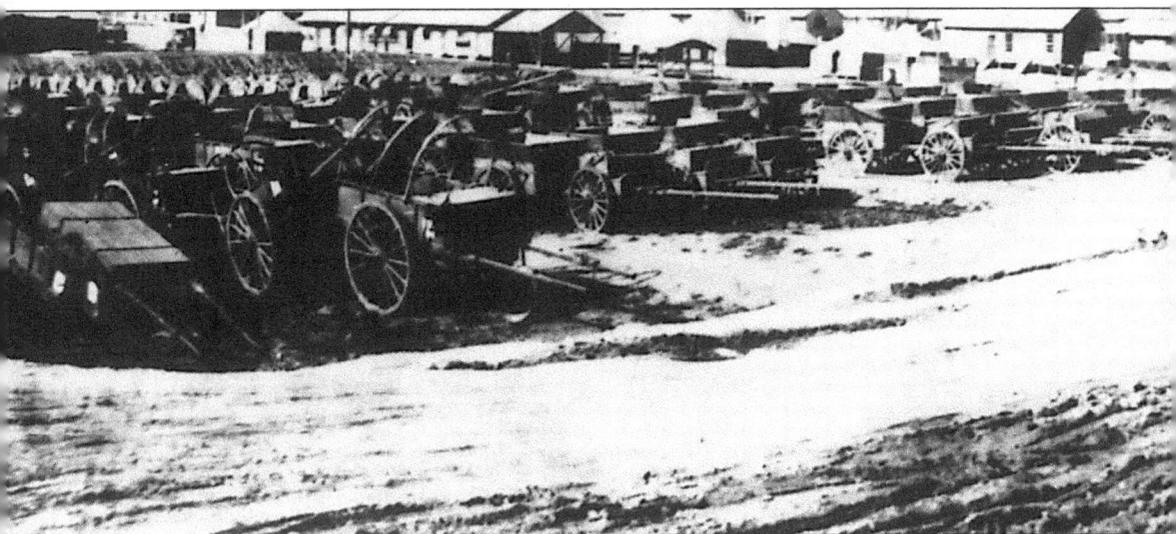

In the early 20th century, the army relied on horse and mule power to move the army. Two-wheeled wagons, or caissons, were used for transporting ammunition. They were pulled by mules since horses were usually officers' mounts. The supply wagons were similar to Conestoga wagons and pulled by draft animals. From 1917 to 1940, animals supplemented motorized vehicles at Fort McClellan. (Courtesy of Fort McClellan.)

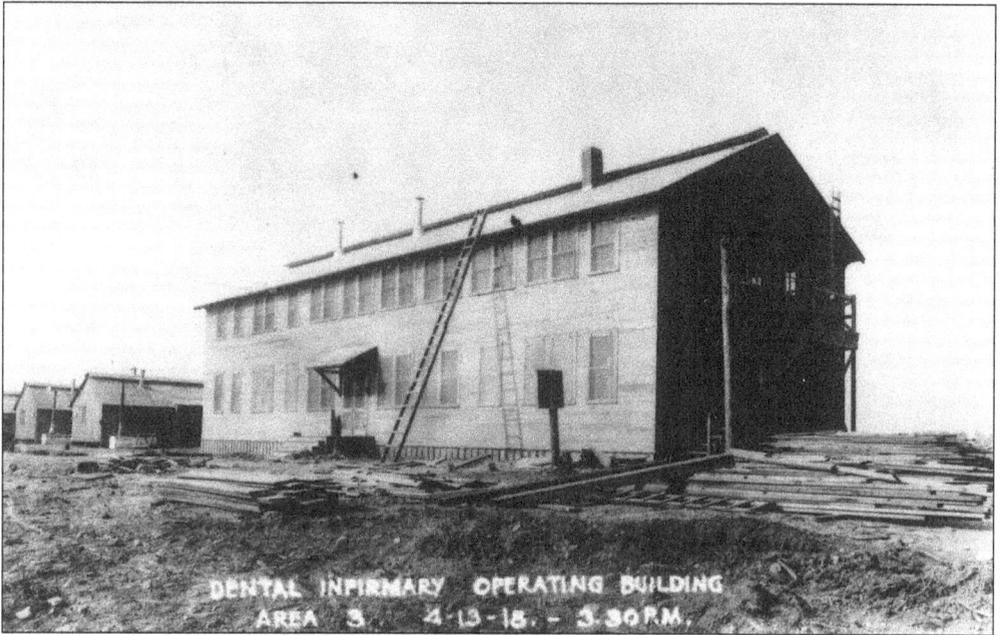

DENTAL INFIRMARY OPERATING BUILDING
AREA 3. 4-13-18. - 3.30 P.M.

In 1919, the hospital area was located between Baltzell Gate Road and Summerall Gate Road on the present-day site of post headquarters. The base hospital of 1919 included 118 buildings with single ward buildings aligned in four columns. These buildings were connected by walkways and divided into northern and southern areas. The northern area included the neuropsychiatric unit, isolation unit, and officer's wards, kitchens, mess halls, and latrines. The nurse's quarters, offices, Red Cross, post exchange, "operating" building, laboratory, mess hall, and dental clinic were located to the south. (Courtesy of Fort McClellan.)

DENTAL INFIRMARY OPERATING BUILDING
INTERIOR VIEW SECOND FLOOR
AREA 3. 4-4-18 - 5.30 P.M.

Roads into the camp were dirt and needed bridges to cross the creeks that ran through the area. During the early construction, labor was conveyed from Anniston to the camp by trucks to help soldiers construct the camp. The construction was a struggle for numerous reasons, including finding laborers, dealing with labor strikes due to wages and conditions, and the heavy rainfall during July and August 1917. (Courtesy of Fort McClellan.)

There are numerous cemeteries located on Fort McClellan and Pelham Range. The remains buried in these cemeteries were civilian residents prior to the land becoming a military base. Many of the cemeteries are unmarked, but can be found in wooded areas on the post. The only military cemetery is the one located on the post's west side and contains the remains of 29 POWs, 26 Germans and 3 Italians. (Courtesy of Fort McClellan.)

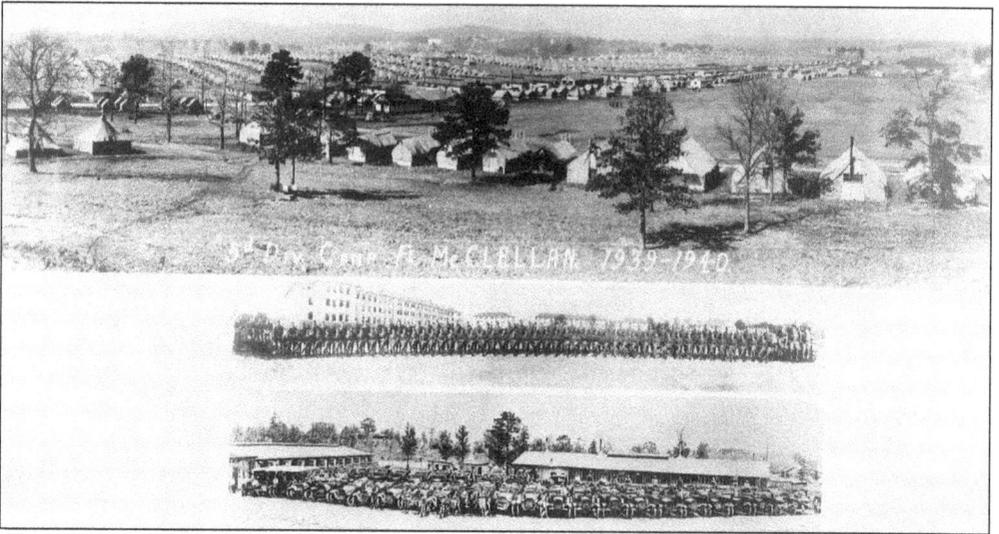

From 1929 to 1933, construction, using the Works Progress Administration, included four new barracks for enlisted men, a mess hall, warehouses, hospitals, garages, and building improvements in the National Guard training sites. The 22nd Infantry served as the post garrison from 1935 to 1941. "Tent Cities" were common sites during Fort McClellan's formative years. The tents were framed and included a heater and a concrete pad. The officers lived in self-contained barracks built near the post headquarters. By 1940, the army used a different "horsepower," so the stables made way for automobiles and motorcycles. In 1939, the 5th "Red Diamond" Division was activated for winter training. By April 1940, they moved to Fort Benning. (Courtesy of Fort McClellan.)

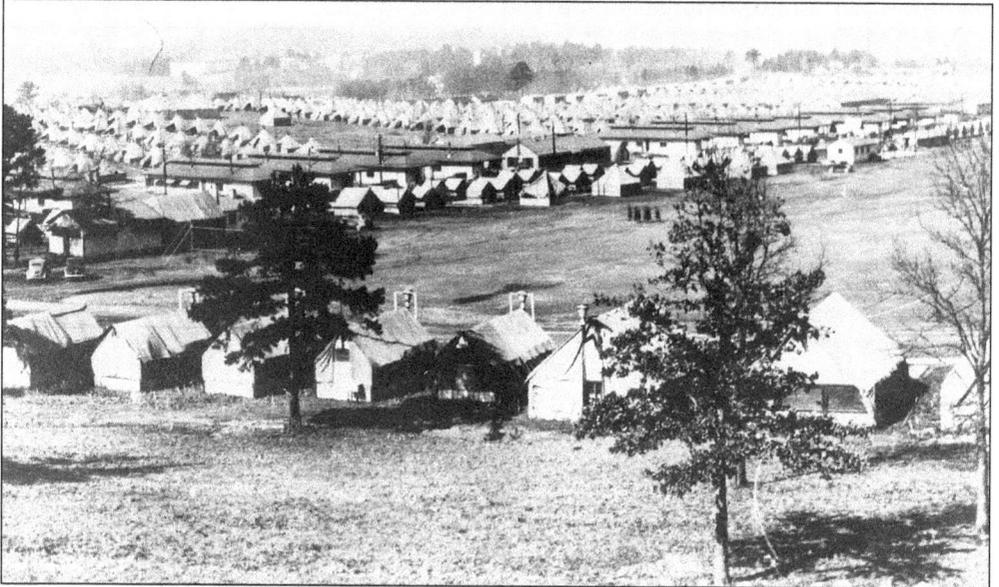

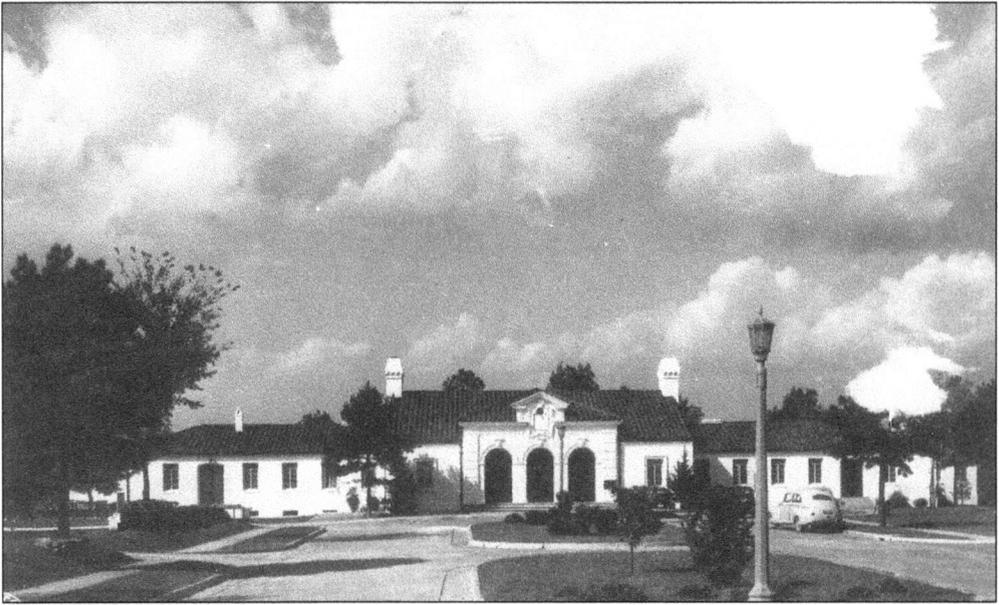

Remington Hall was built of the Spanish Colonial Revival style in 1936 by the WPA as a bachelor officer's quarters. It included five apartments, two sleeping porches, two guest rooms, an office, a library, and a lounge with a kitchen and dining room. It was located on Buckner Circle with the officers' homes. In December 1941, it was converted into an officer's mess and later into an officer's club with a ballroom. During the POWs' stay at Fort McClellan, they were charged with renovating some of the buildings. Many of the POWs were master artisans and craftsmen. They were credited with the carved bar and the murals on the wall of Remington Hall. These murals have scenes of men, women, and children; they are from the genteel to the disturbing. Some have noted that the men in the murals display a striking resemblance to Supreme Allied Commander General Dwight Eisenhower. (Courtesy of Fort McClellan.)

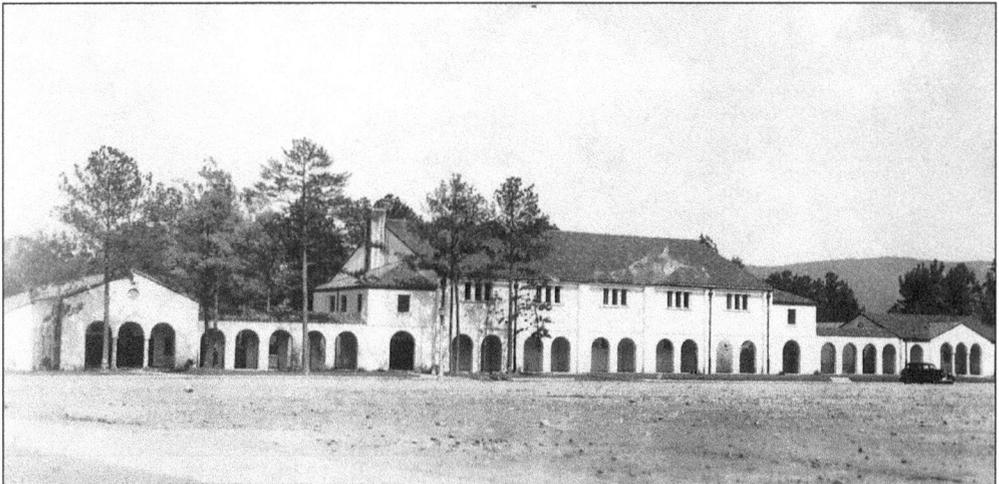

This Spanish Colonial Revival was built in 1936 by the WPA under the Emergency Relief Appropriation Act of 1935. The building to the far left was used as a theater and included a stage and projection screen. The center was a gymnasium for recreation and exercise. The far right was an enlisted men's service club. The buildings later were used for a library and administration offices. (Courtesy of Fort McClellan.)

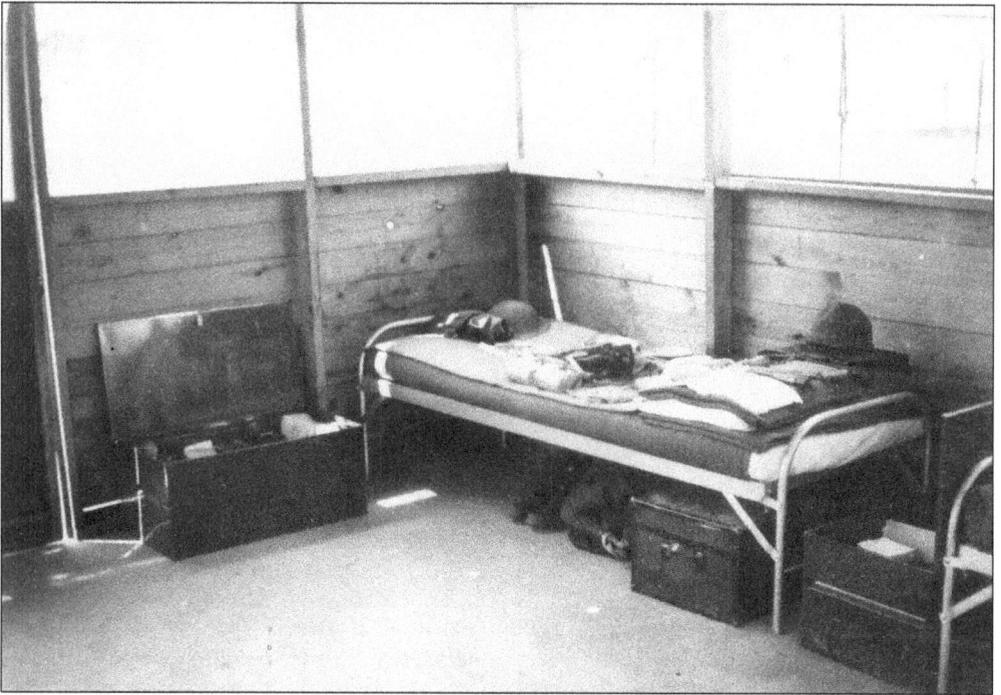

A General Purpose (GP) tent was a long building frame with a screen to keep out insects. A soldier's "hootch" contained a neatly made bunk and several trunks to hold his gear. This cavalry soldier's bunk is prepared for inspection and each item has a certain place to occupy. (Courtesy of Fort McClellan.)

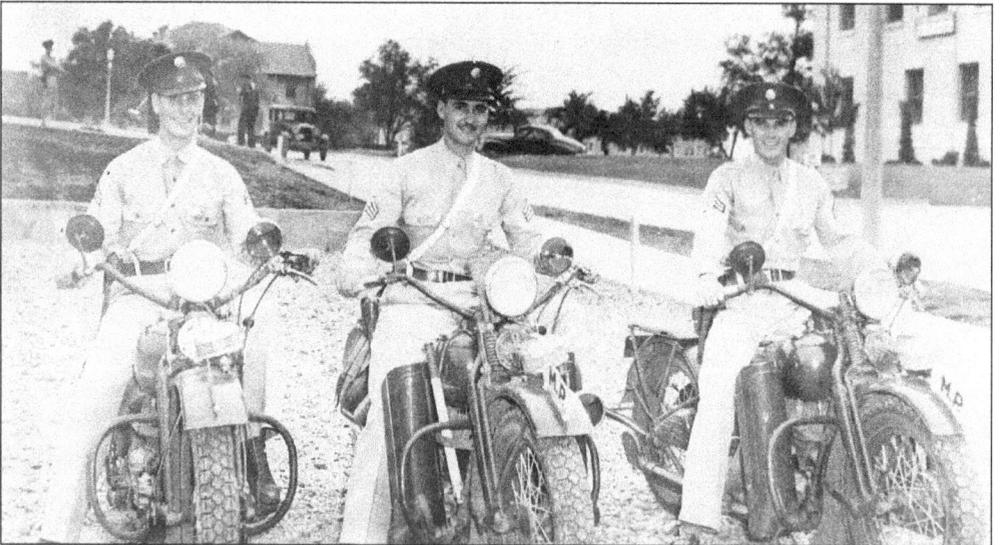

The post headquarters area saw permanent construction in the 1930s. This area was the site of the hospital areas in the early days of the camp. The headquarters was a low one-story building and served as an architectural bridge between the residential architecture of the officers' homes on Buckner Circle and the large-scale barracks. The hospital buildings (right) were reduced in number but still required 4.5 miles of catwalks. The main hospital was located across the street from the post headquarters. (Courtesy of Fort McClellan.)

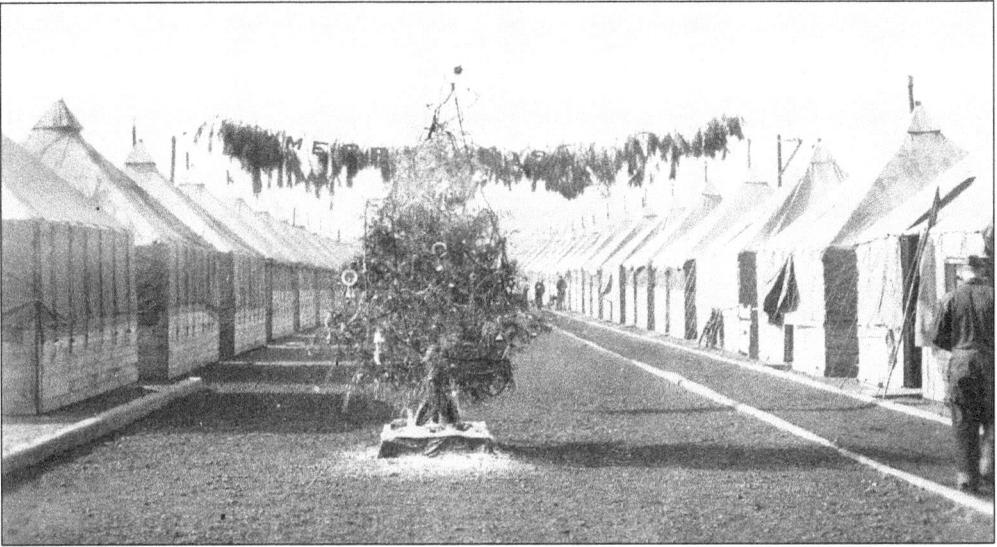

"Tent Cities" were drawn off into streets. Tents were lined in rows with a sidewalk in front and a common area before the next row of tents. Holidays were a lonely time for military personnel. The men improvised in the 1940s and created a little holiday spirit between these two streets of tents. (Courtesy of Fort McClellan.)

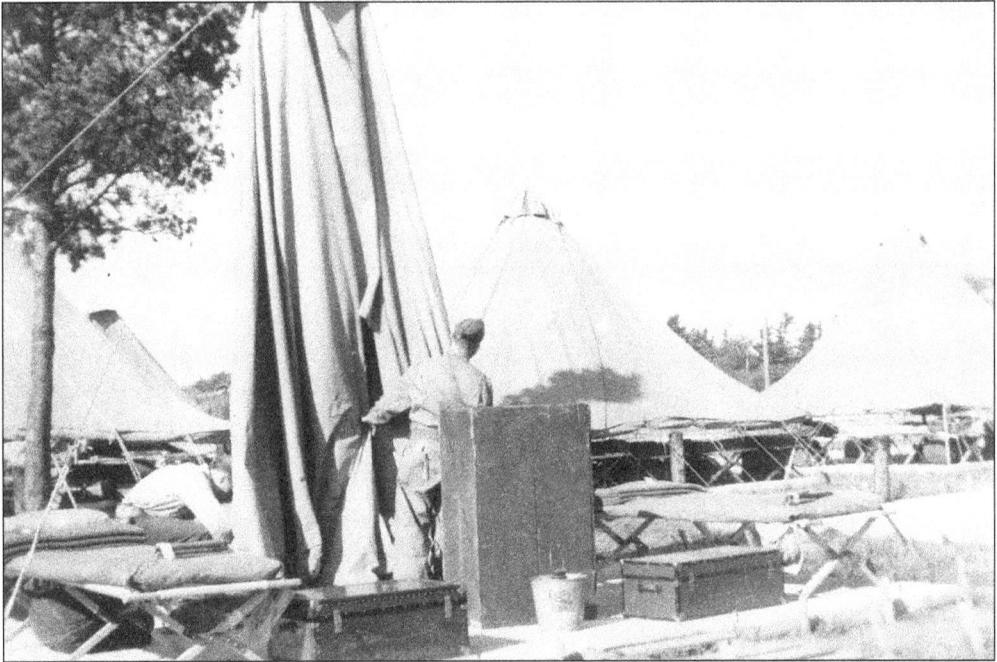

In October 1940, the 27th National Guard Division from New York was ordered to Fort McClellan to train. Pelham Range, in the Morrisville area, was acquired so the men would have an adequate place for artillery training. The area was originally known as the Morrisville Maneuvering Area. On December 19, 1941, the 27th received orders to an unknown destination. The unit arrived at Pearl Harbor, Hawaii, and went on to fight in the Marshall and Gilbert Islands, Saipan, Guam, and the Philippines during the Second World War. (Courtesy of Fort McClellan.)

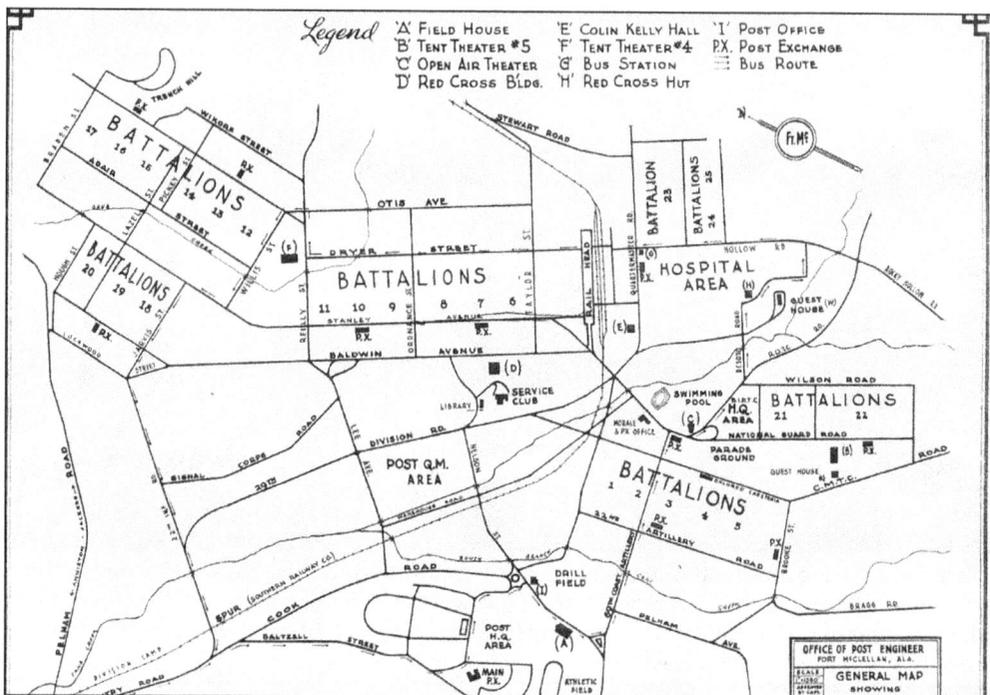

Legend
'A' FIELD HOUSE 'E' COLIN KELLY HALL 'I' POST OFFICE
'B' TENT THEATER #5 'F' TENT THEATER #4 P.X. POST EXCHANGE
'C' OPEN AIR THEATER 'G' BUS STATION ≡ BUS ROUTE
'D' RED CROSS BLDG. 'H' RED CROSS HUT

On January 15, 1942, the Branch Immaterial Replacement Training Center (BIRTC) took the place of the departed 27th Division. Recruits from all across the country came for six to eight weeks of basic army training. Upon graduation, the young men were transferred to combat units or various other army branches. In January 1943, the BIRTC was converted to an Infantry Replacement Training Center (IRTC), where young men received 15 to 17 weeks of basic training, with the last 8 weeks including intense combat training so the soldiers could be sent directly into battle. In August 1945, training was cut to eight weeks and geared to prepare the occupational forces. (Courtesy of the Alabama Room at Calhoun County Public Library.)

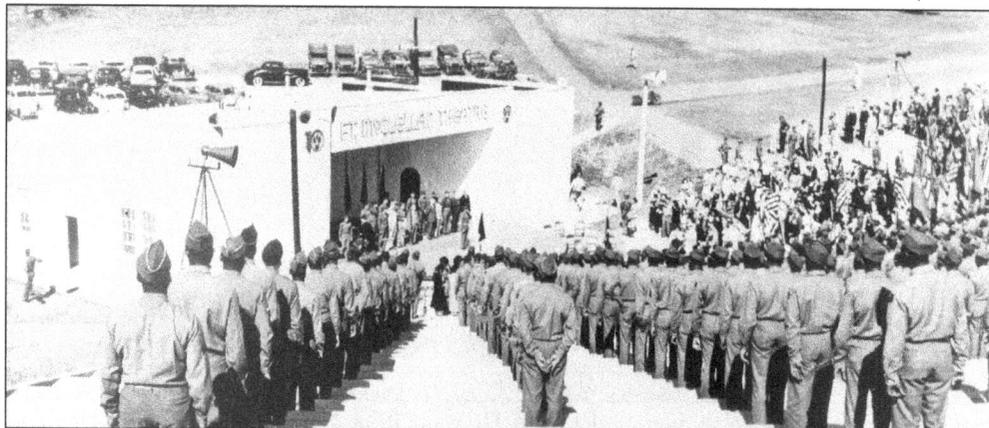

In June 1942, the Monteith Amphitheater was constructed and named for First Lieutenant Jimmy Monteith, an IRTC killed in France. The amphitheater seated 12,000 persons and was used for musical and theatrical performances, as well as exhibitions. Two months after the theater was completed, the 92nd Infantry Division (Negro) was activated under the command of Major General Edward M. Almond. This segregated division remained at Fort McClellan until 1943, when they moved to Arizona and later Italy. (Courtesy of Fort McClellan.)

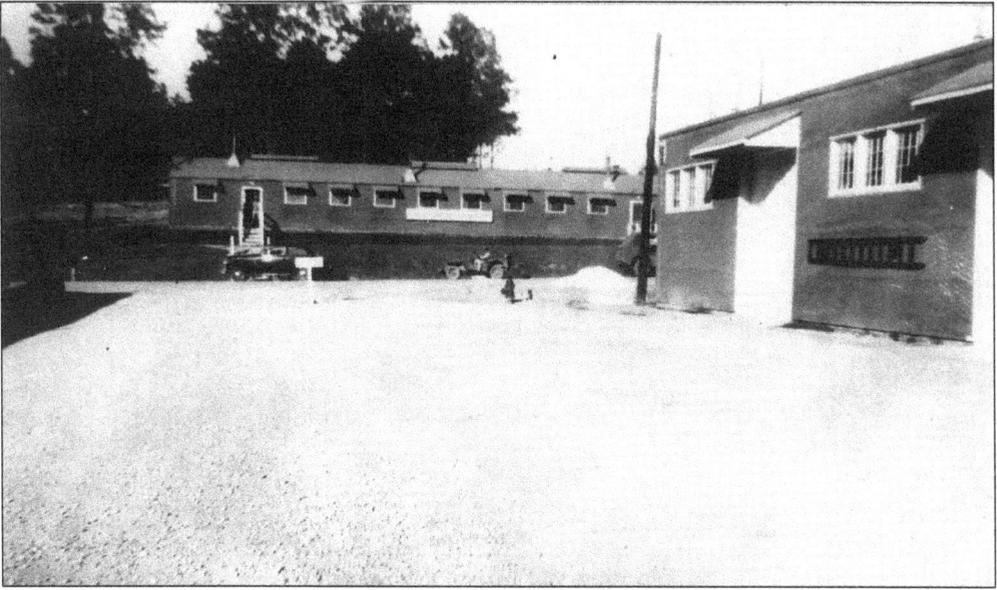

In May 1943, a 3,000-capacity prisoner-of-war (POW) camp was completed at the middle gate of Fort McClellan. The POW camp was essentially self-contained and included barracks, kitchens, orderly rooms, dayrooms, dispensaries, a library, a reading room, a chapel, an open-air stage, and athletic fields. The camp was a processing center for all POWs interned in Alabama camps and was the last to be deactivated on April 10, 1946. (Courtesy of Fort McClellan.)

POWs lived in "Caribbean-type buildings" that were 20 by 40 feet and could house 20 men to a barracks. The POWs were used on the base as support staff for the depleted forces. They were used in construction, clearing and excavating, and the motor pool. If the fort did not need the labor, POWs were allowed to contract their services to local farmers. The military trucks would take the prisoners, with their guards, to the work sites. The POWs were given their lunch and paid $1 a day by their civilian employers. (Courtesy of Fort McClellan.)

The POWs at Fort McClellan were mostly Germans, though some Italians were interned at the camp. Many of the men were skilled artisans in stonecutting, stonemasonry, and woodworking. The POWs set up art studios in four barracks. The men passed the day working on painting, sculpting, toy making, and handicrafts. This provided an outlet for the confined prisoners. Lieutenant Colonel Schmidt, who controlled the camp, tried to find areas at the fort to market the finished products. Approximately 120 men worked in the shops in weaving, leather work, and wood carving. The POWs even printed their on newspaper which included games, cartoons, line drawings (shown above), and general interest articles about life in the camp. *Die Oasew*, translated to "the Oasis," also provided an outlet for the creativity of the men. Unfortunately no record of the men's names were kept, so the work of these artisans remains unsigned. (Courtesy of Fort McClellan.)

The military police (MP) served as the law enforcement on the military installation. The MPs of the 1940s primarily used motorcycles as a means of transportation. For this formal picture, the MPs are in a V formation with their commanding office at the point of the two rows. In 1975, the Military Police School was moved to Fort McClellan. (Courtesy of Fort McClellan.)

Each division of Fort McClellan had a marching drill team for competitions. On Armed Forces Day, 1956, the WAC Honor Guard performed a "right column," or flanking movement, to win the drill team contest and beat the post and chemical drill teams. (Courtesy of Fort McClellan.)

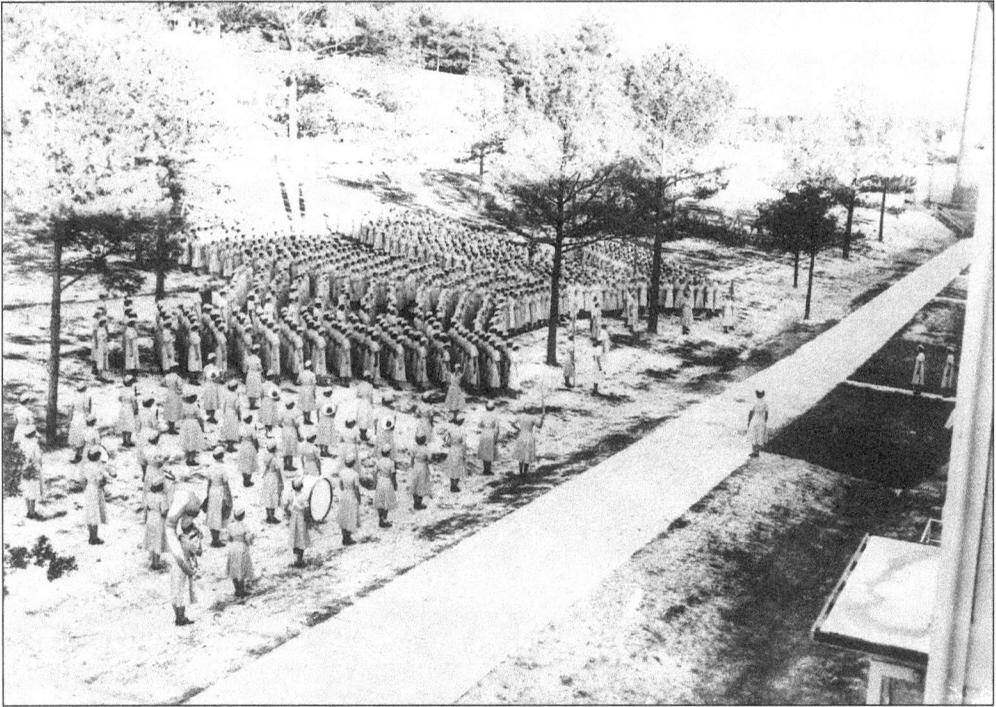

In 1942, the First Women's Army Auxiliary Corps (WAAC) Training Center Band was organized at Fort Des Moines, Iowa. A year later, the band was renamed the 400th Army Band and went through several years of performances across the nation before being deactivated in 1946. In 1948, the band was reactivated and officially named the 14th Army Band. In 1954, the band moved to Fort McClellan with the WAC Training Center. The band participated in presidential inauguration parades, as well as touring the United States for performances. On January 1, 1976, the band was integrated to include men. (Courtesy of Fort McClellan.)

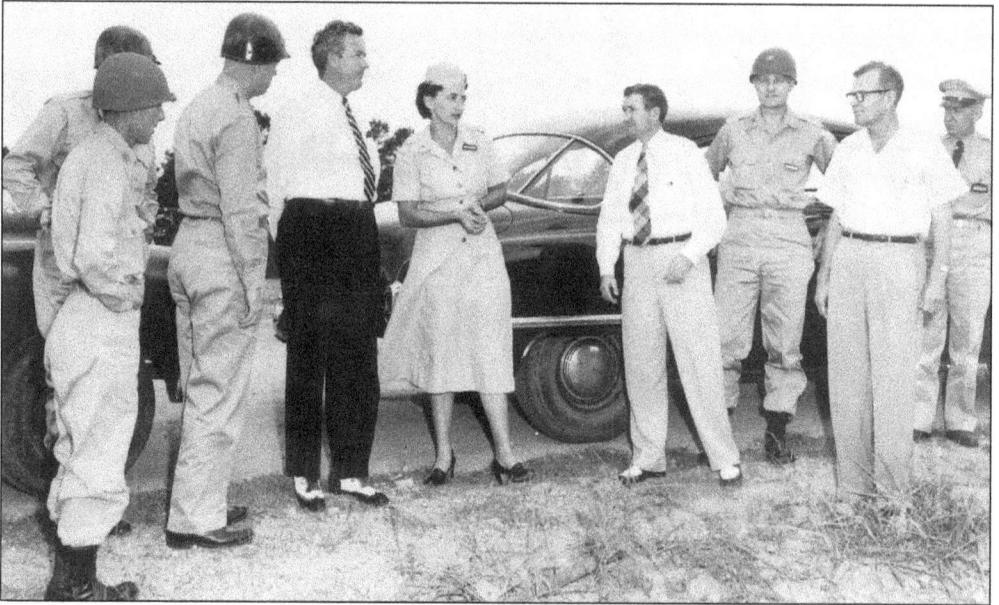

In August 1953, Fort McClellan invited Alabama's congressmen to view the post and the construction of the Women's Army Corps Training Center. Senator John Sparkman and Third Congressional District Representative Kenneth Roberts are shown the construction site by Major Patricia E. Grant, WAC liaison officer. The construction was completed in 1954, and Fort McClellan became the home of the WAC Training Center until the flag was retired in 1978. (Courtesy of Fort McClellan.)

During the 1950s and 1960s, the WAC Training Center trained Women's Army Corps units from many Asian nations, including Japan, Korea, and Vietnam. These Vietnamese WACs stand at the pagoda, adjacent to the Memorial Triangle, given to Fort McClellan by the Tokyo WAC detachment in August 1955. (Courtesy of Fort McClellan.)

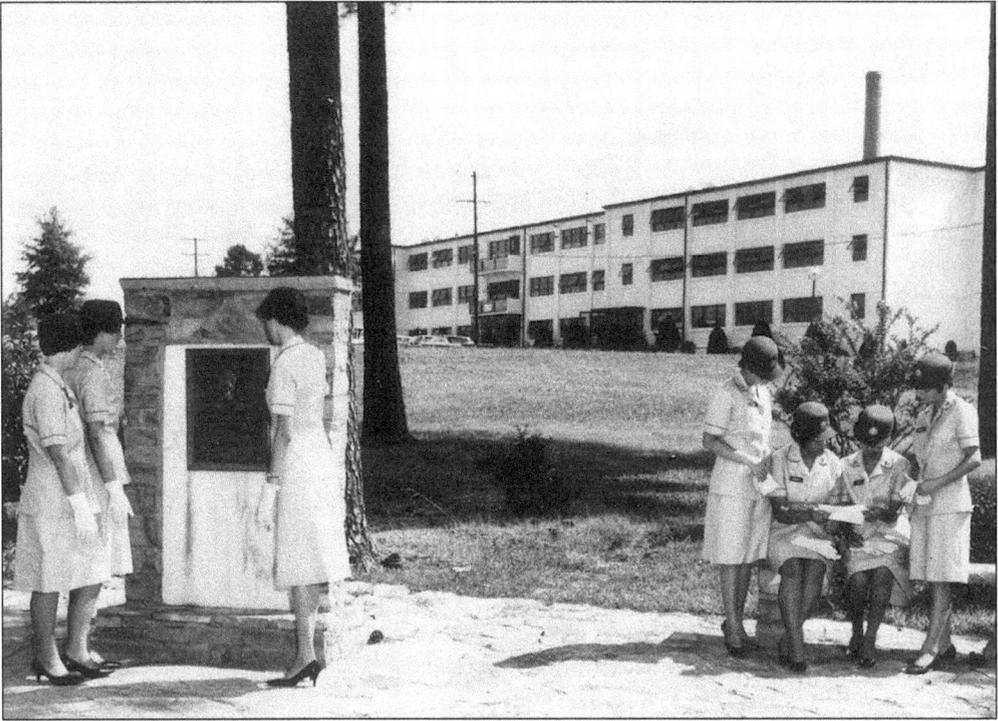

Memorial Triangle, located in front of Faith Hall, has several benches and a plaque commemorating the Women's Army Corps training center. The plaque reads as follows: "The WAC Center Dedicated to the members of the Women's Army Corps who serve their country in Peace and War. Fort McClellan, Alabama. 27 September 1954." (Courtesy of Fort McClellan.)

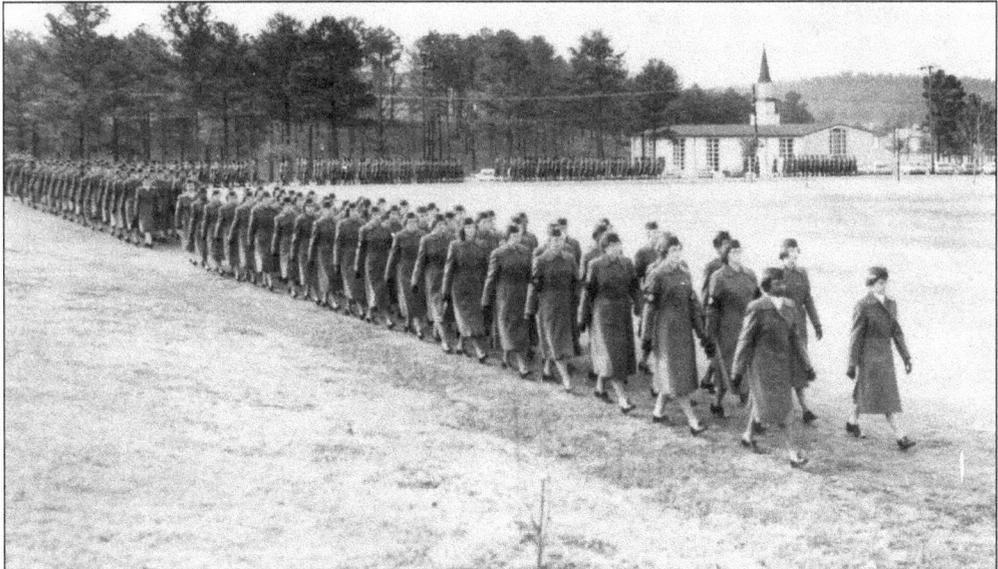

The George C. Marshall Parade Ground was located in front of the WAC Training Center. The WAC chapel, located at the end of the parade ground, had the cornerstone laid on September 29, 1955, and was dedicated on May 14, 1956. (Courtesy of Fort McClellan.)

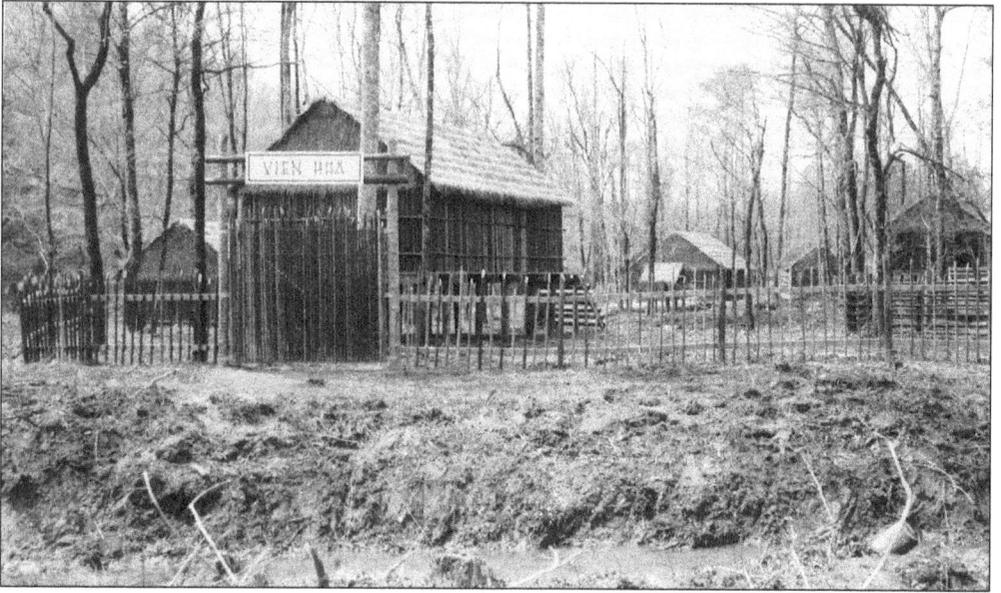

During the early years of the Vietnam War, Fort McClellan built a mock-up village to train soldiers for what they would encounter in Southeast Asia. Upon entering the village, a Buddha shrine was set up to show the trainees the different religious beliefs of the Vietnamese. (Courtesy of Fort McClellan.)

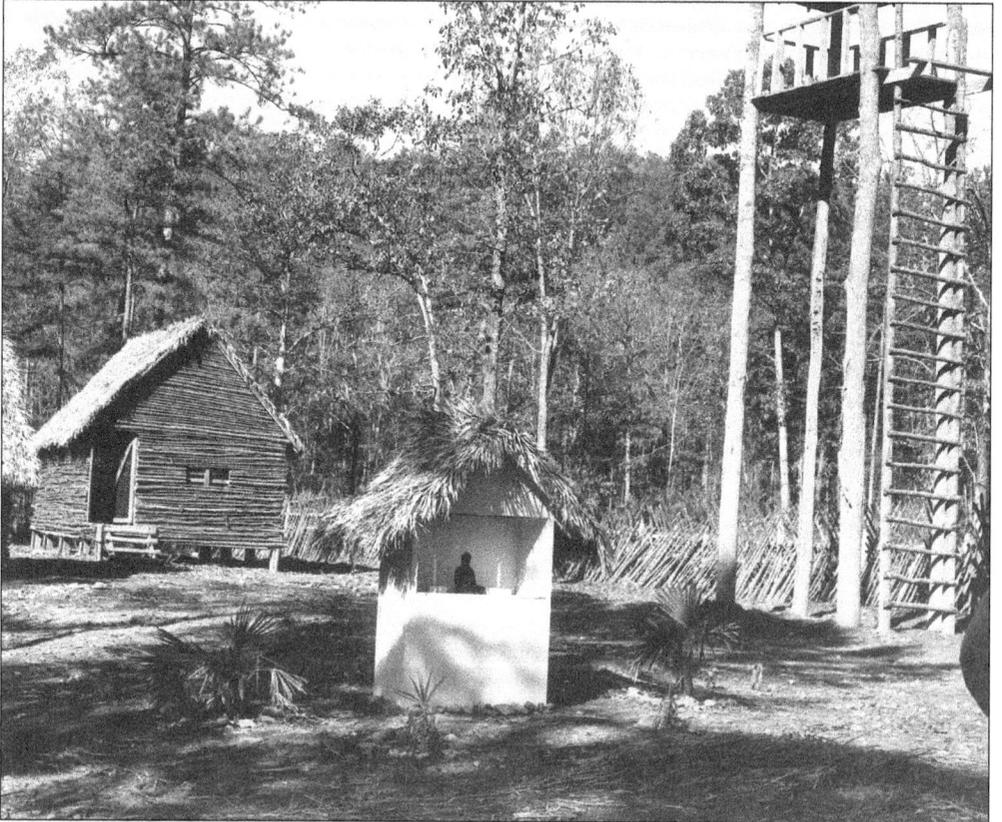

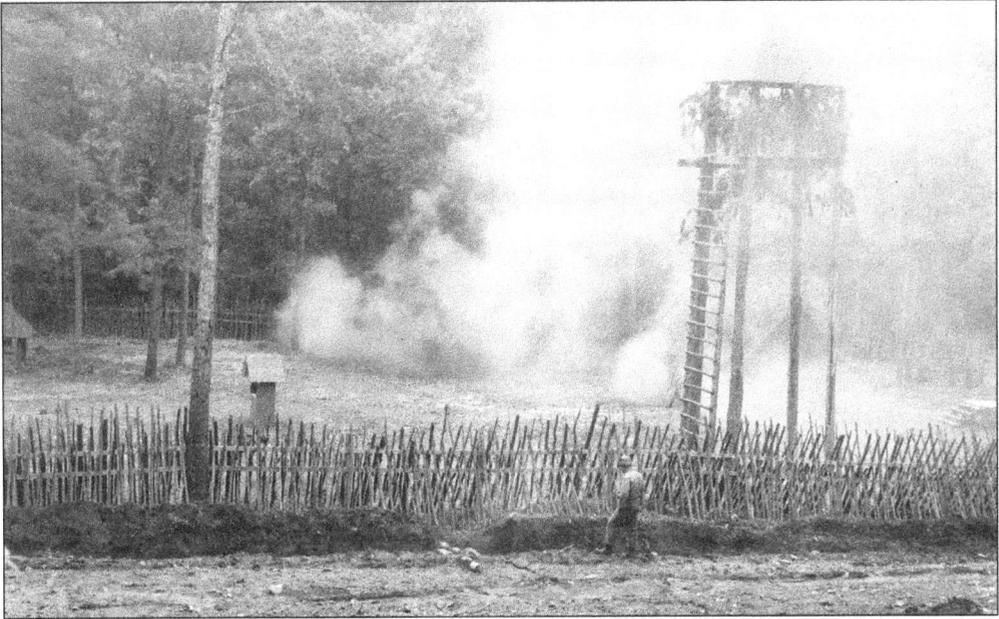

Soldiers faced difficulty in identifying who were the Communist North Vietnamese, or Viet Cong (VC), and friendly South Vietnamese regulars. Training exercises included dropping gas into the village and catching VC in the tunnels that ran under the village. (Courtesy of Fort McClellan.)

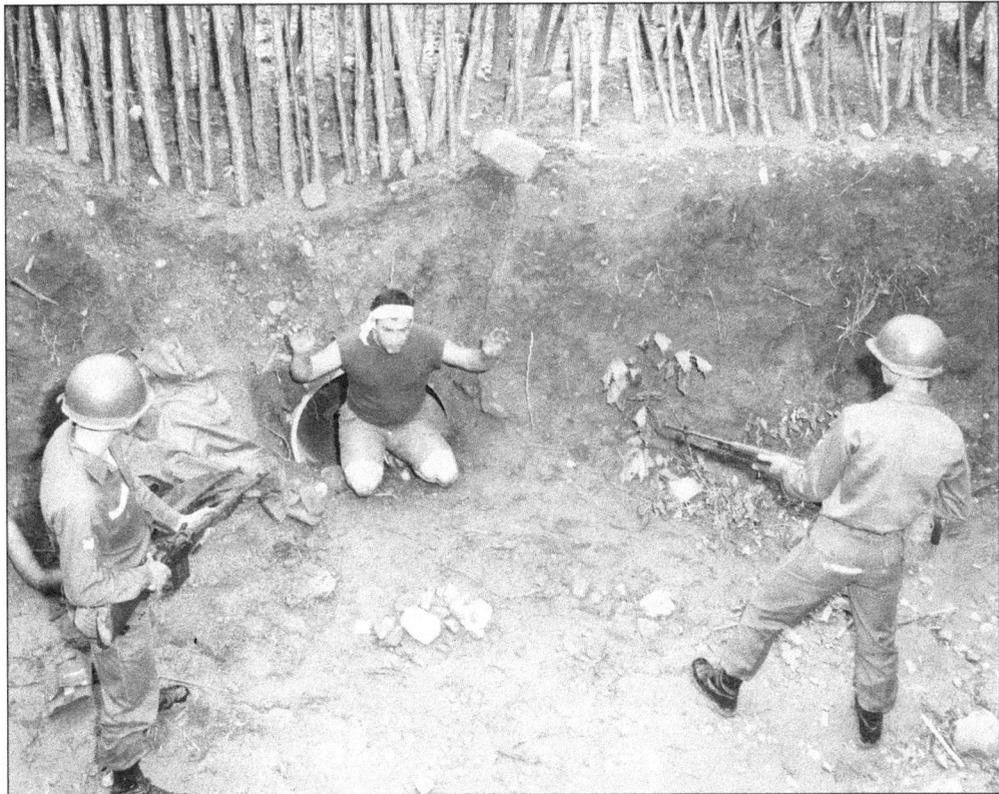

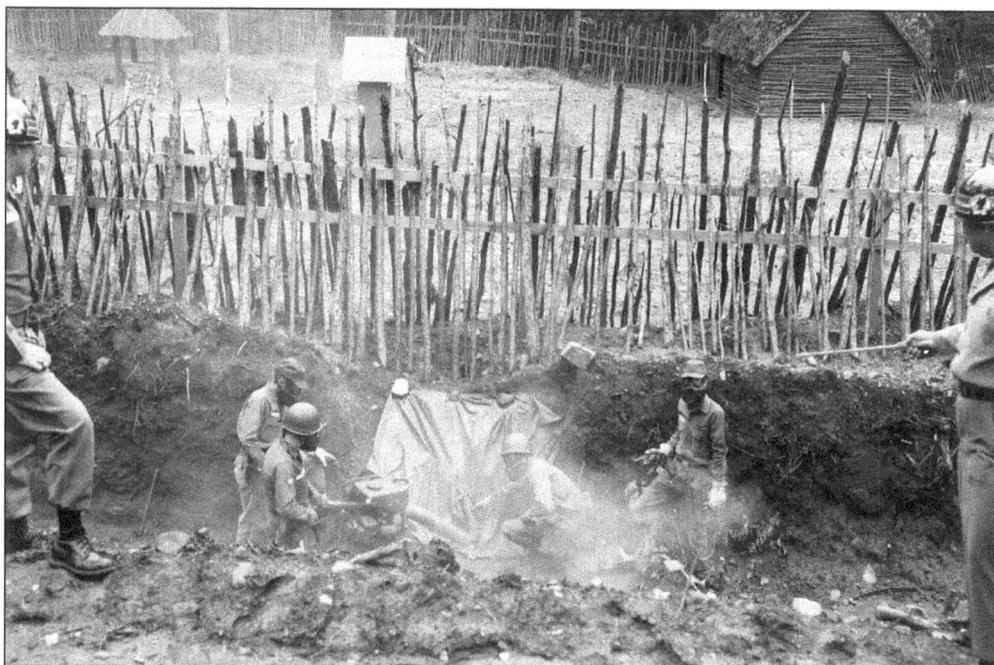

To clean out the underground tunnels, a "Mighty Mite" was used. The M6 Mighty Mite was a riot dispersal agent that shot tear gas into the tunnels. The gas was not hazardous but did irritate and burn the skin. (Courtesy of Fort McClellan.)

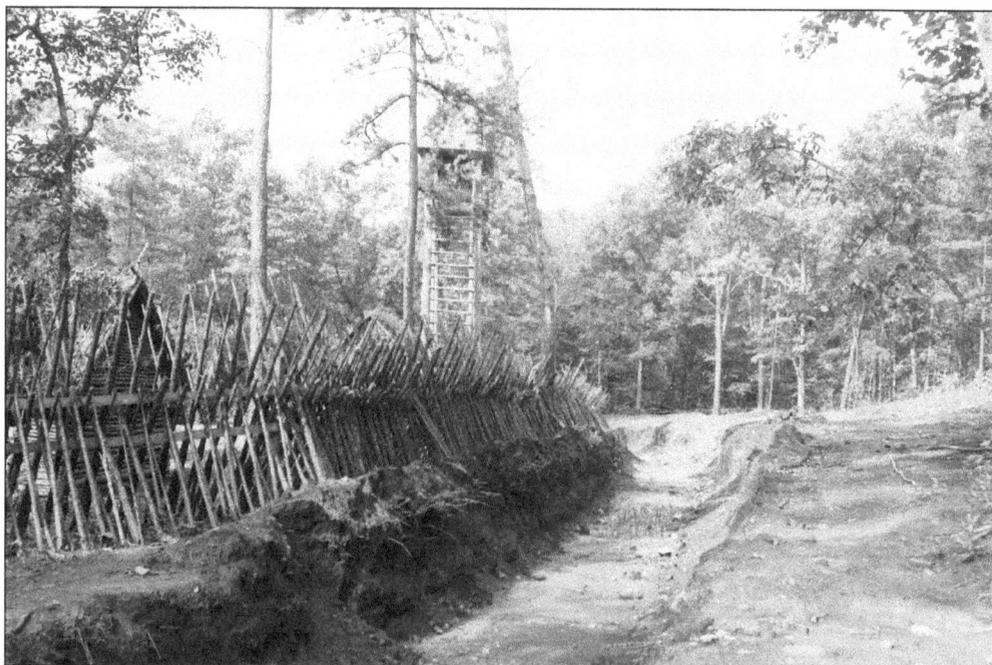

To complete the realistic training, trenches and punji stick fences were placed around the village. The punji sticks were bamboo stakes with a needle sharp tip. This village was built on Pelham Range and remained as a training tool during the 1960s and early 1970s. (Courtesy of Fort McClellan.)

Seven

Around the County

There were numerous communities in Calhoun County. Some of these locales have disappeared while many have survived and thrived. Each of the regions has its own distinct history that plays a part in the history of Calhoun County. Among some of these areas were Peaceburg, White Plains, Ohatchee, Bynum, DeArmanville, Weaver, and Alexandria.

Bynum, in the southwest corner of the county, was settled by South Carolinian Eli Bynum around 1833 at the intersection of the roads to Talladega and Oxford. In the 1880s the Georgia Pacific Railroad built a road through the settlement, and the Bynum family gave money to build a depot at "Bynum's Station." In 1942, Eli Bynum's original home became the site of the Anniston Army Depot, which is still in operation.

The community of Weaver, between Anniston and Jacksonville, was settled around 1837 by Simeon Henry Weaver, originally of Georgia. In the 1870s, the farming area was known as Weaver's Station but by the 1890s the name was simply Weaver. The Southern Railroad passed through the small town, which had three general stores, three churches, a blacksmith shop, a cotton gin, a public well, and a drug store. The town of Weaver, first incorporated in 1945, maintains a police department and an elementary and high school.

In 1834, John DeArman purchased land in the southeast corner of the county and built a plantation near Choccolocco Creek. Known as Centre until after the Civil War, the area's name was eventually changed to DeArmanville as there was a Center, Alabama, in Cherokee County. It remains a rural community to this day.

Alexandria, in northwest Calhoun County, was settled as early as 1828. Originally known as Coffeeville in honor of General John Coffee (the hero of the Battle of Tallasseehatchee in November 1813), the community took the name Alexandria in 1836 in honor of the Alexandria family, who were among the original settlers of the area. By the 1920s the area had become a tenant farming community with a post office, school, and a L&N Railroad station.

White Plains, a farming community on the banks of Quataquilla Creek in eastern Calhoun County, is one of the oldest towns in the area. It was incorporated in 1837 with a marshall and a jail, 10 stores, 2 bars, 2 blacksmiths, and 2 churches. By 1842 a post office was established.

Several other small communities were located in Calhoun County, including Wellington (settled c. 1900), Eastaboga (established c. 1854), Middleton (established in 1858), and Eulaton (established c. 1884). One community that did not survive was Peaceburg, located on the present-day Pelham Range just east of Morrisville. In 1941 the federal government assumed the property for a training area; the remains of some houses are still visible on the range today.

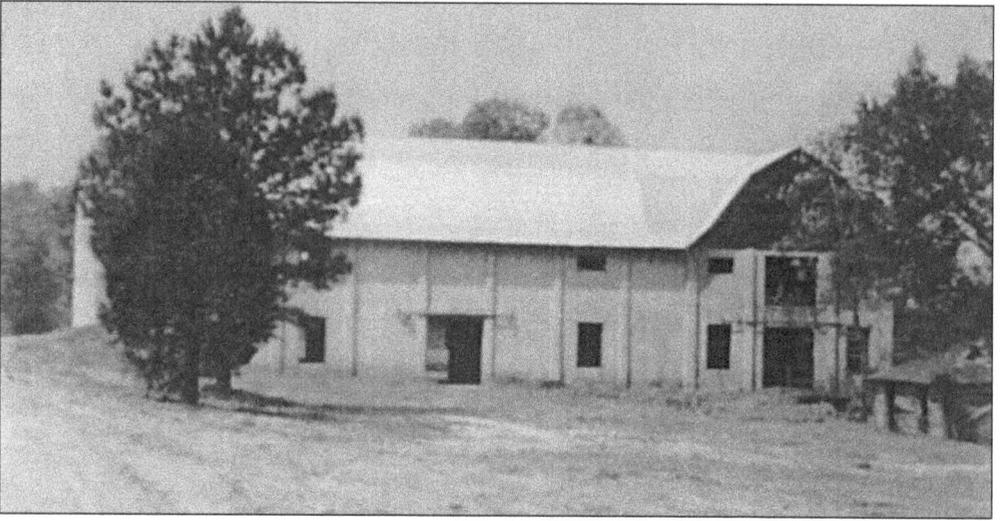

Henry Farm, located south of Jacksonville near the Four Mile Community, was once a bustling plantation complete with slaves and a Greek Revival-style mansion. It originally had 1,400 acres in 1852, when Col. James A. Stevenson moved to Jacksonville from Rome, Georgia, after a typhoid epidemic took his wife, son, and numerous slaves. Hill Crest, the mansion, was built in 1856. In 1910, the property was sold to C.B. Henry, a partner in the Profile Cotton Mill, who remodeled the home as a summer retreat for his family. In 1937, the home became a restaurant called the Plantation, which remained opened until around World War II. It was destroyed by arsonists in the 1950s. The Barn, built around 1910 for about $35,000, contained equipment for a dairy farm. In the 1990s, the barn is a potential restaurant complex. (Courtesy of Jacksonville Public Library.)

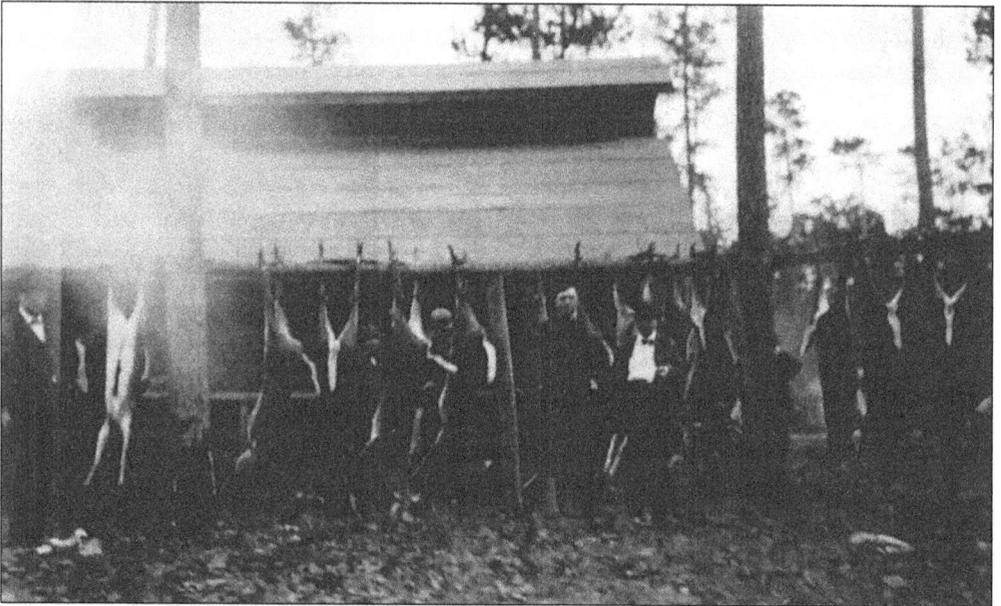

Hunting and fishing were part of life in Calhoun County. Many supplemented their family's food supply through deer meat and fish. This hunting camp, shown around 1900, demonstrates the plentiful bounty of deer running through the hill country of north Alabama. (Courtesy of Mrs. T.E. Kilby Jr.)

122

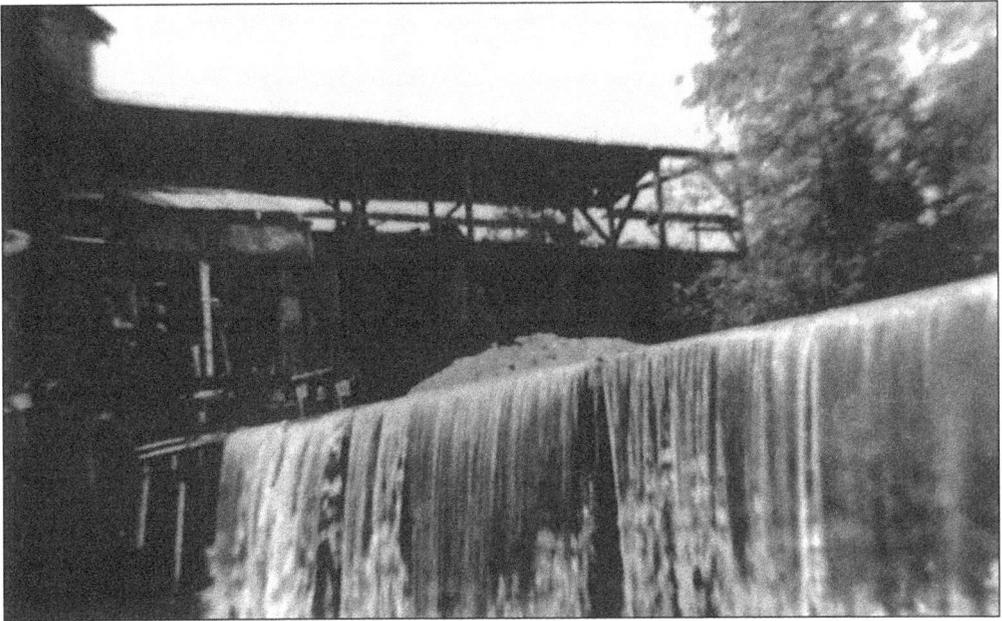

Leyden's Mill, located west of Jacksonville in the Cedar Springs community, was built by John Aderhold in 1852 as a gristmill with a large wooden wheel. The name of the property changed over the years. In 1917, the property was known as Edmondson's Mill and by the 1920s, Leyden's Mill. The name Leyden's Mill remained, and in 1926 Mr. Leyden moved the mill across from his home on the near side of the creek. In 1968, Reverend and Mrs. Lowery Hughes purchased the property and renovated the mill to be a community center. The mill is no longer standing. (Courtesy of Lou Hughes.)

The Leyden's Mill house was built about 1840 for Frank Aderhold's family. During the Civil War, Union soldiers camped just to the west of the house, and when they left, the soldiers took Frank's livestock except for a calf that belonged to his five-year-old daughter. The house was initially two front rooms separated by a hall with additions later made to the original house. (Courtesy of Lou Hughes.)

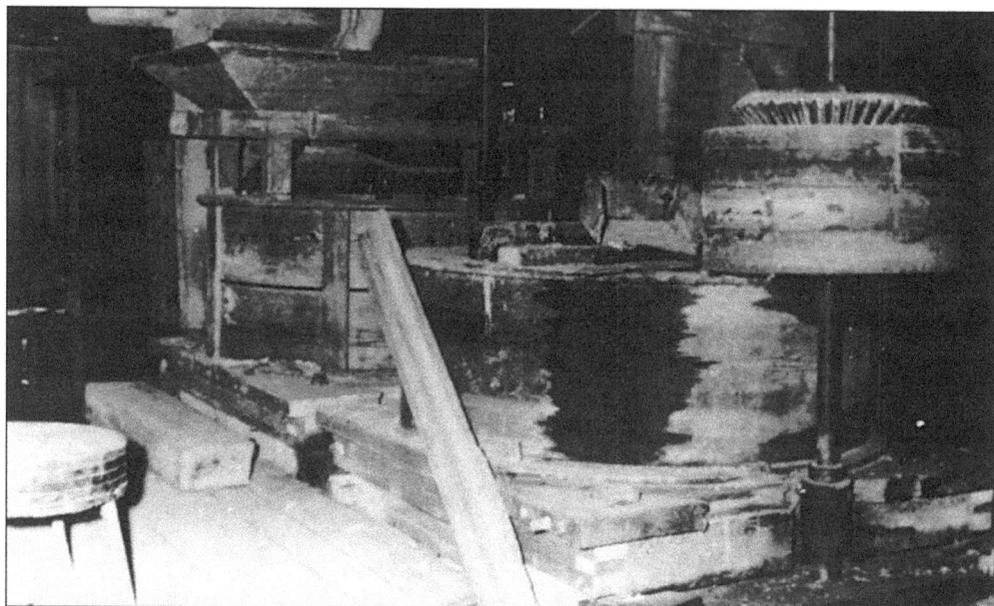

Whiteside's Mill, shown around 1901, was a gristmill located in White Plains. The mill used a water-powered wheel to grind corn. The operator poured the corn in the hopper (upper left), where it was ground and came out into a box. The large gears (in the foreground) turned the grinder, which converted the corn to meal. (Courtesy of Alabama Room at Calhoun County Public Library.)

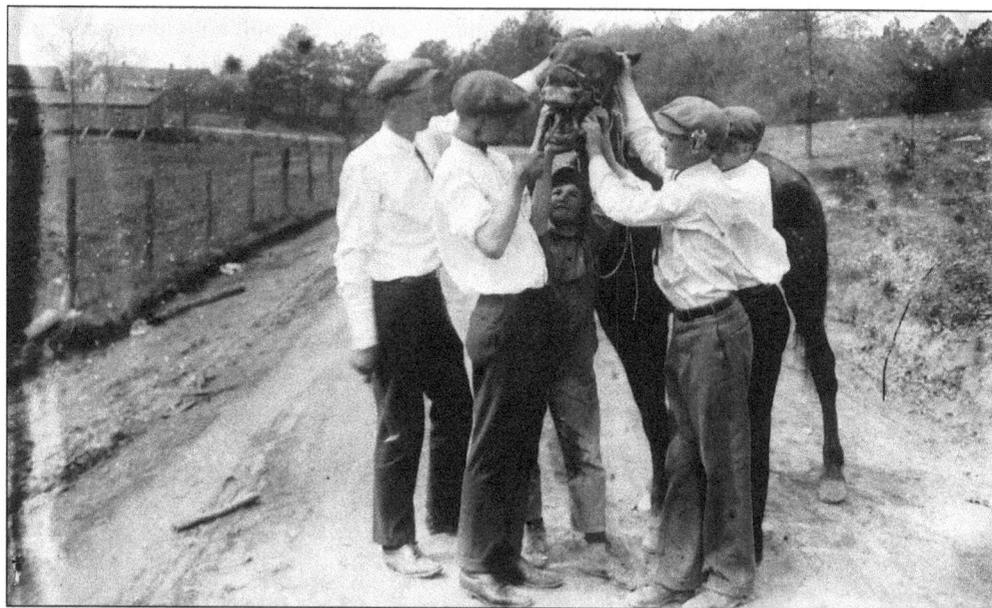

Ohatchee, located in the northwest section of the county, was a small community. The area was settled for farming lands. The money crops of the county were corn and cotton. Families generally produced everything on the farm they needed. It was therefore essential that young people be well schooled in livestock and farming techniques. Veterinary classes, like this one at Ohatchee, were offered in the early 1900s. Most schools in the 1990s have vocational schools since agriculture still plays a roll in the county. (Courtesy of Russell Brothers Collection.)

124

Pulpit Rock, located in the southern portion of Calhoun County, reaches some 1,800 feet in height and has an interesting legend. It was said that an Native American maiden threw her unfaithful lover from the peak and then followed him to her death. Some say miners found her packet of letters that explained the tragic story. The spot was ideal around 1900 as a site for picnics and long walks. (Courtesy of *Alabama Military Institute Catalogue*.)

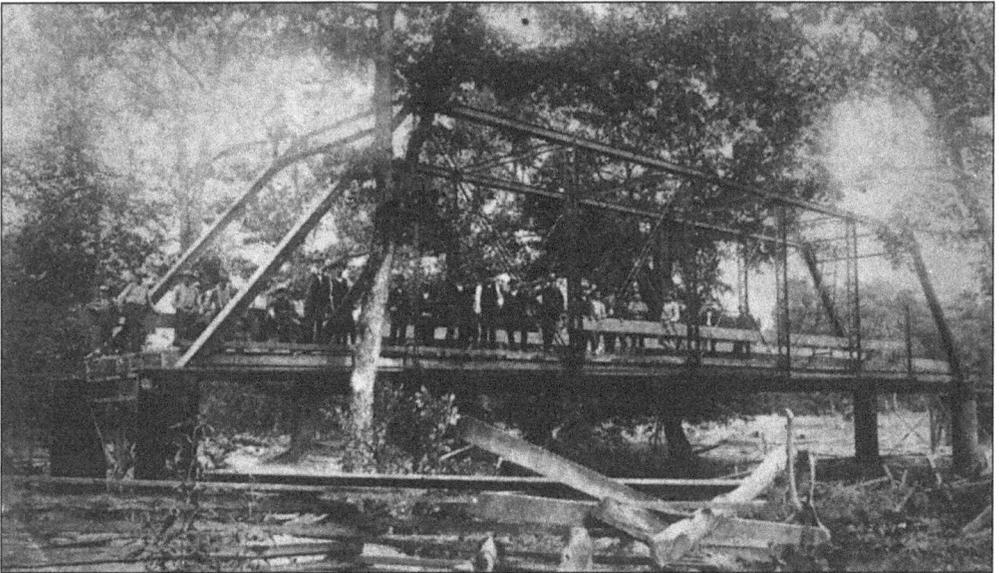

Boiling Springs, located west of Oxford, was so named because the water from the springs boiled up from the ground and flowed to Choccolocco Creek. The area is filled with majestic weeping willow trees and watercress plants. A bridge constructed around 1900 allowed traffic to pass across the springs. (Courtesy of Oxford Public Library.)

The Choccolocco Valley, located in the southeastern section of Calhoun County, was largely farming country that was isolated and undeveloped until the late 1870s. In 1878, a post office at Choccolocco was established. In September 1884, the "Choccolocco Highway" opened and connected Anniston to Dearmanville. The area is a rural-like area with the post office still standing. (Courtesy of Alabama Room at Calhoun County Public Library.)

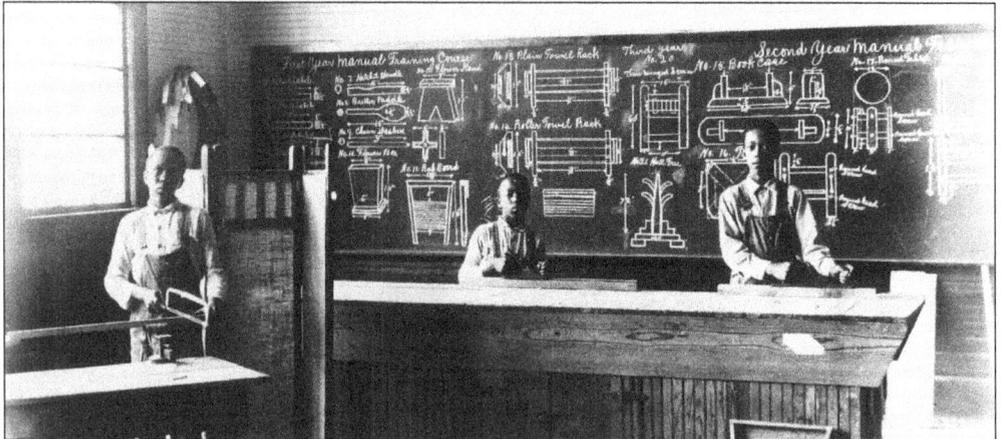

Hobson City, located west of Oxford, was an African-American community created in 1899. The Oxford School District excluded the African-American residents from attending the schools, but imposed an education tax on the residents. There were approximately 400 residents who felt they needed their own incorporated city, and they petitioned the state legislature to create a separate municipality. The residents received permission to incorporate and named their town after Richmond Pearson Hobson, a hero of the Spanish-American War. The new city government faced a lack of money and called for a free will offering to keep the city afloat financially. The Calhoun County Training School, which taught manual trades to African Americans, was loacted in Hobson City. The training school, shown here in 1931, was under the direction of Principal C.E. Hanna. The town survived its early problems and still exists as one of the handful of African-American towns. (Courtesy of the Russell Brothers Collection.)

Selected Bibliography

A Brief History of the City of Oxford, Alabama. Oxford file. Oxford Public Library. 1989.

Caldwell, Ronald J. *A History of Saint Luke's Episcopal Church, Jacksonville, Alabama, 1844–1994*. Jacksonville, AL: St. Luke's Episcopal Church, 1994.

Camp McClellan News. July 17–23, 1917.

Davidson, James West, et al., eds. *Nation of Nations: A Narrative History of the American Republic*. New York: Alfred A. Knopf, Inc., 1991.

Entire, Robert, ed. *Anniston, Alabama Centennial 1883–1983 Commemorative Book and Centennial Program*. Anniston, AL: Higginbotham, Inc., 1983.

First National Bank of Jacksonville. n.d. *The Jacksonville Story . . . an Enduring Heritage*.

Fort McClellan News. July 18, 1967.

Foscue, Virginia D. *Place Names in Alabama*. Tuscaloosa, AL: University of Alabama Press. 1989.

Gates, Grace. *The Model City of the New South*. Tuscaloosa: University of Alabama Press, 1978.

Historic Jacksonville Semi-Centennial 1902–1952. General John H. Forney Chapter United Daughters of the Confederacy, 1952.

"History of Jacksonville." Alabama Room File. Calhoun County Public Library.

"History of Oxford." Alabama Room File. Calhoun County Public Library.

"History of Piedmont." Alabama Room File. Calhoun County Public Library.

The Manufacturers' Record. Baltimore, MD: Bigsby and Edmonds, 1886.

Martin, Lenore. "History of Leyden's Mill, 1852–1968." Jacksonville, Al: Cedar Springs Extension Homemakers Club, 1968.

McClellan News. July 16, 1982.

National Society of the Colonial Dames of American in the State of Alabama, ed. *Early Courthouses of Alabama Prior to 1860*. Mobile: Jordan Printing Co, 1966.

A Note on the History of Fort McClellan. Fort McClellan: Abrams Library. 1995. Photocopy.

Oxford Alabama 1860–1960 Centennial Souvenir Program. 1960. n.p.

Reed, Mary Beth, Charles E. Cantley, and J.W. Joseph. n.d. *Fort McClellan: A Popular History*. Stone Mountain, GA: New South Associates.

Remington, Craig and Thomas J. Kallsen, eds. *Historical Atlas of Alabama. Vol. 1, Historical Location by County*. University of Alabama: Department of Geography, 1997.

Savage, Robert Haynes. *The Story of Piedmont*. Centre, AL: Stewart University Press, 1979.

Sawyer, Effie White. *The First Hundred Years: The History of Jacksonville State University, 1883–1983*. Jacksonville, AL: Jacksonville State University Centennial Committee, 1983.

Stewart, James Douglas, Jr. *The Earliest Settlers of Calhoun Co., Alabama*. Paper presented at Jacksonville State University, August 28, 1984. Photocopy.

Acknowledgments

Calhoun County has been home to my family for several generations, so this book has been a labor of love to produce. I was fortunate to have the aid of many wonderful people. I would like to thank the following institutions who have graciously shared photographs: Irene Sparks of the Oxford Public Library; Kathryn Childress of the Jacksonville City Library; Tom Mullins of the Calhoun County Public Library; Bill Hubbard of Jacksonville State University; and the staff at Fort McClellan.

I would also like to thank numerous Calhoun County residents who were kind enough to share their private photographs: Gerald Whitton, Lou Hughes, Ralph Callahan, Ralph Burgess, and Mrs. T.E. Kilby Jr. In addition to these residents, I would like to thank Craig Remington, for the use of the map of Calhoun County; and Sacred Heart Catholic Church, for use of their sketches. I wish to extend my appreciation to Karen Hendricks, Lance Johnson Studios, Moore Printing, and Don Hayes and the Training Service Center Staff for reproducing these photographs.

This book would not be complete without information supplied about the photographs, and I would like to thank the following for their aid: Ft. McClellan Public Affairs Officer Paul McGuire, Jerry Burgess, Glenda Southerland, Tim Rice, SGM (Ret.) George Murray, Van Roberts; Ron Burke, Gerald Powell, Dr. Warren Sarrell, and Lt. Gen. (Ret.) Harold Hardin.

Finally, I wish to thank my editor, Jim Dunn. To my family, I want to express my love and appreciation for everything, especially my "Grampie," to whom this book is dedicated.

.